the wood that doesn't look like an elephant

**black dog
publishing**

london uk

In memory of Michael Cameron
designer, educator and good friend
of The Chase.

thirty years of the chase

Chairman's Statement

Ben Casey, Chairman
and Co-founder

Thirty Years in the Making
This book is a celebration of thirty years of creativity. Other design books may touch on strategy and effectiveness but this one focuses on the part of the process in which a creative spark brings a piece of communication to life. That's why the book takes the form of a creative awards annual. Not least because it is made up of award-winning work (but just to prove the rule we have included the odd exceptions that we believe have slipped through the net). The structure also helps us show off the breadth of our work and, although every piece of work states the year it was done, they are all mixed up in their category which makes for interesting comparisons. In each section a high-profile person, from differing roles within the industry, was invited to choose their favourite piece of work and write a few notes about why they selected it.

Creative League Table
In November 2012, *Design Week Magazine*'s annual creative league table was published. It was based on a points system that graded all the important national and international creative competitions. From this they worked out a top 100. That year the number one spot went to The Chase. It wasn't a complete surprise as we had been hovering around the top five for a number of years. Later we were told that in fact, we had been number one the year before but that league table hadn't been published because *Design Week* was in the transitional stage of changing from a printed to an online magazine. Then, the following year, we were number one again. A sort of Geoff Hurst World Cup Final hat-trick, two undisputed goals, one dodgy one.

In the Beginning
The Chase started in 1986. I was working with the incredible John Gillard at the time, helping him set up the School of Communication Arts in London. I think it was the lecture programme that read like a Who's Who of the creative industries that made me succumb to a friend who ran a typesetting company called Quick Brown Fox. For years he had been trying to persuade me to open a design

group in Manchester. It seems strange now but people in the business at that time with whom I'd discussed the idea almost all had serious doubts that it would be possible for a design company to succeed outside of London. Ignoring their advice I approached Lionel Hatch, a freelance designer whose work I really admired, and asked him if he would consider joining me. Fortunately, Lionel said yes. I also recruited two talented young designers, Hugh Adams, who was at Pentagram and Jim Williams, who worked in advertising at Collett Dickenson Pearce. I knew them from my teaching days at Preston Polytechnic and I suppose it was the success of the graphic design course that gave me the confidence to set up in the provinces. It had swept the board in the inaugural D&AD Student Awards Scheme and Alan Fletcher, the Godfather of British graphic design, paid us the backhanded compliment, "I've nothing against Preston but shouldn't the best course in the country be in its capital city?" At least I think it was a compliment.

In Search of a Mantra

So we'd opened our doors and in trying to establish ourselves we were faced with the same dilemma that all start-ups have. No portfolio of work and therefore no case studies that we could put our name to. We needed to do for ourselves what we were claiming we would do for others, which was to find a creative solution to sum up our approach to work. While I was pondering over this I was driving home one evening listening to a local radio station. Someone was talking about a trip to India and told a story about a street trader who carved beautiful little elephants out of blocks of discarded wood and sold them to tourists. When asked how he made them he replied, "I just cut away the wood that doesn't look like an elephant."

To me this disarmingly simple response epitomised the bedrock that underpinned our creative process.

We quickly designed a mailer, complete with a wooden elephant, that won us a lot of business and has guided us ever since. We continually refer to it when defining a strategy right through to the way our concepts are expressed, whereby everything has to have a reason for being. "We're communicators not decorators", as Harriet Devoy, a former creative director, would put it. The mailer also won us our first awards and started us off on an unbroken run of 26 years of having work accepted by D&AD, the most coveted award scheme in the UK.

What Influenced Us

Although Pentagram set the standard for design companies in the UK, the work that influenced us more than any other came from a different but related source. It was what I considered to be the golden age of advertising that was created in London in the 1970s and early 1980s led by Collett Dickenson Pearce.

This followed a pattern set by the music industry when the Beatles et al had taken the groundwork done in America and added a 'Britishness' which seemed to move things on to a new level.

Much in the same way, a radical form of creative advertising that had been heralded by Bill Bernbach in New York was embraced by London agencies and developed into a form of its own. Given it was before the globalisation of advertising it had the freedom to indulge in British humour and the value of understatement.

I suppose it could also be linked to that distant cousin, fine art, who had started the ball rolling with the development of conceptual art in the mid-60s.

The big idea was king. Styling and aesthetics moved towards a more supporting role and, although the importance of an exceptionally high level of craftsmanship was never undervalued, its purpose was always to enhance the concept. So what exactly do we mean by an 'idea' anyway?

Many years ago a relative of mine was on holiday in Ireland and went into a shop and asked the shopkeeper if they sold English newspapers.

The lady asked, "Do you want today's or yesterday's?"

A bit puzzled, my relative said she would prefer today's.

The lady replied, "Well you'll have to come back tomorrow."

Now some would argue that it's an example of a poor piece of communication. Why couldn't she have simply said that it takes a day for them to arrive from England?

But if she had I wouldn't be recounting the conversation all these years later.

By being thought-provoking and using whatever device that is appropriate, like humour for instance, we believed that we could add a new dimension to communication that came under the banner of design.

Uncivil War

The approach which we chose to adopt was not to everyone's taste and in the late 80s a war of words broke out in the design industry.

On one side stood what were described as idea-led companies; on the other there were style-led companies. The Chase never really got involved in this debate. If the creative process could be basically divided into two parts, conception and expression, then it was simply a case of on which part a company chose to place the emphasis.

Although the war seemed to have long since petered out in the UK, it had in fact spread to mainland Europe. Three years ago I was a member of an international jury at the Cannes Festival. After the first round of judging it became apparent that a group of judges had given 'nul points' to any work in which they felt the concept had dictated an unacceptable aesthetic. They argued that it was no longer design but had wandered into the domain of advertising.

Going back to what influenced us in the first place, perhaps they had a point.

Yet, ironically, the boundaries that were the subject of debate were already beginning to be dismantled by the onslaught of technology.

Conventional media channels continue to give way to new forms of communication.

So, in many ways, this book marks the end of an era.

In readiness we are constantly adapting the way we work and responding to all the new opportunities that are now up for grabs.

Driven by Bev Hutchinson, who leads our management team, we have become a lot more proactive in our relationship with clients, a creative consultancy rather than a team of designers. To meet the new challenges we have broadened our skill base, not least with the introduction of an in-house film production company led by Oscar-nominated director Mark Gill.

Yet the thing that we believe will never change is, whatever the future might throw at us, it will still require the pin-sharp creative thinking that you see throughout the pages of this book.

Pre-Chase work for Conways, London's largest photo-typesetting company. The owner, Stan Conway, told me he wanted to use Herb Lubalin but couldn't afford him so he would have to use me.
For a while I became a Lubalin tribute designer.

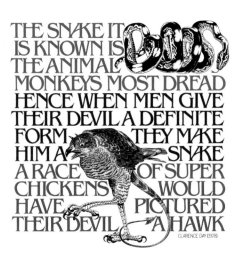

Two mailings for Preston Polytechnic where I lectured for eight years.

Left
The concept dictates the expression mimicking Carter's Seed packaging.

Below
Two slits in the card carry the invitation message. Illustrated by Bob Rowinski.

Lionel Hatch, Co-founder

Two of the many examples of work that made me pick up the phone to Lionel Hatch and ask if he would like to help me start up The Chase. Fortunately, Lionel said yes.

THIRTY · days · hath · Septem-ber · April · JUNE · and · Novem-ber · All · the · Rest · have (30) (8)

January 1
2 3 4
5 6 7
8 9 10 11
12 13 14
15 16 17
18 19 20
21 22 23 24
25 26
27 28 29
30 February
31 32 33 34
35 36 37 38
39 40 41
42 43 44
45 46 47 48 49
50 51 52 53 54 55
56 57 58 59
March 60
61 62 63 64
65 66 67 68
69 70
71 72 73 74 75
76 77 78
79
80 81 82
83 84 85 86
87 88 89 90 April
91
92 93 94 95
96 97 98 99 100
101 102 103
104
105 106 107 108
109 110 111 112 113
114 115
116 117 118 119 May 120
121 122 123 124 125 126
127 128 129 130 131 132
133 134 135

I 136
137 138 139 140
141 142 143
144 145 146 147
148 149
Saturday 150 · Sunday ·
152 151

I	II	III	IV	V	VI
Saturday	· Sunday ·	Mon-*day*	(Tues)*day*	Wednesday	Thur(s)*day*
152	153	154	155	156	157
VII	VIII	IX	X	XI	XII
Fri*day*	Saturday	· Sunday ·	Mon-*day*	(Tues)*day*	Wednesday
158	159	160	161	162	163
XIII	XIV	X5	16	17	18
Thur(s)*day*	Friday	Saturday	· Sunday ·	Mon-*day*	(Tues)*day*
164	165	166	167	168	169
19	20	21	22	23	M I D S U M M E R D A Y
Wednesday	Thur(s)*day*	Friday	Saturday	· Sunday ·	Mon-*day*
170	171	172	173	174	175
25	26	27	28	29	30
(Tues)*day*	Wednesday	Thur(s)*day*	Friday	Saturday	· Sunday ·
176	177	178	179	180	181

July 182 183
184 185 186
187 188 189
190
191 192 193
194 195 196 197 198 199
200 201 202 203
204 205 206 207 208 209
210 211 212 213 214 August
215 216 217 218
219 220 221 222 223
224 225 226 227 228
229 230 231 232 233 234
235 236 237 238 239
240 241 242 243 244 245 September
246 247 248 249
250 251 252 253 254
255 256 257 258 259 260
261 262 263
264 265 266 267 268 269 270 271
272 273 274 275
October 276 277 278
279 280 281 282 283
284 285 286 287
288
280 290 291
292 293 294 295 296
297 298 299
300 301 302
304 November
305 306 307 308 309 310
311 312 313 314 315
316 317
318 319 320 321 322 323 324
325 326 327 328 329 330
331 332 333 334 December
342 343 344 345
346 347 348 349
350 351 352 353 354 355 356
357 358 359
360
361
362 363
364
365

Thirty-one · Excepting · February · alone · And · that · has · 28 · days · clear · & · twenty-nine · in · each · LEAP · Year (XXXI) (TWENTY-EIGHT) (29) (every IV)

Thirty-one · Excepting · February · alone · And · that · has · 28 · days · clear · & · twenty-nine · in · each · LEAP · Year (XXXI) (1) (TWENTY-EIGHT) (29) (every IV)

(upside down text:) *THIRTY·days·hath·Septem-ber·April·JUNE·and·Novem-ber·All·the·Rest·have* (30) (8)

contents & judges

Thanks to all the judges who we invited to select a piece of work from a given category and write a brief description as to why they chose that particular piece.

	Contents	Judges	
01	Best in Show	**Ben Casey and Lionel Hatch** Co-founders, The Chase	12
02	Books & Magazines	**Aziz Cami** Co-founder, The Partners	16
03	Branding	**Deborah Dawton** Chief Executive, DBA	34
04	Calendars	**Nils Leonard** Chairman/Chief Creative Officer, Grey LDN	64
05	Direct Mail	**Tony Davidson** Executive Creative Director, Wieden+Kennedy, London	82
06	Environment	**Peter Higgins** Director, Land Design Studio	102
07	Film	**E Elias Merhige** Film Director	120
08	Literature	**Lynda Relph-Knight** Design Writer and Consultant	134
09	Mixed Media	**Jim Sutherland** Founder, Studio Sutherl&	154
10	Packaging	**John Rushworth** Partner, Pentagram, London	178
11	Posters	**Michael Bierut** Partner, Pentagram, New York	194
12	Promotional Items	**Patrick Burgoyne** Editor, *Creative Review*	216
13	Stationery	**Jonathan Sands OBE** Chairman, Elmwood	234
14	Symbols & Logotypes	**David Stuart** Co-founder, The Partners	248
15	Use of Image	**Mark Denton** Creative Director, Coy! Communications	262
16	Use of Type	**Vince Frost** CEO and Executive Creative Director, Frost Collective	286
	Index	**The Chase** Clients and Staff	310

Selecting just one single piece of work from The Chase's thirty-year existence should have been daunting enough. But for us to then actually agree on which that piece would be—that ought to have been downright impossible.

In fact the choice took us all of two minutes.

Independently we both decided on the first job we ever did: the Elephant Carver's Story. This self-promotional mailer clarified, in our own minds, the philosophy that we would apply to every other project which would come our way.

So the winner is in everything you see in this book.

Ben Casey and Lionel Hatch Co-founders, The Chase

best in show

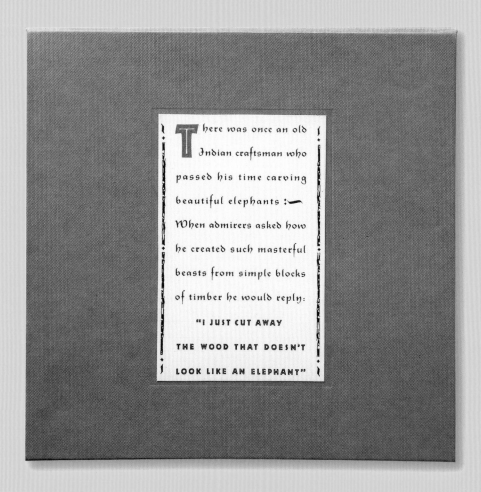

There was once an old Indian craftsman who passed his time carving beautiful elephants :—

When admirers asked how he created such masterful beasts from simple blocks of timber he would reply:

"I JUST CUT AWAY THE WOOD THAT DOESN'T LOOK LIKE AN ELEPHANT"

THIS SIMPLISTIC. IF SOMEWHAT MODEST ANSWER IS JUST AS VALID FOR THE SOPHISTICATED PROBLEMS WHICH FACE THE MODERN DESIGNER.

Before considering any solution the designer must fully understand what sort of animal a company or product is and, equally important, what it is not.

A company must resist the temptation of following any competitors image. For if it fails to do this, its own image will end up being irreparably misshapen.

The unique set of circumstances that create any communication problem should manifest itself as a precise brief and act as a sound platform for creative thinking.

However, just as the craftsman needs a high degree of skill, the most accurate brief in the world is rendered useless without the creative spark that brings its solution to life.

We at The Chase have produced imaginative yet relevant solutions for corporate identities, booklets, packaging, posters, and items of direct mail. If you would like to see these solutions, then please ring either Ben Casey or Richard Rubin on 061-873 7316.

If you haven't got an immediate need of our service then keep the elephant as an appropriate symbol not to forget that you have an exceptional graphic design consultancy right here in the North of England.

Many years ago I used to design posters and programmes for the Royal Shakespeare Company. Given their paltry budgets I struck on the idea of getting the RSC to give up a share of their revenue from posters so that we could commission great photographers and illustrators.

And that's how I managed to work with Ralph Steadman (amongst others). He produced a magnificent image for *Henry VIII* and my job was to then add the cast and production credits to the poster. I must have spent days trying to do this but every attempt only diminished the illustration.

Desperation bred bravery and I sent the illustration back to Ralph and asked him to 'draw' all the type. It was a triumph and my best piece of art direction ever.

In *Othello* Ben and his team have achieved a huge art directorial triumph doing what I couldn't—using their typographic, layout and production skills to enhance David Hughes' outstanding imagery. Every young designer should study this stunning book as it is a masterclass in craft skills.

Unfortunately, as I've been writing this review, I've foolishly managed to lose *Othello* in my library.

Sorry Ben.

Aziz Cami Co-founder, The Partners

books & magazines

02

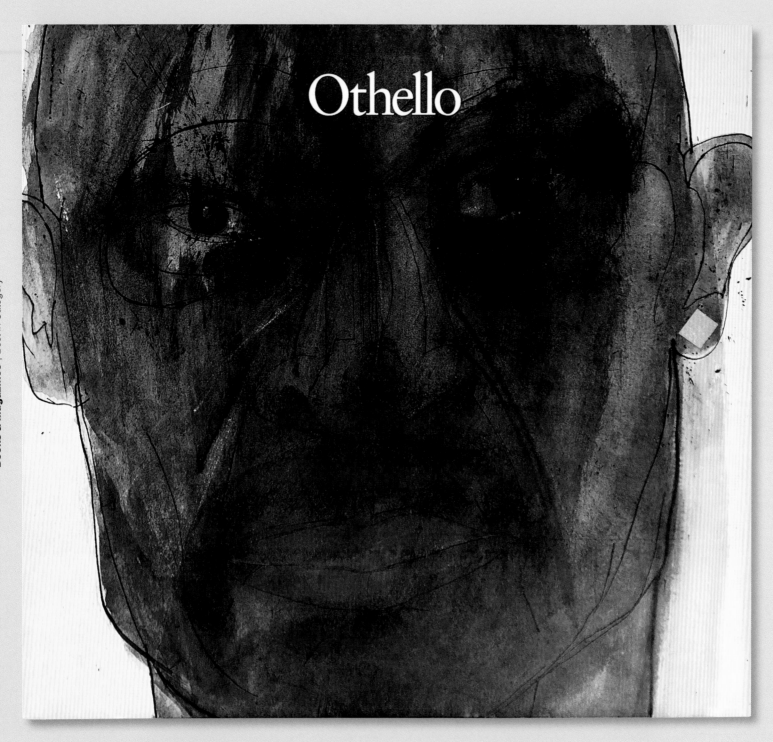

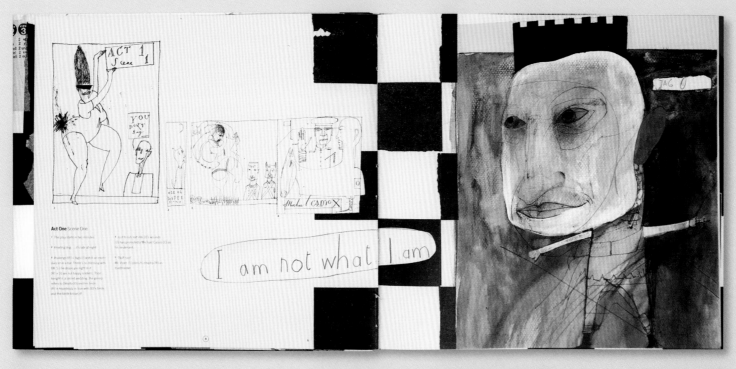

Act Five Scene Two

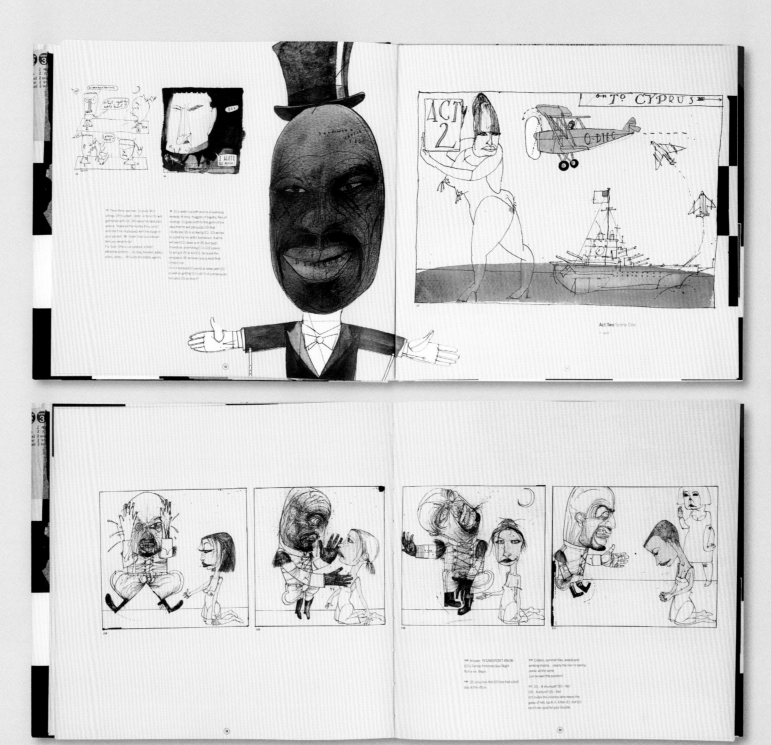

Cock-a-Doodle!
....................................
The design of the cover complements the tone of David Hughes' illustrations within. An interesting detail was the rings, normally used to identify racing pigeons, which were used to number each limited edition.

David Hughes | 1996

Yearbook 2
....................................
The Creative Circle invited us to design their annual, showcasing the very best of British advertising and design. As it was the second yearbook, we looked to a mathematical formula to solve the problem and to the artist Dennis Leigh to bring the concept to life.

The Creative Circle | 1987

As part of the new visual identity we introduced the use of cut-out imagery on a silver background. This allowed a degree of flexibility for individual campaigns to feature graphic, illustrative or photographic imagery yet still look part of a set.

The CO̶OPERATIVE BANK

Travel Services

Travellers Cheques
Foreign Currency
Sending Money Overseas

The CO̶OPERATIVE BANK
Savings & Investments

A tax-free home for your maturing TESSA capital

NO TAX

The CO̶OPERATIVE BANK
Savings & Investments

A flexible savings account with the easiest possible access

The CO̶OPERATIVE BANK
Savings & Investments

If you want guaranteed high returns, maybe not today, maybe not tomorrow, but some day over a three year period.

Image: Hulton Archive/Getty

A campaign was launched to communicate customer support for its ethical policy to become more comprehensive and detailed. The campaign featured a set of photographic icons created to symbolise each aspect of their policy. A development in the visual identity was the introduction of a 50 per cent split to give more emphasis to the message. We also introduced a new strapline at this point to emphasise the customers' involvement.

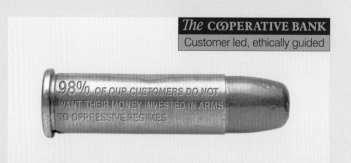

The COOPERATIVE BANK
Customer led, ethically guided

98% OF OUR CUSTOMERS DO NOT WANT THEIR MONEY INVESTED IN ARMS TO OPPRESSIVE REGIMES

the
arms trade

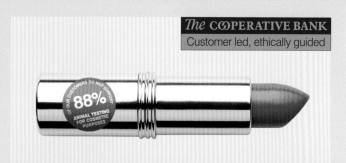

The COOPERATIVE BANK
Customer led, ethically guided

88%

animal
welfare

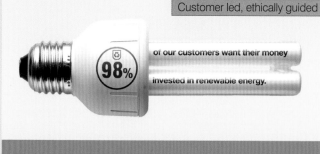

The COOPERATIVE BANK
Customer led, ethically guided

98% of our customers want their money invested in renewable energy.

ecological
impact

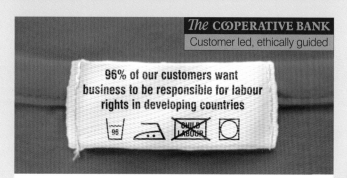

The COOPERATIVE BANK
Customer led, ethically guided

96% of our customers want business to be responsible for labour rights in developing countries

global
trade

The COOPERATIVE BANK
Customer led, ethically guided

human
rights

Having the support of their customers behind them, the bank was never afraid to stand up and be counted. The branding not only helped the bank shape its products but also led to collaborations with like-minded organisations.

Right
The bank obviously still had to compete in the 'day to day'. A new rate offered in January gave us the idea to borrow from the retail stores and promote it as a January Sale.
Many other banks followed suit and it became an annual event in the sector.

Below Left
The bank was not afraid to put their weight behind many issues deemed controversial. This advertising campaign supported Landmine Action's call for the ban on the use of cluster bombs.

Below Right
The bank, in partnership with Greenpeace, developed the first biodegradable credit card. The launch advertisement pulled no punches in pointing out that their card was totally PVC-free.

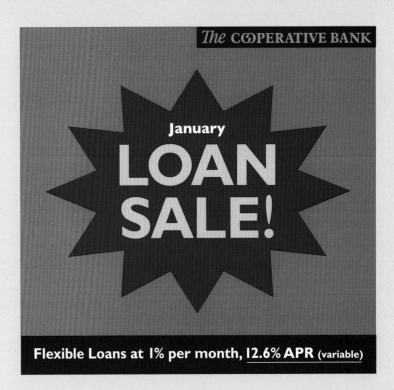

The CO-OPERATIVE BANK

January
LOAN SALE!

Flexible Loans at 1% per month, 12.6% APR (variable)

The CO-OPERATIVE BANK
Customer led, ethically guided

One toy a child will pick up once and never play with again.

To a 5 year old child, anything that looks remotely like a toy is something to be grabbed at with both hands.

Except that it's not a toy, it's a bomb. And a particularly nasty one at that.

Each one of the hundreds of bomblets that spew out of every cluster bomb, sadly, happens to look like a toy. Often brightly coloured, they're especially attractive to children. Some resemble toy parachutes – others tantalisingly look like balls.

To the untrained eye of a child, excited at the prospect of finding something new to play with, it's unquestionably a toy to be picked up or kicked.

It's not a bomb to be messed with. Many children lose their lives or end up badly maimed in so many countries across the world because of unexploded weapons. Not just during wars but in peace time.

One of the most commonly used air-launched weapons in the world today, it's also one of the most unreliable. Of the hundreds of bomblets that rain down on large areas of land from every cluster bomb, up to 20% fail to explode on impact. They're easily blown off course and can land, often miles from intended targets, on soft terrain like farmland, sand and scrub.

And that's where they stay, lying in wait. In villages, near schools, anywhere a child might play.

As you may be aware, The Co-operative Bank has a strict ethical policy. It almost goes without saying, we wouldn't finance the buying or selling or indeed making of such weapons.

But heartened by the part we played in the successful banning of anti-personnel mines, with the Ottawa Treaty of 1997, we believe we can achieve the following aims.

Together with Landmine Action, and the support of our customers, we'd like to see a freeze on the use of cluster bombs until new international law is in place. A law which makes sure that those countries which use explosive weapons, like cluster bombs, go back and clear them up when the fighting's over.

Please, add your name to our petition at www.co-operativebank.co.uk/petition And if you can, make a donation: you can either call into your local branch or send a cheque payable to CB Appeal, to the address below. All your donation will go directly towards clear-up operations in areas affected by unexploded weapons like cluster bombs.

To children in so many parts of the world today, a gift much greater than any toy.

WORKING WITH

The Co-operative Bank, Dept G, Freepost, NWW 655A, Manchester M4 9ED.
Current Account customers can also donate through Telephone Banking

The Co-operative Bank p.l.c., Head Office, P.O. Box 101, 1 Balloon Street, Manchester, M60 4EP.
For more details of how your money will be spent please ask in branch or see our website.

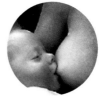

The Greenpeace Credit Card. Welcomed at fast food outlets throughout the world.

PVC is the mother of plastic pollutants (and is the main material in all credit cards). Toxic chemicals released during its manufacture and disposal resist natural breakdown and accumulate in the fatty tissues of organisms.

As they travel up the food chain, levels become concentrated in breast milk. And the recent discovery that phthalates are present in dried baby milk means that it is impossible to avoid feeding toxic chemicals to new born babies.

Politicians assure us that levels are not harmful.

Scientists are divided.

Greenpeace says stuff that. Why take the risk when alternatives to PVC are readily available?

That's why our new credit card is the first to be 99.9% free.

It is a small but positive step that will lead the way for others.

The card is issued in partnership with

The Co-operative Bank, the only UK bank with its own ethical policy and innovative ecological mission statement.

For every account opened by Greenpeace receive a £5 donation and then continue to be paid a further 25p for every £100 spent.

This is brilliant for us – and it's pretty good for you.

The Co-operative Bank offers a unique guarantee, never to charge you an annual fee in your entire lifetime.

You can also switch to The Greenpeace Visa card, bringing with you any existing overall balance and repay it at a preferential rate of 1% a month (12.6% APR variable).

This alone could save you over £150.*

The standard rate for purchases is 21.7% APR (variable).

And to top it all, we'll at least match the credit limit on your existing card.

For further information clip the coupon or phone us free now quoting reference 505.

0800 33 99 22

GREENPEACE The CO-OPERATIVE BANK

53° 16' 46" N 002° 14' 12'' W
Of Anything Like It
..

Alderley Park is home to a world-standard science facility, dedicated to discovery and ideas. Set in 400 acres of sweeping parkland, it's a base for progressive businesses and stylish living.
We developed a brand identity underpinned by an intelligent and intriguing branding device.

An A (Alderley) becomes P (Park) becomes a flag/marker which can be used to unite the varying locations Alderley Park has to offer such as science labs, office space, modern living, parkland and sports facilities.

Bruntwood & Manchester Science Partnership | 2016

ALDERLEY PARK

53° 16' 46" N 002° 14' 12'' W

This isn't the
BEGINNING

£42M & **£5M**

GREATER MANCHESTER
AND CHESHIRE
LIFE SCIENCES FUND

ALDERLEY PARK
VENTURES FUND

53° 16' 46" N 002° 14' 12'' W

of anything like it

ISSUE 2 **ALDERLEY PARK**
53° 16' 46" N 002° 14' 12'' W

ISSUE 3 **ALDERLEY PARK**
53° 16' 46" N 002° 14' 12'' W

A GENIUS IDEA

Farm shop opens this Fall.

Q&A

An open forum to discuss the shared vision for Alderley Park.

The Beauty of Science

Science obviously demands rigour, logic and intelligence. But it can also be viewed as an elegant, aesthetic process that combines thought with fact and a strong sense of wonder. For AstraZeneca we set out to encapsulate those elements using silhouettes of people and objects. They provide a canvas on which those elements of science, disease, medicines and moments of impact and inspiration are illustrated.

These images can also be beautifully animated, expressing original thinking and a devotion to leadership in scientific breakthroughs. They can be many and varied, enabling a wide reach of academic and business agendas conveyed with messages, stories and results.

AstraZeneca | 2015

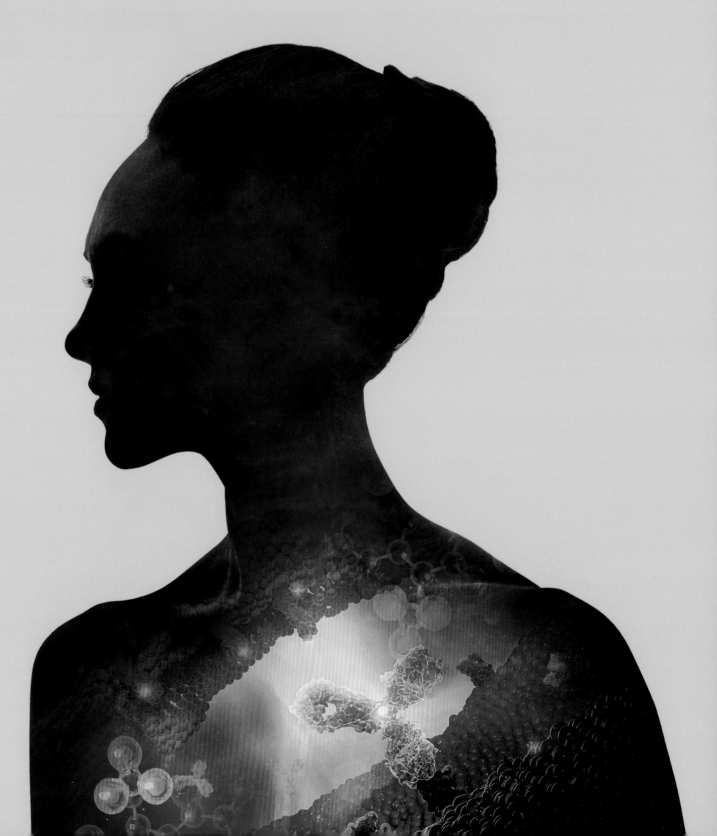

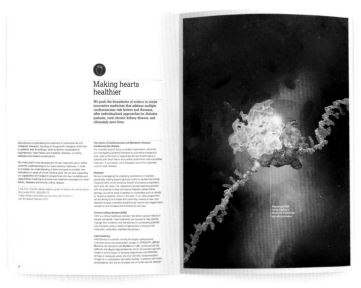

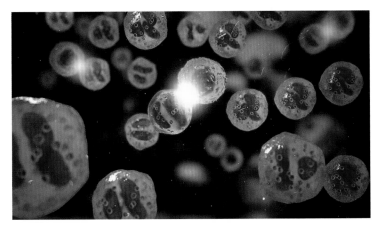

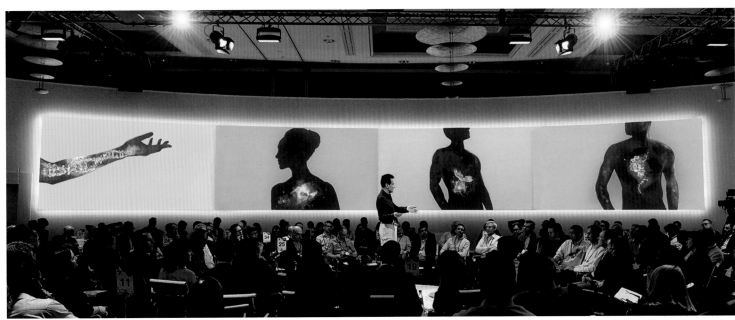

Precious metals

In this sector we are acknowledged as the market leader: gold and platinum inks in a huge variation of finishes. Matt or bright surfaces and lustres in different rose or lemon colours: screenprint (thermoplastic or 'cold') or brushing paste formats. The final result is totally unique but please note that it is also dependent on the application and substrate. Technical Advice: www.colour.matthey.com

Inks from precious metal

Some gold's are more precious than others. Our products are formulated from 99.99% pure Johnson Matthey gold.

Our precious metal technology embraces both functional and aesthetic properties. Its diverse application ranges from glass and ceramic decoration to aerospace and electronics.

To satisfy the most stringent demands for technical performance and application we employ user-centred design; although our products are increasingly complex we seek to make life easier for our customers.

Our expertise in precious metals has taught us to look beyond the bigger picture. Many precious metal products are supplied as inks. The robust metallic films form after a firing process, and although they appear solid and continuous, our technology has revealed complex nanometre scale structures.

Using state of the art instruments, Johnson Matthey has developed techniques to probe and manipulate products at the atomic scale.

	Decorative
	Silver pastes
	Ceramic
	Aerospace

...

Mando is a digital agency whose love of technology and understanding of human behaviour drives them to create great online experiences; this was also central to our rebrand solution. We saw the "and" within Mando as an opportunity to express their personality: "Understanding People and Loving Technology." We then produced a series of statements with Mando at the heart of each one. To add depth, charm and character to the messaging we incorporated Victoriana-style images. They act as literal and metaphorical interpretations of messages or create little puzzles telling small stories.

Mando | 2014

MANDO

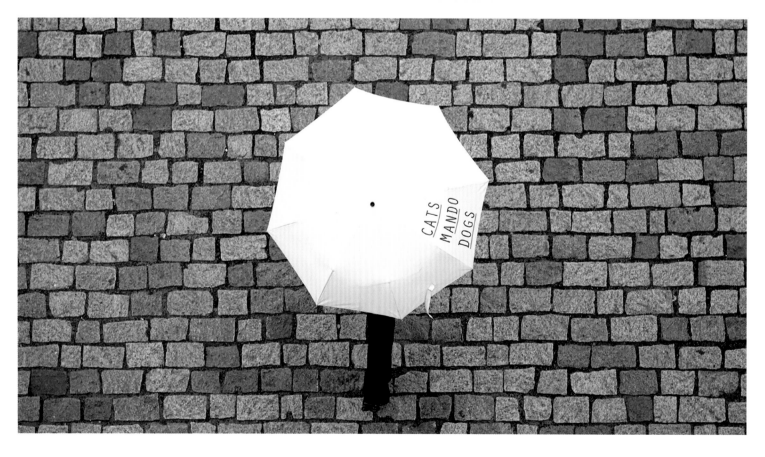

Branding | Corporate

MILK
MANDO
TWO
SUGARS

THOUGHTS
MANDO
DOODLES

A LITTLE CHANGE CAN
MAKE A BIG DIFFERENCE.

Internal values

BRAVE
CAN DO
BIG HEARTED
BALANCED
PIONEERS

Our internal values are the principles
we benchmark ourselves against, as
individuals and as a team. They align
us and inform how we perform and
guide the quality control of what we
deliver. They are also values to inspire
and encourage development of skills.

Brave
You're at Mando because you're brilliant
at what you do… but we want you to go
further. So embrace challenge, tell us your
exciting ideas, and chase ambitions. You'll
find people here ready to listen, support,
and sharpen your thinking.

Can do
You want to solve problems, working in
the challenging space between people and
technology. Mando succeeds because
you're positive and confident; thriving on
complex problems that stretch us all to
ever-better results.

Big-hearted
Our people are all we have. By putting
others first - colleagues, clients, our families
and our community - you make Mando an
amazing place to work, based on openness,
fair play and fun.

Balanced
You add value to organisations struggling
with complexity; balancing smart thinking
and practical action. Things go more
smoothly because you look for ways for
everyone to get a 'win'; meaning clients and
colleagues love working with you.

Pioneers
There are no passengers at Mando.
Your energy, commitment and relentless
application of learning drives Mando's
continued success.

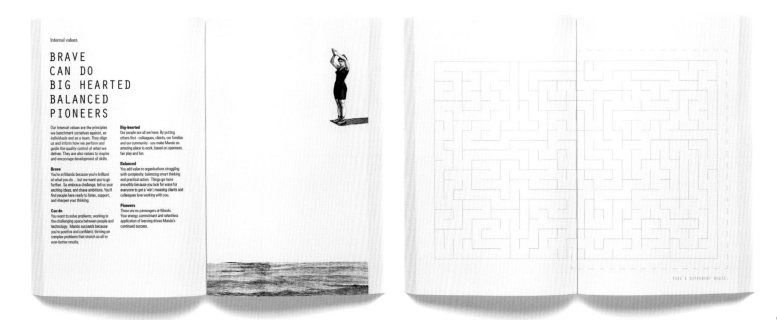

TAKE A DIFFERENT ROUTE.

Home Is What You Make It
...

Merseystride was an initiative supported by Places for People that was set up to help get homeless people into employment and accommodation. We named the initiative "home" as it was both a furniture store and a way back into stable long-term accommodation for homeless people. The furniture was end of line or damaged stock donated by manufacturers in the local area.

The homeless people were trained to build and repair the furniture and it was sold at discounted prices to the general public. The bold graphic styling used was intentionally austere in appearance to emphasise that no money was wasted on presentation and everything was simply printed on cardboard recycled from the furniture packaging.

Merseystride | 2009

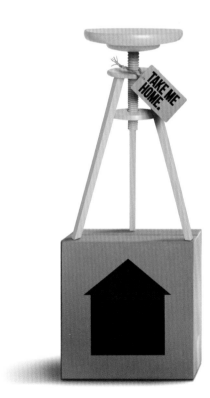

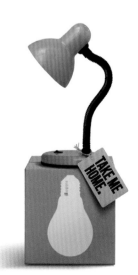

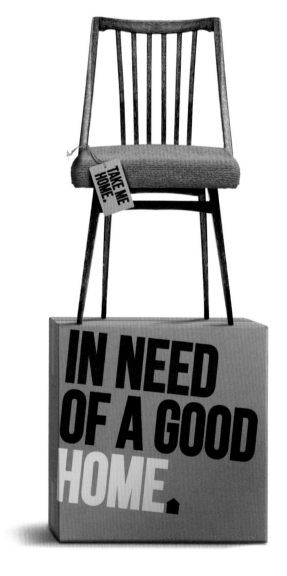

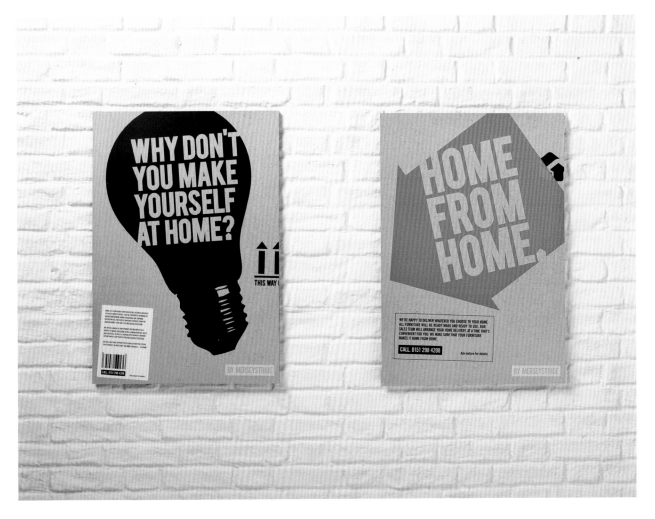

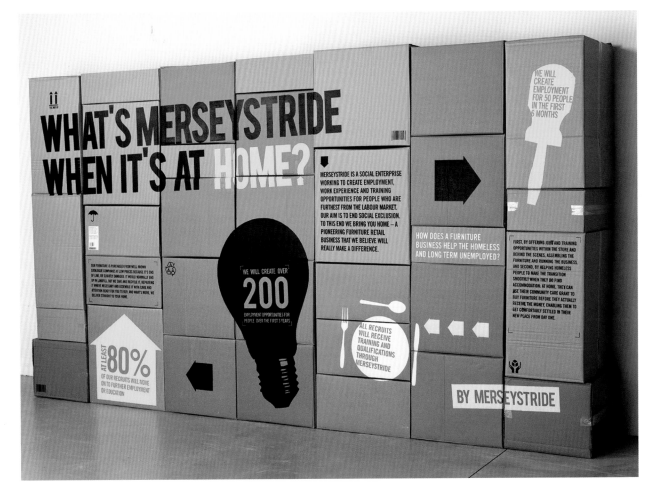

Be Yourself
...

Self is a new digital brand for Russia,
backed by Svyaznoy Bank. It's an
online personal concierge service
that helps to organise and coordinate
an individual's finances and their
lifestyle by linking in services from
well-known Russian partner brands.
The personalised element was
emphasised through the logo, which
had a signature-like feel, and the
use of interesting black-and-white
photography.

Self | 2013

I've lost my

the first self management service

Photography Matt Stuart

One place to

and

/ selfbyself.ru
the first self management service

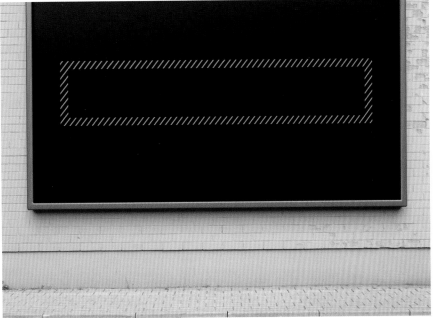

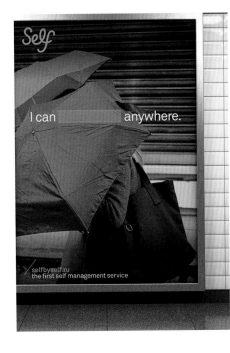

I can anywhere.

/ selfbyself.ru
the first self management service

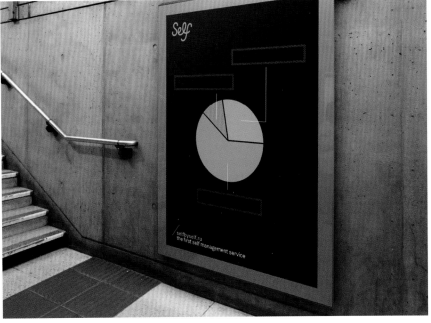

/ selfbyself.ru
the first self management service

Branding on Tap

Against a general public dissatisfaction with utility companies, Yorkshire Water sought to reflect much needed change within the business by reviewing its brand identity. Natural pride in the county meant the Yorkshire landscape became an integral part of the identity. For the literature an illustration style was developed to complement the logo and create a stronger brand.

Yorkshire Water | 2002

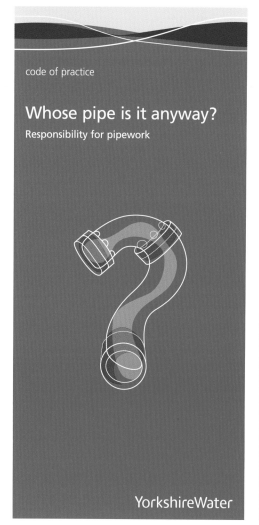

code of practice

Whose pipe is it anyway?

Responsibility for pipework

YorkshireWater

code of practice

Providing some extra help

Additional needs

YorkshireWater

code of practice

Everything you can expect from us

YorkshireWater

Illustrator Evelina Frescura

Without high-street branches to walk into, or friendly staff to chat with, launching the UK's first Internet bank needed bags of personality—the graphics would become its public face. Starting with the marque, it was neither a logotype nor a symbol, it did the job of both as well as providing all necessary contact details. Breaking the number one rule of most visual identities, the marque was designed to be active and ever-changing. It could feature anything that raised a smile from an interest rate to a personalised image added by the customers themselves.

The decision to use magenta was an important one as colour can be a powerful branding device. The fact that no other bank was using any similar colour gave the brand full ownership within its sector.

smile | 1999

Branding | Corporate

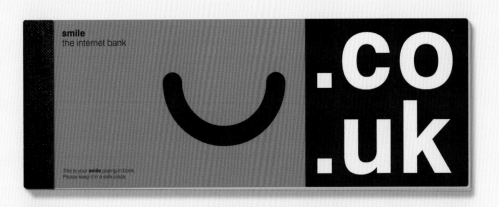

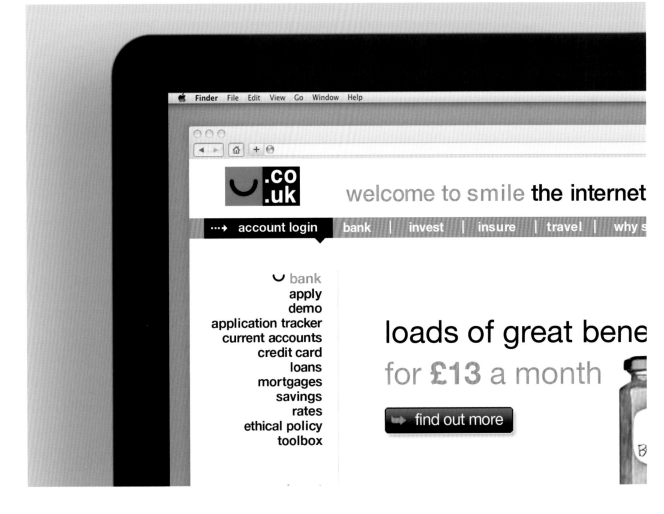

One of the best ideas I've ever seen was a clock placed underneath a sign for a funeral parlour. The most precious human element is time, and its passing is the hardest thing in the world to ignore, the clock against the sign placed our slow-walking, top-hat-wearing friends somewhere deep in my mind.

Like the perfectly placed clock, the humble calendar can be more than just a reminder of our everyday tasks, it can provoke. At its best though, it can become an alarm call for us to achieve and to accomplish.

The Almost Extinct calendar is a daily poke in the ribs, beautifully crafted in black, white and red. The gentle morning before the St Patrick's Day lunch you'd written in weeks ago, quietly hijacked by a menagerie of the endangered.

Putting the calendar's noble mission aside for one second, it is always the smallest things that really create the tingle. Four little holes and some red string to help you hang it. Four little holes and some red string to remind you for 365 days to do what you can for a purpose bigger than yourself.

Nils Leonard Chairman/Chief Creative Officer, Grey LDN

calendars

04

Almost Extinct

**Every day, hundreds
of endangered species
get closer to extinction.
By working together,
we can help save them.**

BBC Wildlife Fund

January

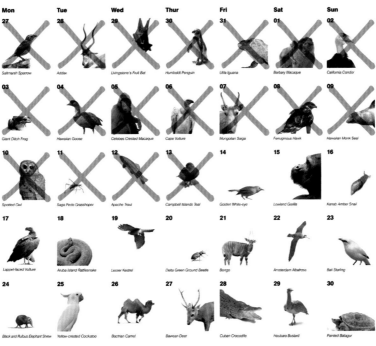

Mon	Tue	Wed	Thur	Fri	Sat	Sun
27	28	29	30	31	01	02
Saltmarsh Sparrow	Addax	Livingstone's Fruit Bat	Humboldt Penguin	Utila Iguana	Barbary Macaque	California Condor
03	04	05	06	07	08	09
Giant Ditch Frog	Hawaiian Goose	Celebes Crested Macaque	Cape Vulture	Mongolian Saiga	Ferruginous Hawk	Hawaiian Monk Seal
10	11	12	13	14	15	16
Spotted Owl	Saga Pedo Grasshopper	Apache Trout	Campbell Islands Teal	Golden White-eye	Lowland Gorilla	Kanab Amber Snail
17	18	19	20	21	22	23
Lappet-faced Vulture	Aruba Island Rattlesnake	Lesser Kestrel	Delta Green Ground Beetle	Bongo	Amsterdam Albatross	Bali Starling
24	25	26	27	28	29	30
Black and Rufous Elephant Shrew	Yellow-crested Cockatoo	Bactrian Camel	Bawean Deer	Cuban Crocodile	Houbara Bustard	Painted Batagur
31						
Black Stilt						

BBC Wildlife Fund

Every day, hundreds of endangered species get closer to extinction. By working together, we can help save them.

The BBC Wildlife Fund works to raise funds and awareness to help threatened wildlife and places. Show your support at **www.bbc.co.uk/wild**

Designed by Thi Chase
thechase.co.uk

Printed on Cyclus Offset
100% recycled paper

Pen & Ink
..

For Pen & Ink, a fundraising calendar
to benefit Amnesty International,
we asked fifty-two of this country's
leading illustrators to each donate a
piece of work. The brief: create a stink
about anything that gets up your nose.

Amnesty International | 1992

Calendars | Wall

CREATE A PEN & INK! 1992 CALENDAR

THE CHASE
CREATIVE CONSULTANTS

THE CO-OPERATIVE BANK

THE BLOOMSBURY ART
COMPANY

PHILIP MYERS PRESS

FEBRUARY

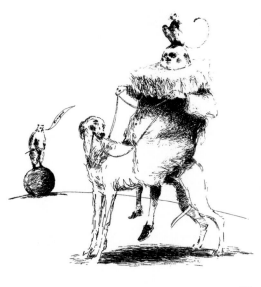

FEBRUARY

Illustrators

1. Michael O'Shaughnessy
2. Martin Chatterton

1

2

3. Ian Saxton

4. George Hardie

5. Peter Horridge

6. Jake Abrams

The Art of Recycling
.......................................
A reminder throughout the year of
the need to recycle. Twelve leading
illustrators depart from their familiar
techniques and use only recycled
materials to create collages
representing environmental issues
they feel strongly about.

APT Photoset | 1990

THE ART *of* RECYCLING

1990
CALENDAR

The Chase
APT
Photoset Ltd

Brunels Paper Ltd
Wace Group plc
Jo Print Group

THE ART *of* RECYCLING

The title of the calendar is derived from the brief we sent to twelve of

the country's leading illustrators. We asked them to produce a piece

of work that expressed an environmental issue which they felt par-

ticularly strongly about. We also asked them not to use illustration in

the conventional sense but to

construct their images from

found objects or materials. This

meant a radical departure for many of the illustrators from their more

familiar styles. Inevitably, cynics may see the calendar as jumping

onto the environmental bandwagon, but we see it as an appropriate

vehicle to continually remind us of the part we can play to preserve

our planet. We thank the illustrators, their agents, and photographers

for their enthusiasm and talent, generously donated free of charge.

1

2

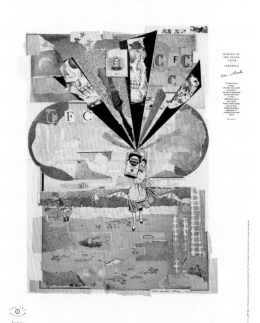

Illustrators

1. Dennis Leigh

2. David Hughes

3. Ian Beck

4. Bush Hollyhead

July

September

3

4

70

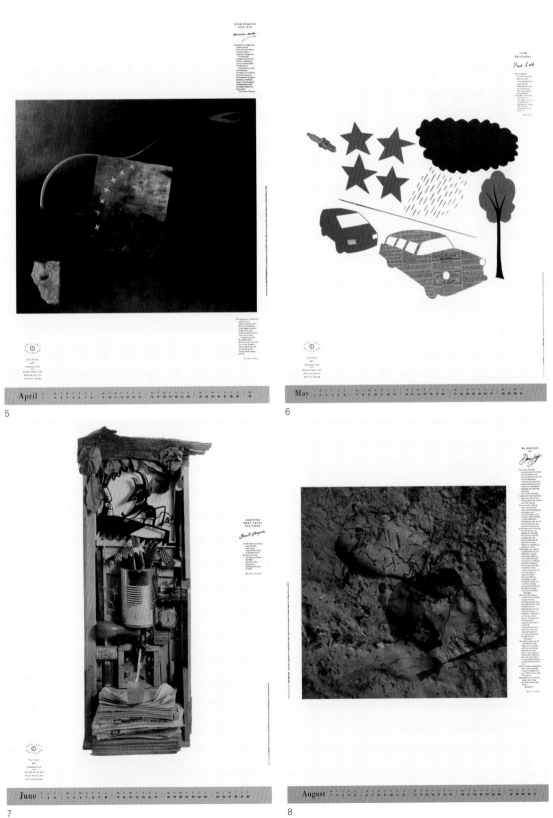

April

May

June

August

5

6

7

8

5. Russell Mills
6. Paul Leith
7. Benoit Jacques
8. Dennis Leigh

The photographer David Walker wanted to celebrate his hometown of Leigh in Lancashire with portraits of the people who lived there, idiosyncrasies and all. Twelve of the shots became this self-promotional calendar.

David Walker Photographer | 1997

[NINETEEN NINETY SEVEN CALENDAR]

There's nowt so *queer* as FOLK

[A PHOTOGRAPHIC ESSAY ON THE PEOPLE OF LEIGH]

[THE PEOPLE OF LEIGH]

I stopped them in the street. I called them at home, out of the blue. *Just be yourself* was the difficult bit. Eventually, they were ⊚ The campanologist, quiet as a church mouse ⊚ The white Rasta with a black face ⊛ Roland, the diving instructor ⊛ The Army & Navy Store's disarmed guard ⊛ Great Britain's most glamorous grandma ⊚ The eccentric, more High Noon than High Street ⊚ Billy and Jeff (was that a ferret down their trousers?) ⊛ Robert, the pet shop owner ⊛ The young Channel swimmer ⊚ Helen, the direct link to the other side ⊛ Doreen, every school kid's best pal ⊚ The Reptile Club Secretary. The kind of people that you come across *everyday* in an ordinary Lancashire town.

[DAVID WALKER PHOTOGRAPHER]

The Old Friends

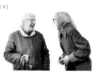

The Bell Ringer
[JANUARY]

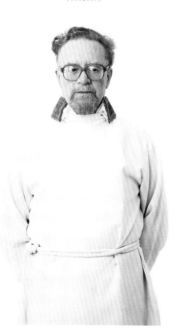

1
2
3
4
5
6
7
8
9
10
11
12
13
14
15
16
17
18
19
20
21
22
23
24
25
26
27
28
29
30
31

The Miner
[FEBRUARY]

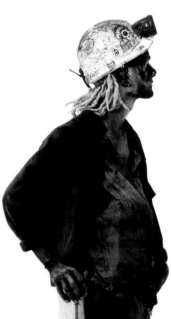

1
2
3
4
5
6
7
8
9
10
11
12
13
14
15
16
17
18
19
20
21
22
23
24
25
26
27
28

The Diver
[MARCH]

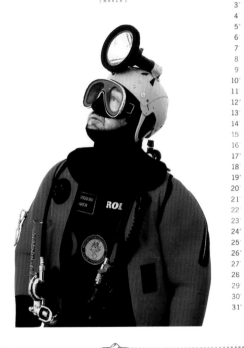

1
2
3
4
5
6
7
8
9
10
11
12
13
14
15
16
17
18
19
20
21
22
23
24
25
26
27
28
29
30
31

The Hunters
[JULY]

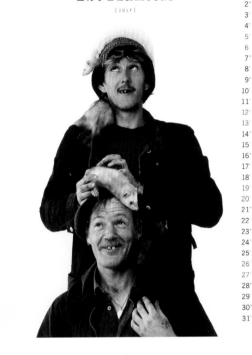

1
2
3
4
5
6
7
8
9
10
11
12
13
14
15
16
17
18
19
20
21
22
23
24
25
26
27
28
29
30
31

The Swimmer
[SEPTEMBER]

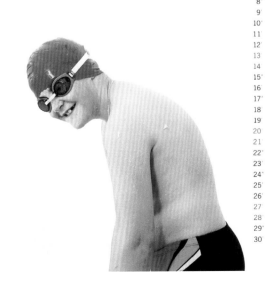

1
2
3
4
5
6
7
8
9
10
11
12
13
14
15
16
17
18
19
20
21
22
23
24
25
26
27
28
29
30

The Lollipop Lady
[NOVEMBER]

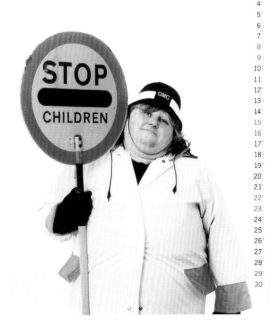

1
2
3
4
5
6
7
8
9
10
11
12
13
14
15
16
17
18
19
20
21
22
23
24
25
26
27
28
29
30

Strung Along

This self-promotional wall calendar for
The Chase makes virtue of necessity.
It provides a witty graphic solution
to the problem of string intrusion by
utilising the hanging string to create
a visual illusion as it completes each
line illustration.

The Chase | 2008

Illustrator Mark Blade

Dot to Dot

The brief here was to show off the
texture of the paper, so we designed
a calendar that people were invited
to write on: join up the dots and the
name of the month emerges.

Fenner Paper | 2006

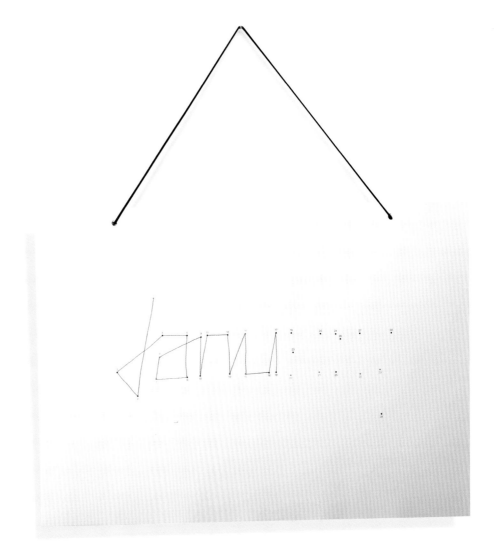

Career Life-break

Does working for your living ever feel
a bit like a prison sentence? For
adventure holiday company, Vivisto,
this year planner helps you count
off the days. Marker provided.

Vivisto | 2007

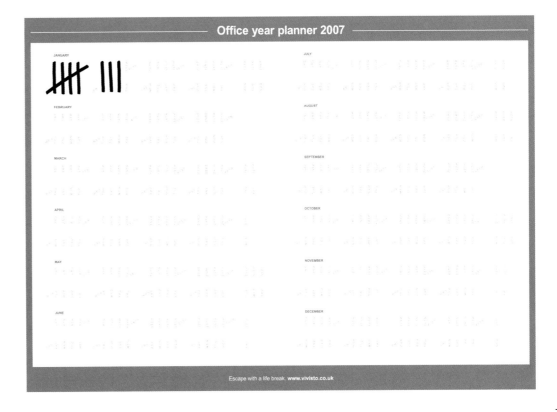

Shot in the Dark

Things that appear normal enough during the day can take on a much eerier quality seen by night. For this self-promotional calendar, Shot in the Dark, photographer David Walker's black-and-white shots were enhanced in the printing process with six black inks and two varnishes.

**Highlight Printers &
David Walker Photographer** | 2005

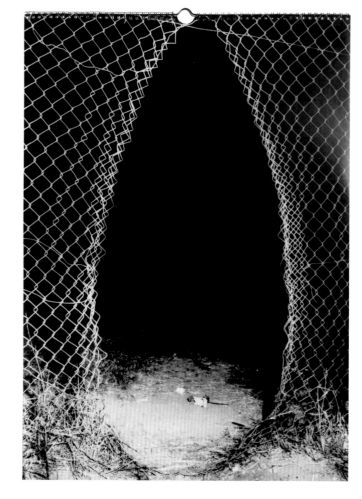

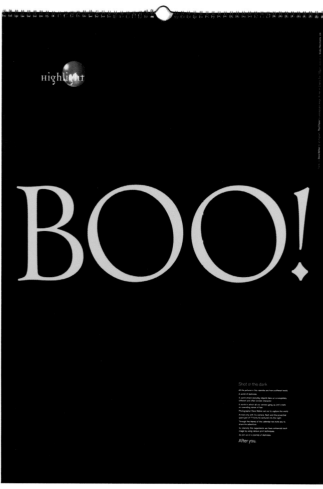

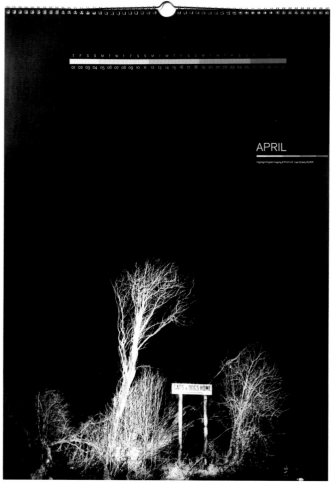

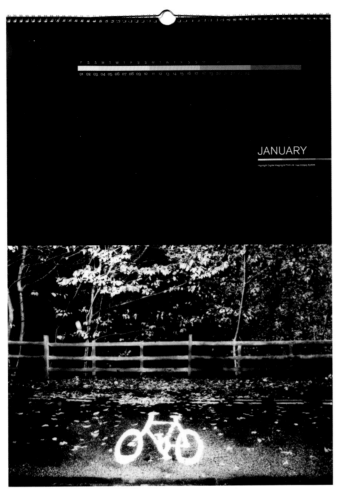

JANUARY

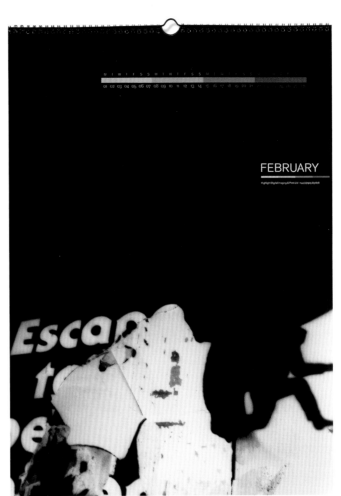

FEBRUARY

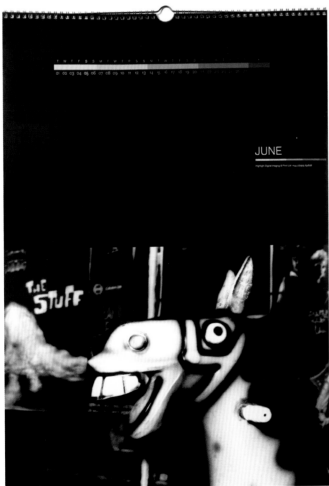

JUNE

DECEMBER

Kick Off

Twelve member clubs kicked off
the original Football League. To mark
the opening of the National Football
Museum we asked a dozen illustrators
to represent each of them.

National Football Museum | 1998

Illustrators

1. Paul Slater
2. David Hughes
3. Geoff Grandfield
4. George Hardie

Calendars | Wall

1998 January 1 2 3 4 5 6 7 8 9 10 11 12 13 14 15 16 17 18 19 20 21 22 23 24 25 26 27 28 29 30 31

2

1998

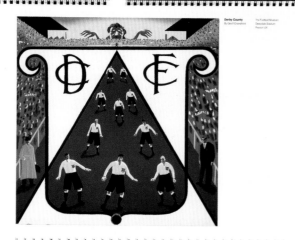

1998 October 1 2 3 4 5 6 7 8 9 10 11 12 13 14 15 16 17 18 19 20 21 22 23 24 25 26 27 28 29 30 31

3

1998 May 1 2 3 4 5 6 7 8 9 10 11 12 13 14 15 16 17 18 19 20 21 22 23 24 25 26 27 28 29 30 31

1

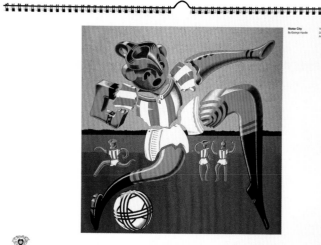

1998 December 1 2 3 4 5 6 7 8 9 10 11 12 13 14 15 16 17 18 19 20 21 22 23 24 25 26 27 28 29 30 31

4

78

Year of the Dog
...
When Manchester & Cheshire Dogs'
Home asked us to produce this
calendar we took advantage of the
fact that 2006 was also the Chinese
Year of the Dog. Calligrapher Peter
Horridge created these Chinese-
influenced illustrations. A subtle
touch—the calendar is held together
by a bulldog clip.

**Manchester & Cheshire Dogs'
Home** | 2006

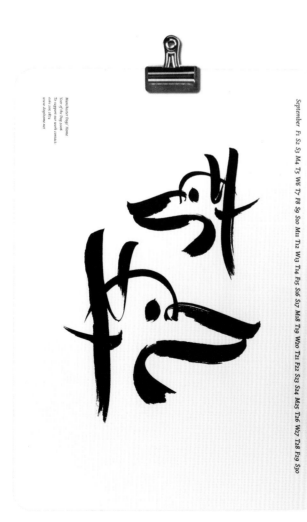

Manchester Dogs' Home
Year of the Dog 2006
To support our work contact:
0161 205 2874
www.dogshome.net

September F1 S2 S3 M4 T5 W6 T7 F8 S9 S10 M11 T12 W13 T14 F15 S16 S17 M18 T19 W20 T21 F22 S23 S24 M25 T26 W27 T28 F29 S30

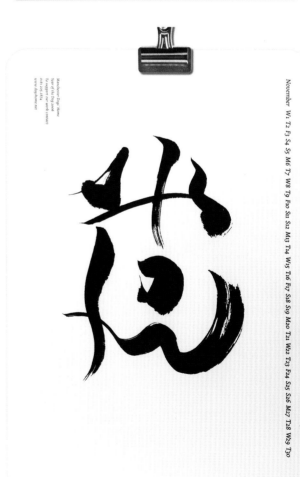

Manchester Dogs' Home
Year of the Dog 2006
To support our work contact:
0161 205 2874
www.dogshome.net

November W1 T2 F3 S4 S5 M6 T7 W8 T9 F10 S11 S12 M13 T14 W15 T16 F17 S18 S19 M20 T21 W22 T23 F24 S25 S26 M27 T28 W29 T30

Time and Space
..

The printers, Spectrum Press,
wanted to emphasise their long-term
commitment to their clients. Time
and Space was a five-year calendar
notepad designed to count down
the days to the millennium one page
at a time.

Spectrum Press | 1995

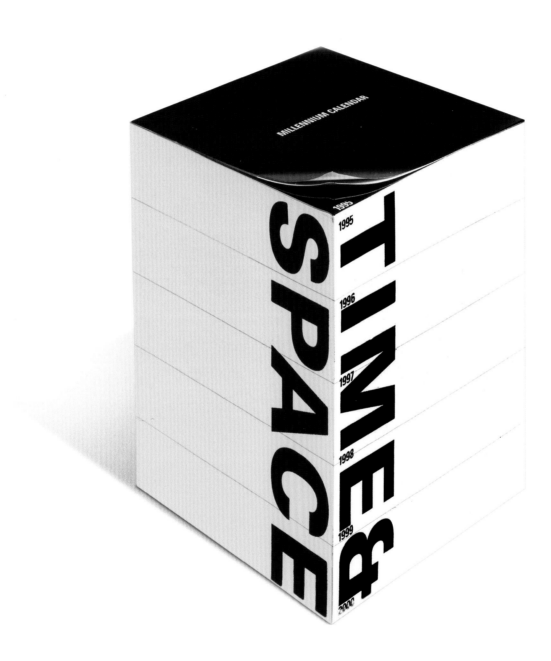

A Printer's Calendar
..
The year in colour for printers
Spellman Walker, with each
day represented by a tear-off
Pantone colour chip.

Spellman Walker | 2004

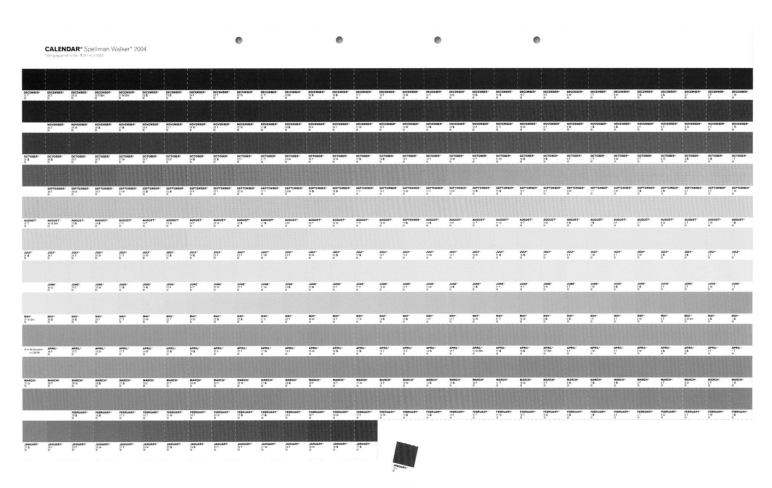

Just how many Christmas cards do you receive each year that have had little or no effort put into the design? Well this was certainly not the case here.

Ten green two pence stamps and one brown five pence stamp form the shape of a Christmas tree. Together they add up to the cost of a then first class stamp. It was posted as a flat postcard with a score down the middle so that on receiving it you fold it to make your card with the stamps forming the illustration on the front.

Only one thing missing: the postage mark. They could have left that to the post office to slap on anywhere. But that would've been too easy and a missed opportunity. Why not get them to stamp them three times in the right place so they look like baubles on the tree?

As Mies van der Rohe said: "God is in the details."

Tony Davidson Executive Creative Director, Wieden+Kennedy, London

direct mail

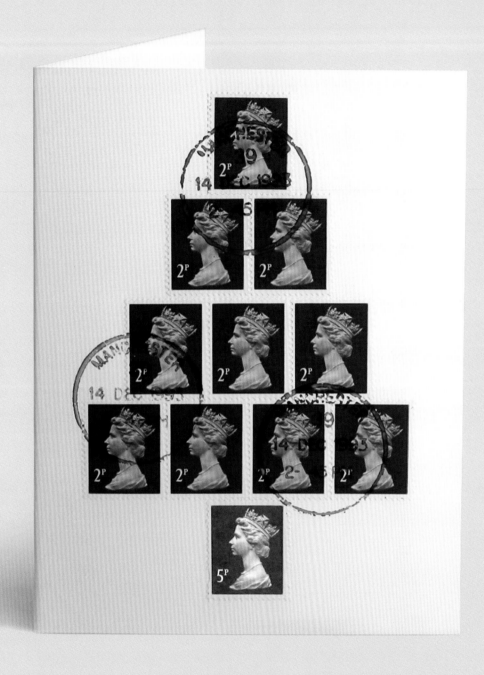

Christmas Kiss

..

This card features one of our special
stamp designs for Royal Mail celebrating
100 Years of Going to the Pictures.
We just added a sprig of mistletoe and
took advantage of it being a 25p stamp.

The Chase | 1996

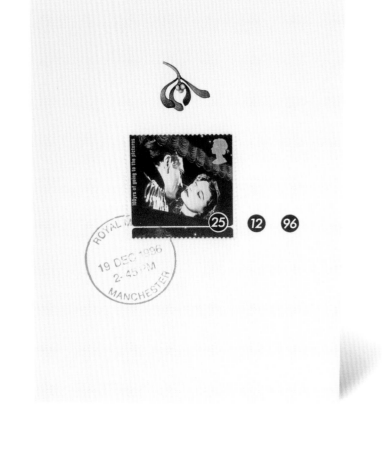

Queen's Speech

..

Continuing the theme of postage
stamps forming the illustrative element
of The Chase's Christmas cards is
something we practised for a number
of years.

The Chase | 1999

Boxing Clever
...

A multiple-choice Christmas card
where you put an X in the box against
your client's name, your own name
and to complete the word "Xmas".

The Chase | 2002

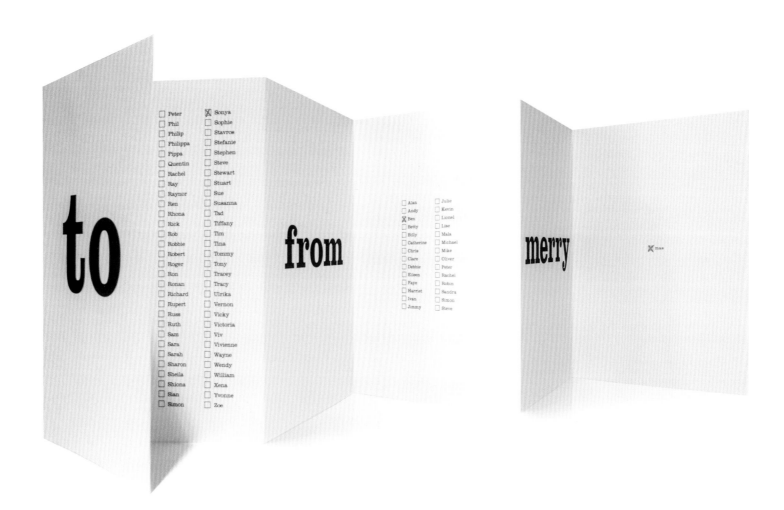

Christmas Street Food

..

Another year, we were left wandering
the streets for an idea until someone
came up with this.

The Chase | 2004

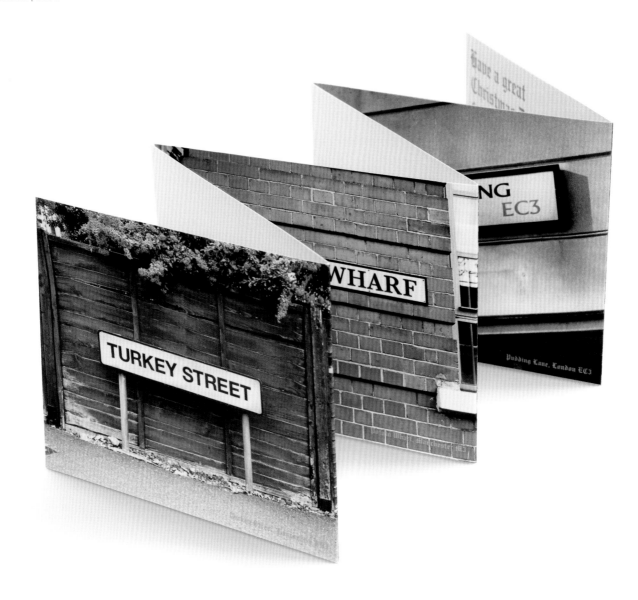

Moving Card

The Manchester Evening News was moving and expanding so we designed a mailing card that moved and expanded.

Manchester Evening News | 2006

Clean Up Campaign
..

Yorkshire Water worked hard to clean up Yorkshire's seaside. To promote awareness of their achievement we worked hard to clean up classic seaside postcards.

Yorkshire Water | 2006

Illustrator Paul Slater

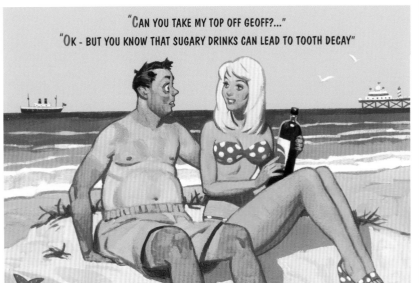

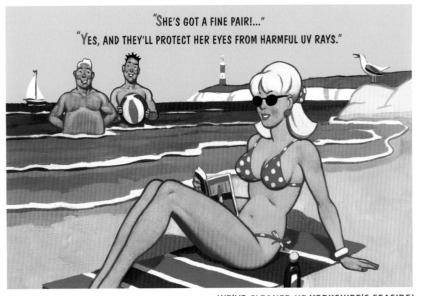

Landmine Mailer
...

As part of their ethical programme, The Co-operative Bank wanted to draw attention to the tragic consequences of the trade in landmines. This invitation to a launch event was mailed to key politicians and opinion formers. When opened an elastic band forced the mailing to spring out of the envelope and with a bang it snapped into a cube.

The Co-operative Bank | 1996

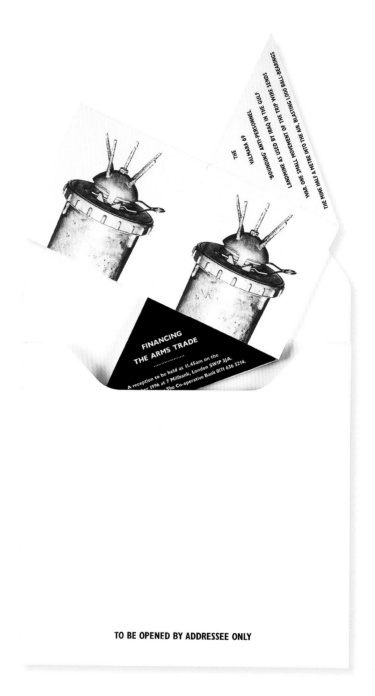

THE
VALMARA 69
'BOUNDING' ANTI-PERSONNEL
LANDMINE AS USED BY IRAQ IN THE GULF
WAR. ONE SMALL MOVEMENT OF THE TRIP WIRE SENDS
THE MINE HALF A METRE INTO THE AIR, BLASTING 1,000 BALL-BEARINGS

FINANCING
THE ARMS TRADE
...............
A reception to be held at 11.45am on the
... 1996 at 7 Millbank, London SW1P 3JA.
... The Co-operative Bank 0171 636 5214.

TO BE OPENED BY ADDRESSEE ONLY

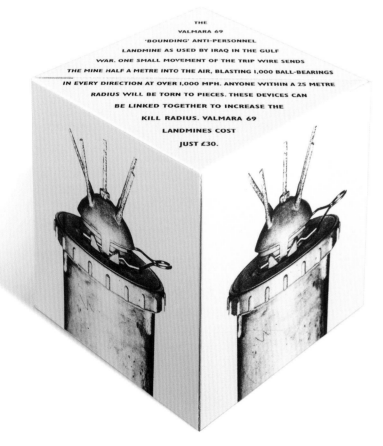

THE
VALMARA 69
'BOUNDING' ANTI-PERSONNEL
LANDMINE AS USED BY IRAQ IN THE GULF
WAR. ONE SMALL MOVEMENT OF THE TRIP WIRE SENDS
THE MINE HALF A METRE INTO THE AIR, BLASTING 1,000 BALL-BEARINGS
IN EVERY DIRECTION AT OVER 1,000 MPH. ANYONE WITHIN A 25 METRE
RADIUS WILL BE TORN TO PIECES. THESE DEVICES CAN
BE LINKED TOGETHER TO INCREASE THE
KILL RADIUS. VALMARA 69
LANDMINES COST
JUST £30.

Cat and Dog

For a joint exhibition called Cat and Dog by two of Britain's most irreverent illustrators, we created a broadsheet-sized, turn-it-upside-down cat and dog invitation, printed on newsprint that was rolled up and posted.

David Hughes & Jake Abrams | 1991

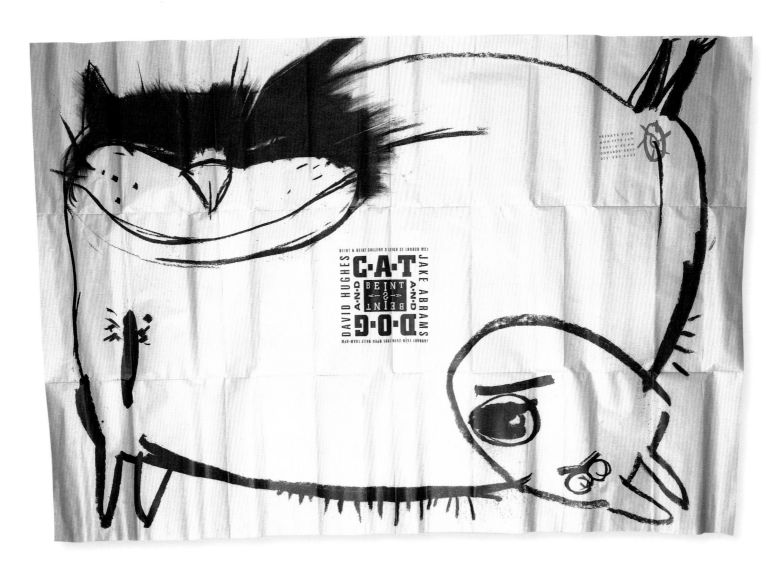

A degree show invitation for the
Faculty of Art and Design. To qualify
for an artistic licence, you had to
complete a test course and stop off
at all the degree show exhibits.

**Manchester Metropolitan
University** | 1994

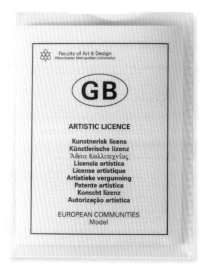

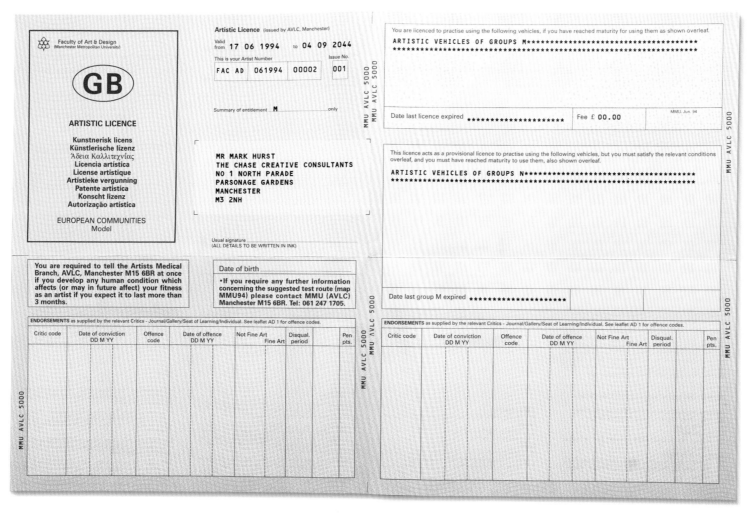

Wedding Invite
···
Mr & Mrs Rooney's daughter wanted
to get married and have children. But
not necessarily in that order.

Mr & Mrs Rooney | 1988

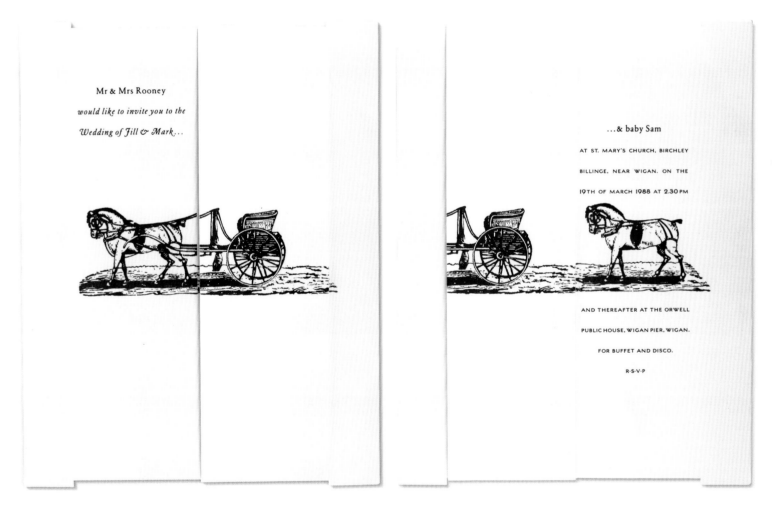

Mr & Mrs Rooney

would like to invite you to the

Wedding of Jill & Mark . . .

. . . & baby Sam

AT ST. MARY'S CHURCH, BIRCHLEY

BILLINGE, NEAR WIGAN, ON THE

19TH OF MARCH 1988 AT 2.30 PM

AND THEREAFTER AT THE ORWELL

PUBLIC HOUSE, WIGAN PIER, WIGAN,

FOR BUFFET AND DISCO.

R·S·V·P

Decking Invite
...
When The Chase's London office built
its own roof terrace, it mailed offcuts
of the decking to invite people to its
topping out ceremony.

The Chase | 2004

COME AND
SEE WHY
WE'RE
DESIGNERS
NOT
BUILDERS

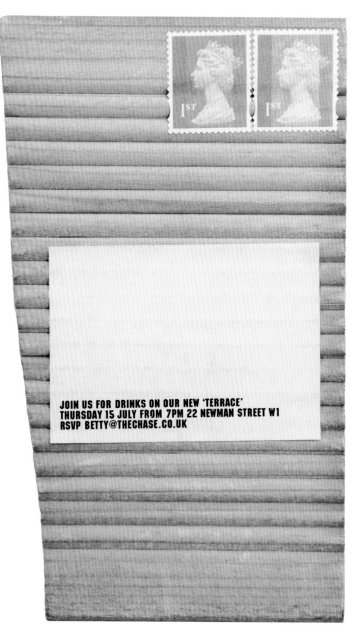

JOIN US FOR DRINKS ON OUR NEW 'TERRACE'
THURSDAY 15 JULY FROM 7PM 22 NEWMAN STREET W1
RSVP BETTY@THECHASE.CO.UK

Yellow Pencil People
..

Influenced by the German artist
Katharina Fritsch, the two figures
represent the famous D&AD
Yellow Pencil on a poster for an
exhibition in the "rainy city". They
also featured on an invitation
and a series of postcards promoting
the event.

D&AD | 2006

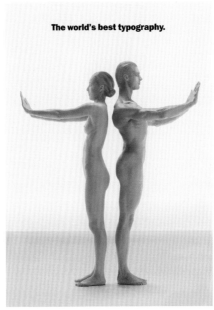

The world's best typography.

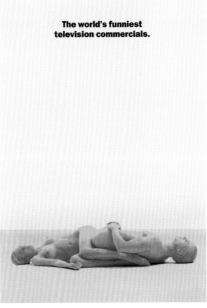

The world's funniest
television commercials.

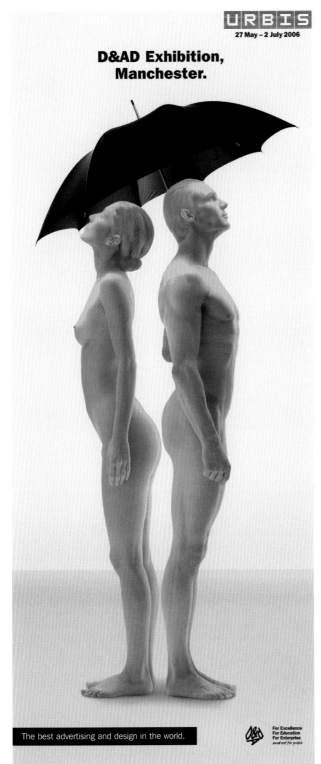

URBIS
27 May – 2 July 2006

D&AD Exhibition,
Manchester.

The best advertising and design in the world.

For Excellence
For Education
For Enterprise
and not for profit

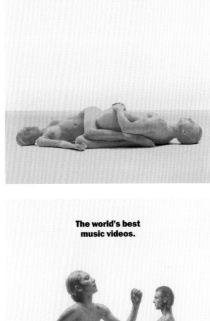

The world's best
music videos.

Private View.

G&H Big Bag
...

With this mailing for Gask & Hawley's
data storage facility, we didn't want
anyone to be left in any doubt about
its capacity.

Gask & Hawley | 2003

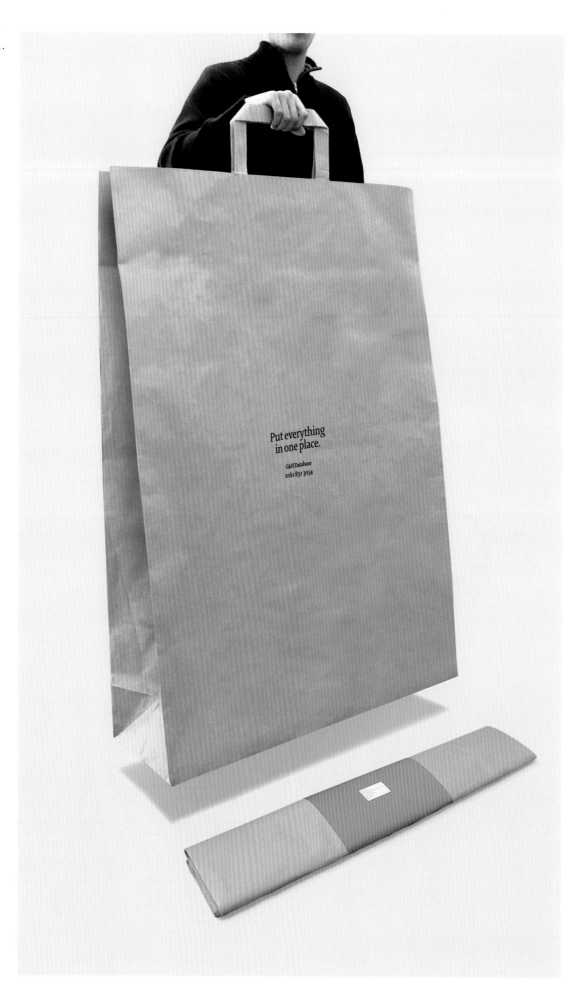

Put everything
in one place.

G&H Database
0161 832 3034

Kinder to Trees
..

Gavin Martin is one of the UK's
leading printers and had recently
completed the process of becoming
FSC accredited. They asked us to
make an announcement to the world
illustrating just how much they cared
about the environment.

Gavin Martin Printers | 2011

Body Bag
...

A collection of postcards highlighting
a variety of print techniques and
processes with a human touch.

Highlight Printers | 1997

Photography Rob Walker

The Road to Monte Carlo
...

Royal Life offered its agents the
chance to win a trip to Monte Carlo.
Competition details were contained in a
distributed retro-style book. Stages of
the competition to be completed arrived
throughout the year and were placed
inside the album to maintain interest.

Royal Life | 1990

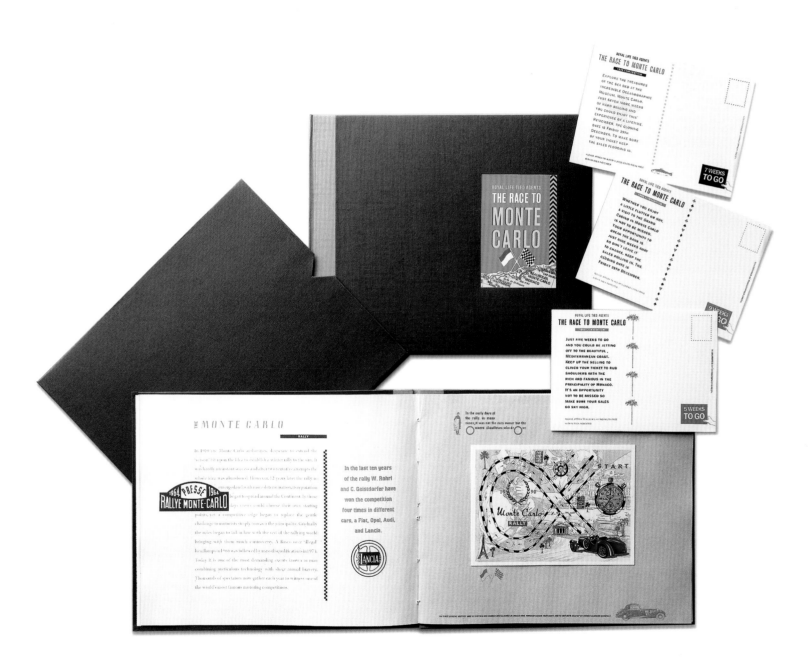

The Postcards Set
..

This collection of postcards from a
printer were mailed each day for two
weeks. They demonstrate and advise
on a variety of processes and tactile
techniques that online design could
never achieve.

Highlight Printers | 1997

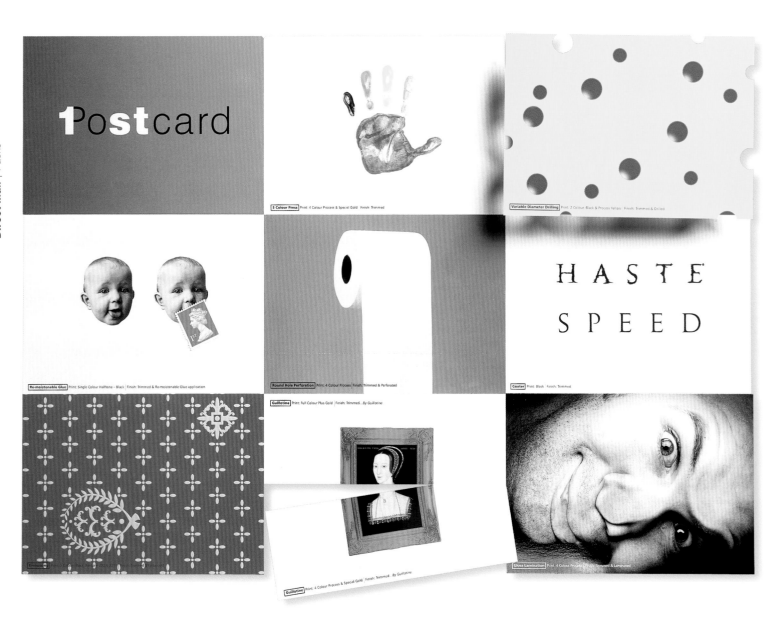

Small Wonder
..

A mailing that folds out and folds
out and folds out and folds out again
to demonstrate the advantages of a
new dry-cleaning solvent and the big
disadvantage of its competitors.

ICI Chlor Chemicals | 1993

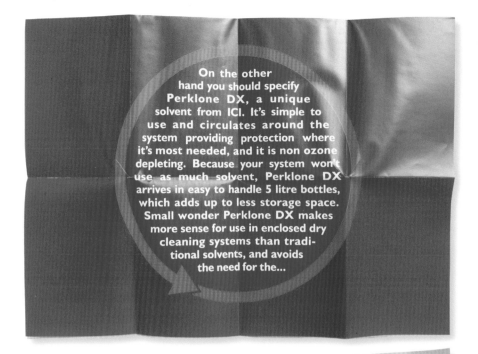

On the other
hand you should specify
Perklone DX, a unique
solvent from ICI. It's simple to
use and circulates around the
system providing protection where
it's most needed, and it is non ozone
depleting. Because your system won't
use as much solvent, Perklone DX
arrives in easy to handle 5 litre bottles,
which adds up to less storage space.
Small wonder Perklone DX makes
more sense for use in enclosed dry
cleaning systems than tradi-
tional solvents, and avoids
the need for the...

Small Wonder.

When you invest in a new dry cleaning
system, it is vital from the start that
you think carefully about the solvent
you put into it. Traditional solvents
are not designed to combat additional
acid build up, typical in enclosed dry
cleaning systems.

There are systems
which can help
neutralise this acid. Get it
wrong though and
the equipment may start
to corrode, which
can shorten the life of
your investment.

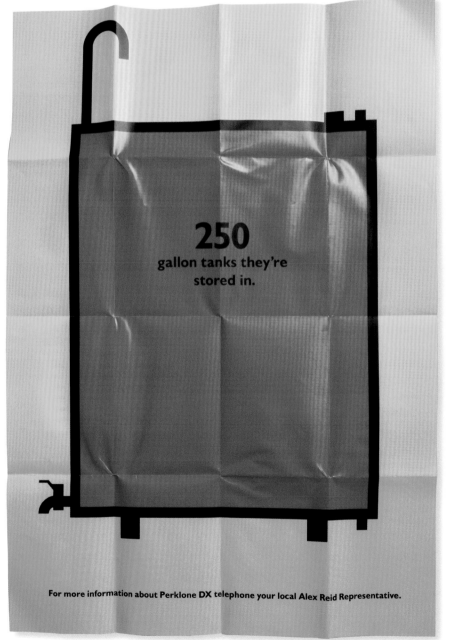

250
gallon tanks they're
stored in.

For more information about Perklone DX telephone your local Alex Reid Representative.

What the bloody hell are graphic designers doing dabbling in the rarefied field of architecture and engineering? As it happens, life-long 'North End' fan Ben Casey had for many years acted as an unpaid consultant at Deepdale, now the oldest football ground in the country.

The design of the stadium evolved from Casey's extensive research trips through Europe in search of precedents and inspiration. Architects AFL were instructed to respond to his conceptual design and subsequently developed the no-nonsense stand modules with the deep trussed roofs supported by the corner floodlight pylons. Preston's 'North End' is now on the map.

Not content with raising the contemporary profile of the club in such a physical way, The Chase were now able to add a poetic touch to the structures. 'Pixelated' seating blocks became the palettes to celebrate the heroes that had graced the very turf before our eyes; Tom Finney, Bill Shankly and Alan Kelly watch over the empty stadium only to be momentarily dispensed to history for the duration of a live game.

Peter Higgins Director, Land Design Studio

environment

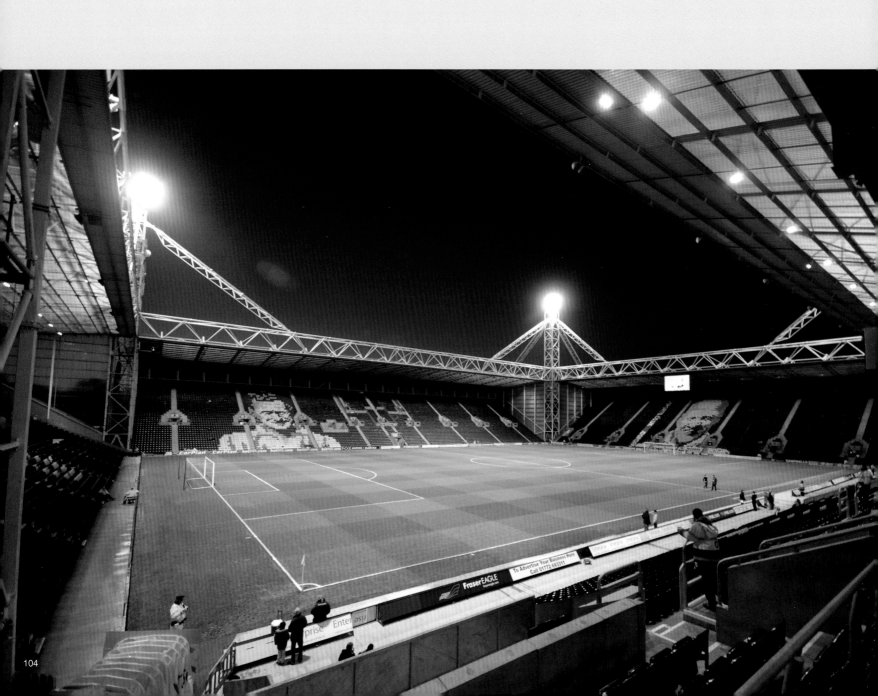

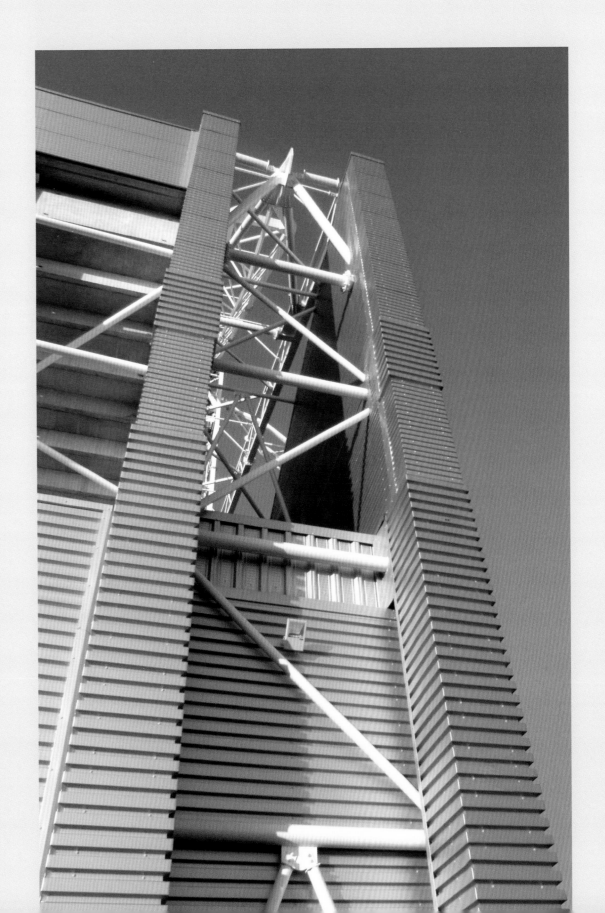

Best in Category | Football Stadium

Preston North End FC | 1996

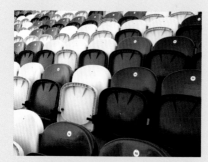

The arrangement of the coloured seats create a portrait of a famous player after whom the stand is named.

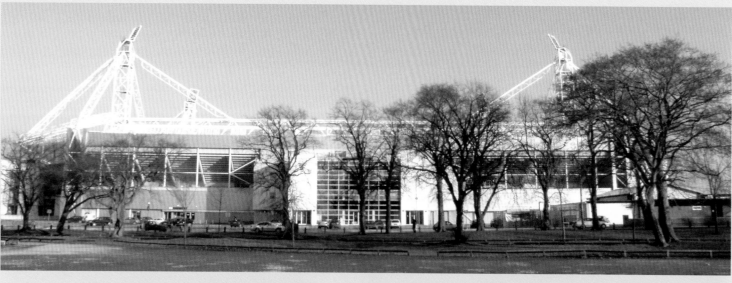

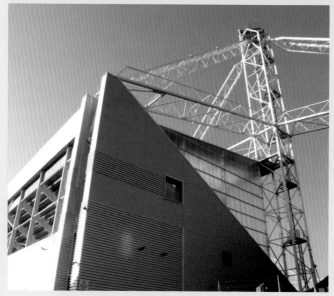

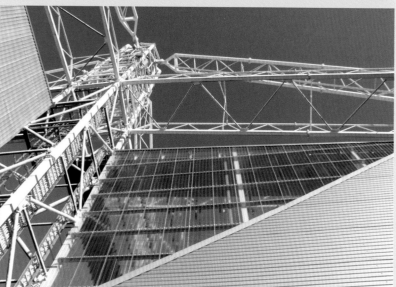

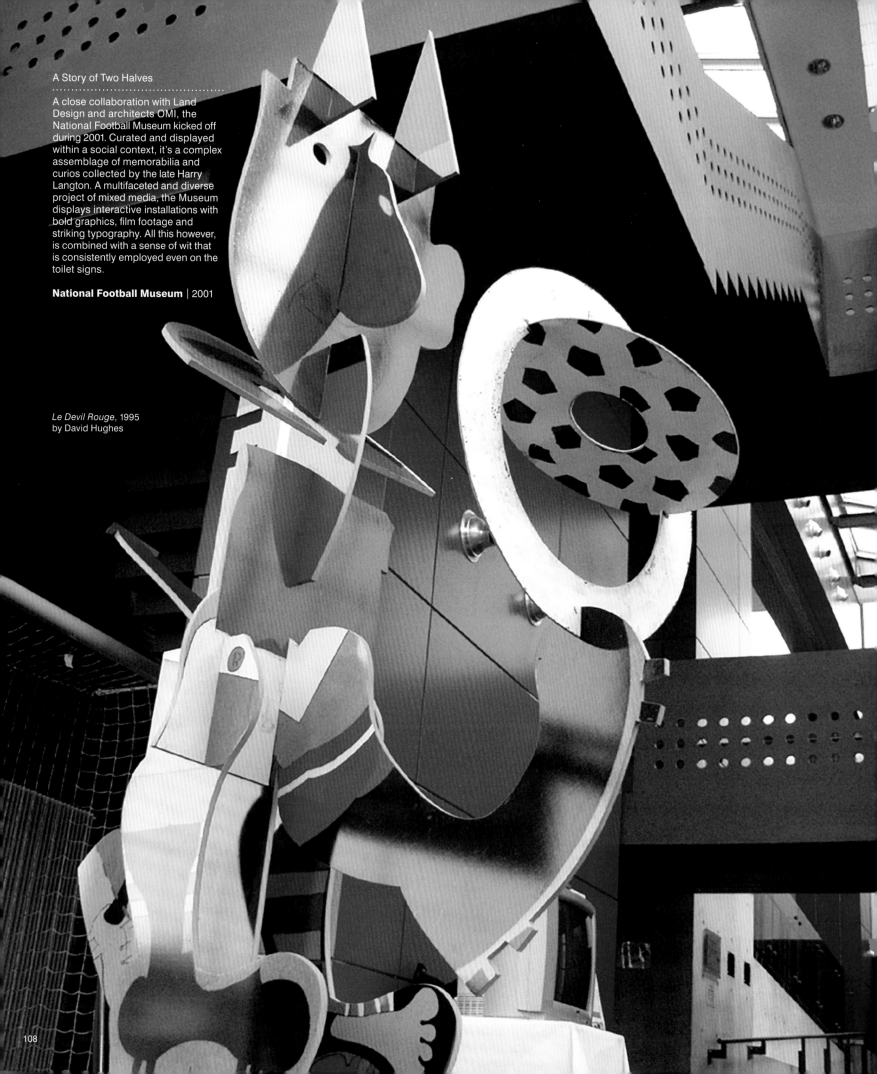

A Story of Two Halves

A close collaboration with Land Design and architects OMI, the National Football Museum kicked off during 2001. Curated and displayed within a social context, it's a complex assemblage of memorabilia and curios collected by the late Harry Langton. A multifaceted and diverse project of mixed media, the Museum displays interactive installations with bold graphics, film footage and striking typography. All this however, is combined with a sense of wit that is consistently employed even on the toilet signs.

National Football Museum | 2001

Le Devil Rouge, 1995
by David Hughes

Boring, Boring Arsenal
...

Unlike the attacking team of the modern
game, Arsenal teams of the 70s and
90s were ridiculed for their brand of
football. This installation invited visitors
to the National Football Museum to
literally watch paint dry. A coating of
heat-sensitive ink concealed the
Arsenal team. Their identities were
only revealed by pressing buttons on
a console that activated a hair dryer.

National Football Museum | 2001

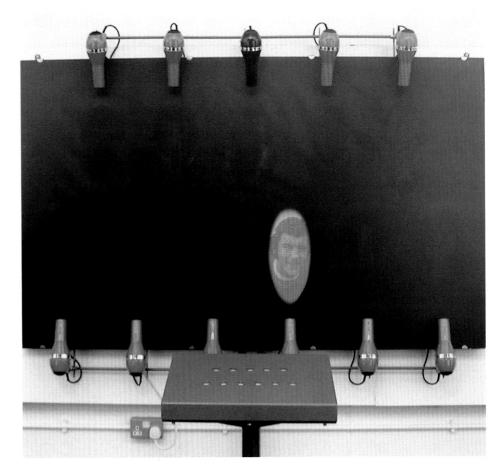

Splash
......................................

The 1955 Sports Photograph of the Year is a wonderful shot of the legendary Tom Finney aquaplaning on a waterlogged Stamford Bridge pitch. We commissioned sculptor Peter Hodgkinson to transform this iconic image back into three dimensions to create a fountain that welcomes visitors to Preston North End's Deepdale Stadium.

Preston North End FC | 2001

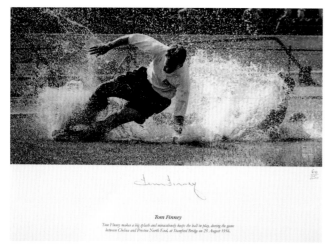

Tom Finney

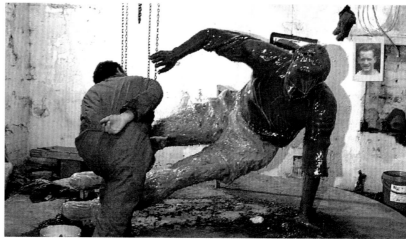

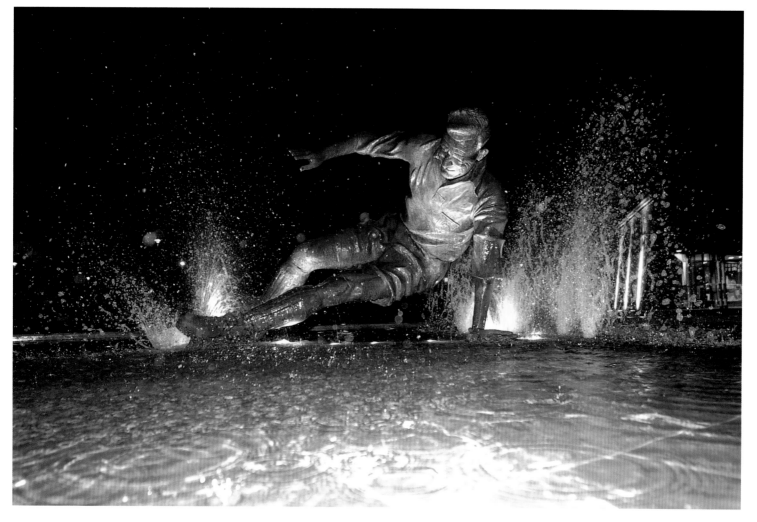

Clunk Click
..

To mark the fiftieth anniversary of the British road sign, fifty designers were asked to create thought-provoking signs to feature in an exhibition at the Design Museum. Our concept was based on the fact that 1965 was also the year that car manufacturers became legally obliged to fit seat belts, marking the end of an era when travellers put their trust solely in religion for their own protection.

The diagonal bar also symbolised the seat belt, which had been featured in the famous Jimmy Savile "Clunk Click" advertising campaign. His portrayal in the media as a saint-like figure worthy of taking over the mantle of protection turned out to be one of the darkest cover-ups of all time.

The Design Museum | 2015

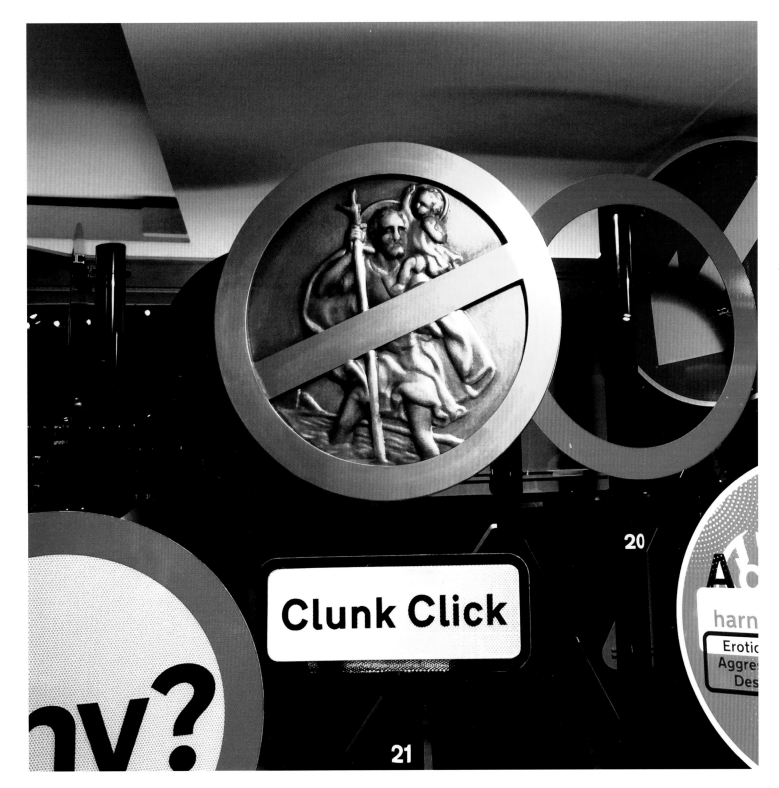

Millennium Dome Faith Zone
..

Working alongside architect Eva Jiricna and JJA we created the Millennium Dome's Faith Zone. The essence of the nine foremost religions regularly practised in the UK are collated and encapsulated here. The history, beliefs and practices of each faith were explored through individual 'pilgrimages' guided around curving walls of interpretive panels and screens.

New Millennium Experience Company | 2000

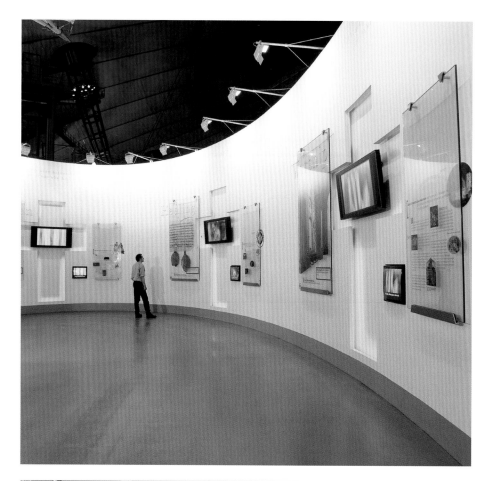

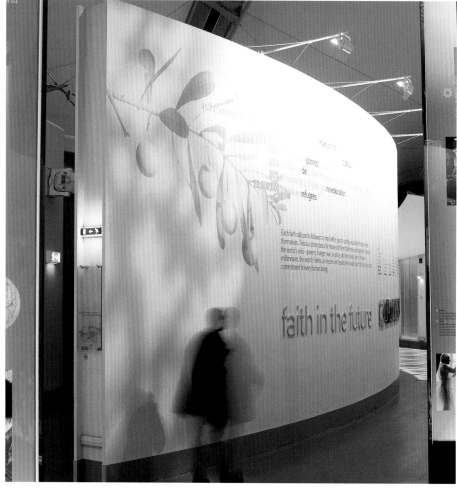

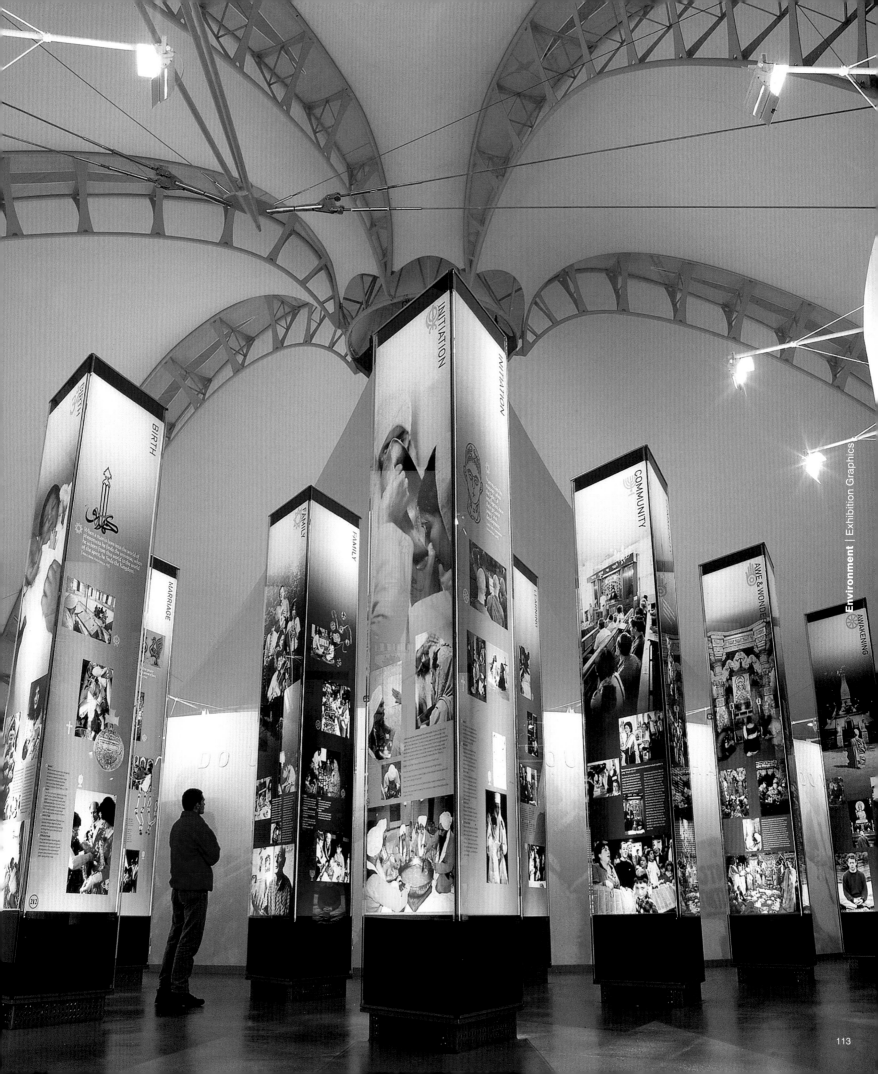

Environment | Exhibition Graphics

Cecilybrand
..

This project was a collaboration with the Graphic Design Department of the University of Central Lancashire in Preston and tutors Bryn Jones and Peter Thompson.

In 2002 Preston was awarded city status. To mark this we put forward a number of imaginative suggestions to enhance its public realm.

Through funding from the North West Development Agency, a unit was set up in the university called Citybrand. Working with staff and students we developed a number of projects including an outdoor museum that would direct the visitor along a route around the city centre following a series of exhibits. Each one would depict an interesting fact about the city. At various points public seating would appear to peel out of the ground revealing an historic story about the

location. Other project ideas included visual identities for the city's assets. A cohesive approach rather than blanket consistency was considered to be more appropriate for something so complex as a city. For instance, the markets were depicted in a lively, vibrant way, whilst the Victorian parks required a more elegant solution, in which each individual park had its own version of a graphic tree shape that was made up from silhouette images of its facilities. Developed from a concept by artist Dennis Leigh, a large-scale landmark sculpture was planned to span the River Ribble. The "Sunken Soldier" would mark the spot in which Cromwell defeated the Royalists in arguably the most important battle of the English Civil War.

Preston City Council | 2003–2006

HASLAM PARK

MOOR PARK

CITY OF
PRESTON PARKS

ASHTON PARK

AVENHAM PARK

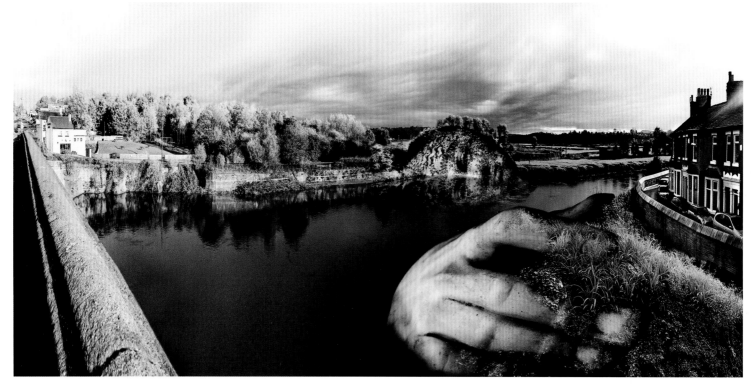

Artist Dennis Leigh

Environment | Place Making

114

1

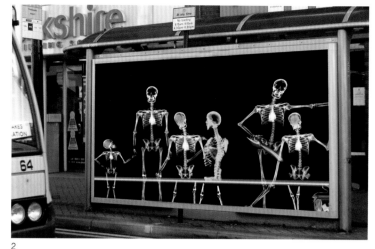

2

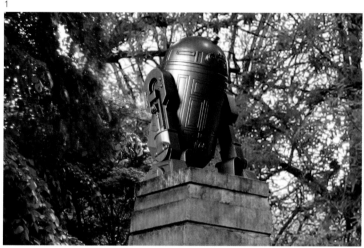

3

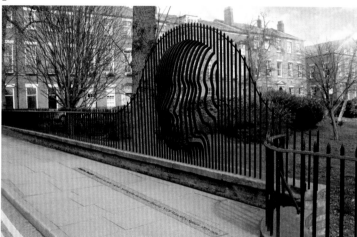

4

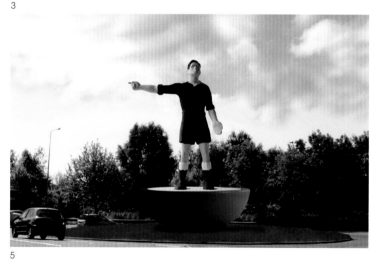

5

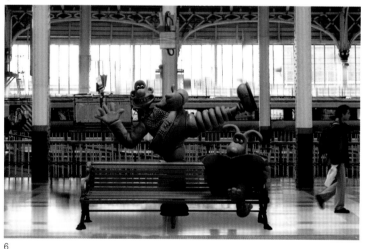

6

Examples of the exhibits planned for the outdoor museum.

1. Bash Street Kids paving stones. A collaboration with their creator, Prestonian Leo Baxendale.

2. An animated image on a high street bus shelter in reference to the first medical X-rays being performed at Preston Royal Infirmary.

3. A bronze R2D2 on a classic stone plinth to celebrate the performance of Preston actor Kenny Baker.

4. A portrait modelled out of railings seemed a fitting way to mark the home of Edith Rigby, one of the driving forces of the suffragette movement.

5. Marching orders to Preston North End's Deepdale Stadium by artist Peter Hodgkinson.

6. Nick Park, the creator of Wallace and Gromit, modelled this photo opportunist bench for his home town.

Salford Identity

During the mid-90s we created a
new identity for the University of Salford.
Part of the challenge was to apply
signage onto uncompromising
architecture from different eras. Rather
than concealment we went for

embracement, borrowing fascia designs
that reflected the buildings' moments
of glory whilst bolting on these
three-dimensional identity badges.

University of Salford | 2003

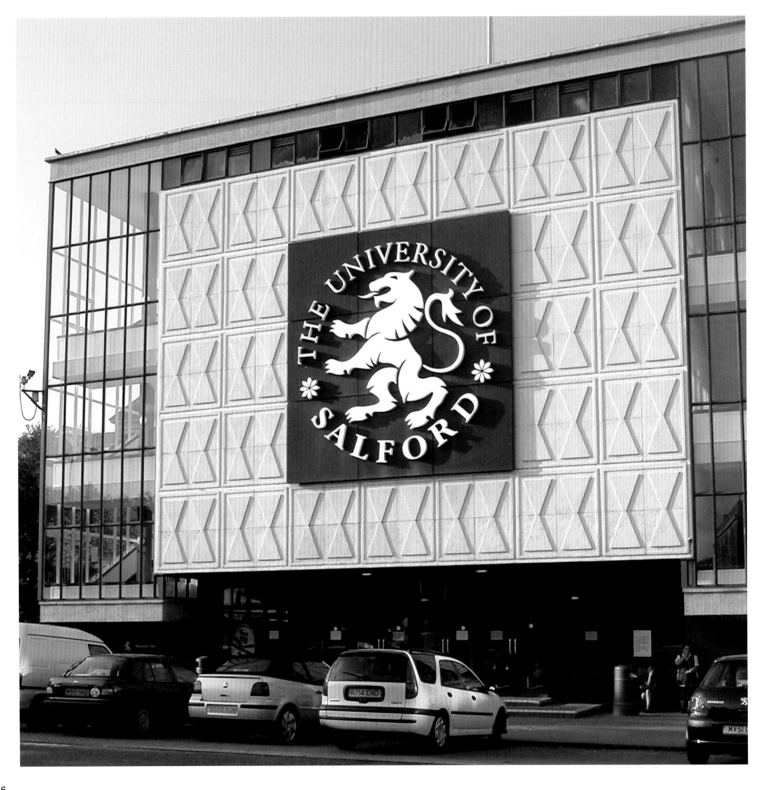

Southwark Bridge

Most of us would like to believe our work will be around for a considerable time. Not so this poster. It's a vast 50-metre-long decoy, behind which a permanent commission by the artist Ian Davenport continued as a work in progress.

Land Securities & Ian Davenport | 2006

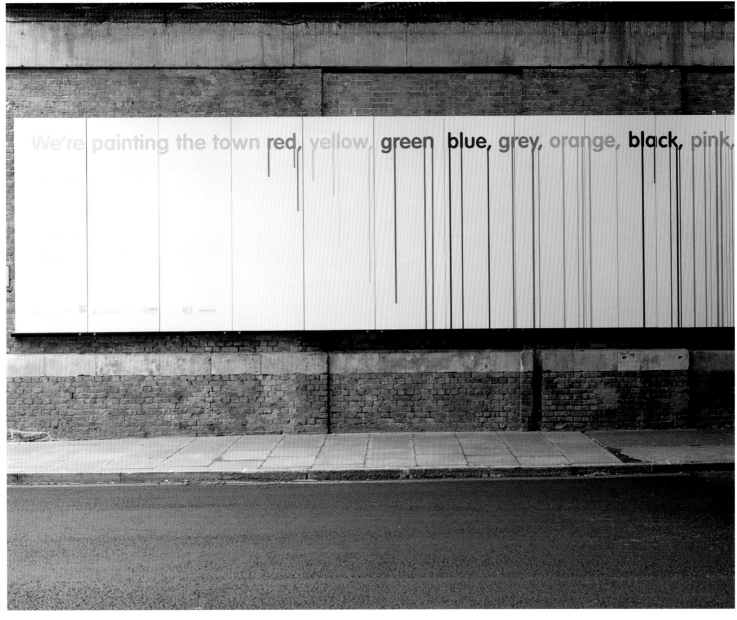

In the Frame

For Royal Mail Special Stamps we had these larger than life, 'perforated' frames built, photographing them in locations echoing each set of stamps' subject matter. Accompanying the photos is text explaining why and how the stamp issue had been conceived and produced. It's a concept then taken through to ambient vinyl pieces. They comically frame smiling assistants and turn them, in effect, into living stamps.

Royal Mail | 2008

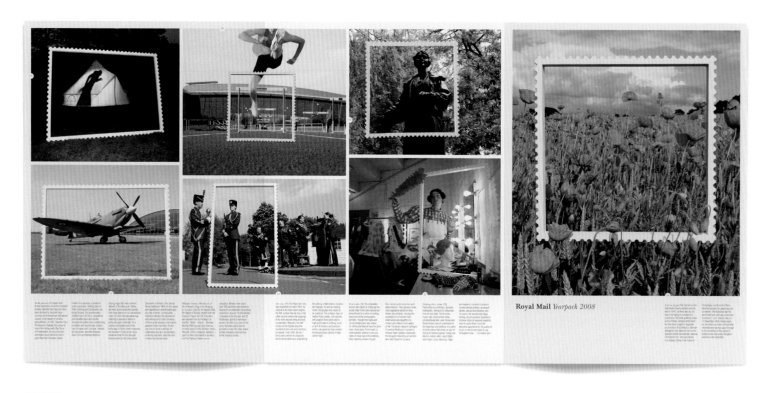

Royal Mail *Yearpack 2008*

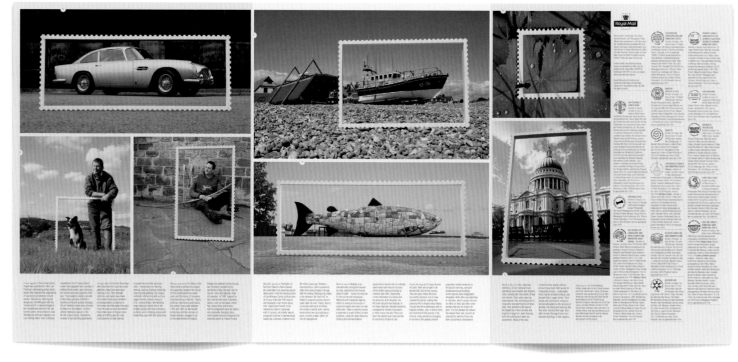

Photography Maria Moore

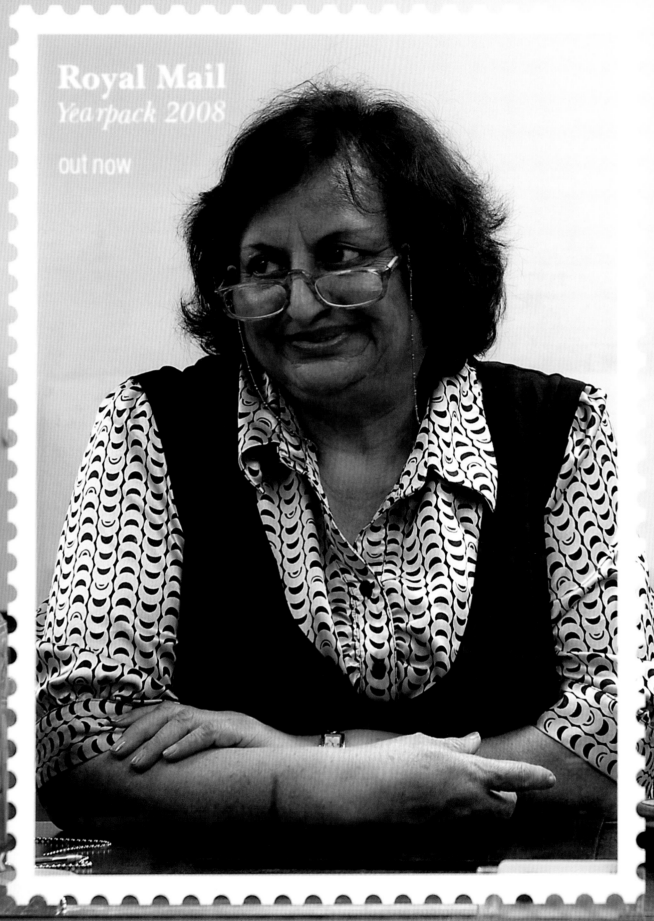

Royal Mail
Yearpack 2008

out now

The short film I've chosen is *The Voorman Problem*; I really enjoyed the discipline with which a very complex idea and story was told simply and with a great deal of seriousness and humour.

It is a film that makes you think about how much we do not actually know about the world outside our mind, in that once you chip away at the big pieces and look at time and the interior life of the mind more closely, anything becomes possible and madness suddenly is closer than you ever imagined.

It is well-directed and well-cast and the locations were excellent. The opening with the long high brick wall of the prison seemed like some monstrous cathedral—a church of some kind, yet entirely foreboding and imposingly sinister. I like the extraordinary elements of Mr Gill's storytelling with its original take on theology and its humorous relation to madness, which he allows to slowly blossom out from deep within the narrative of the ordinary realms of a prison, a psychiatrist and a patient.

God as mental patient. Makes perfect sense.

E Elias Merhige Film Director

Best in Category | *The Voorman Problem*

Honlodge Productions | 2011

The Voorman Problem is our Oscar and BAFTA-nominated short film produced through our sister company Honlodge Productions.
Doctor Williams (Martin Freeman) is called in to examine the enigmatic Mr Voorman (Tom Hollander), a prisoner with a peculiar affliction: he believes he is a god. The doctor must decide on the sanity of Mr Voorman— is he a faker or a lunatic?

Honlodge Productions | 2011

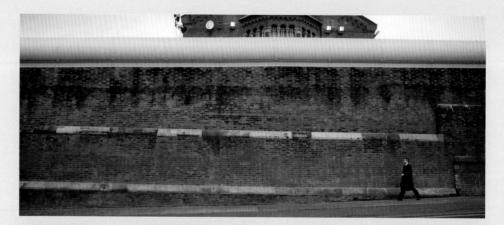

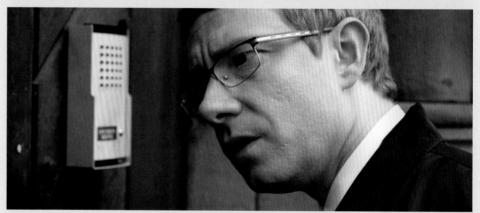

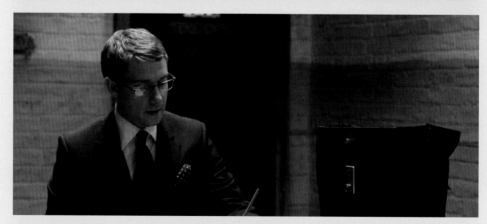

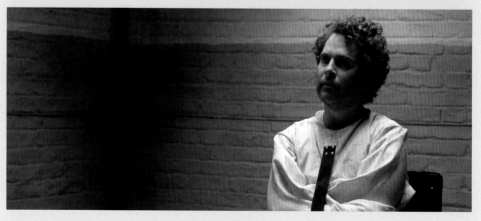

Film | Best in Category

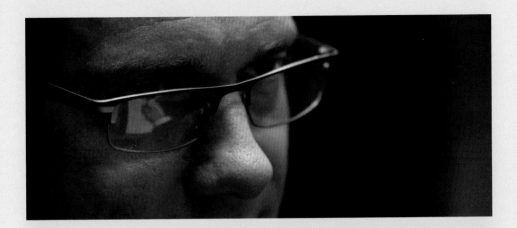

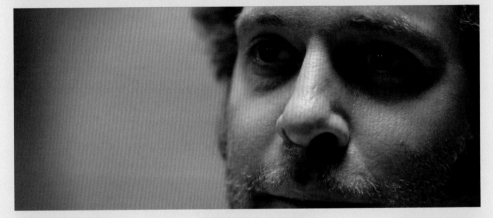

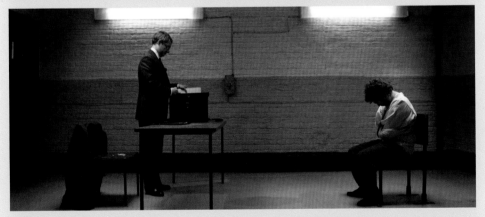

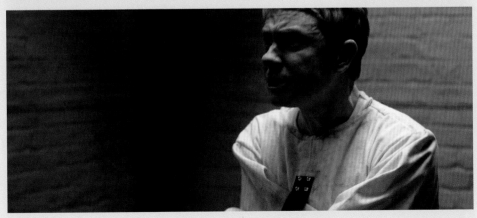

From Sheep to Shop
..

This client takes raw material and makes
something lovingly handcrafted from
that. There are parallels here with our
own philosophy. The film explores
Private White's century-old heritage with
stunning photography, finally revealing
the care and attention to detail apparent
in creating some of the finest clothing
produced in England.

Private White VC | 2015

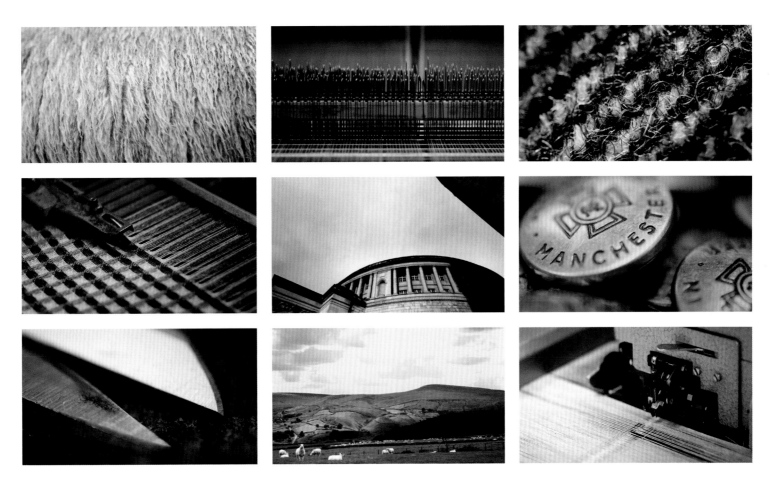

A Moving Story
..

Taking our philosophy of the elephant carver as inspiration, we created this short film to announce the move to our new Castlefield address after twenty-five years at Parsonage Gardens, the other end of Deansgate.

The Chase | 2015

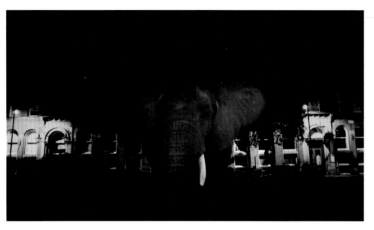 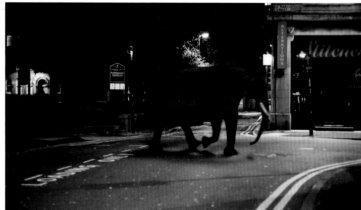

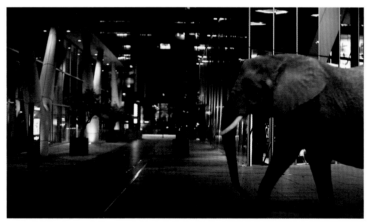 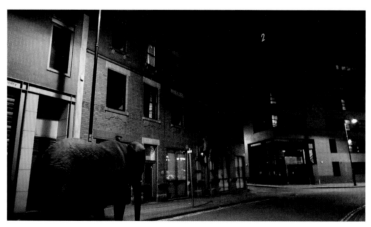

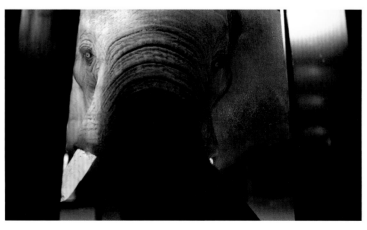 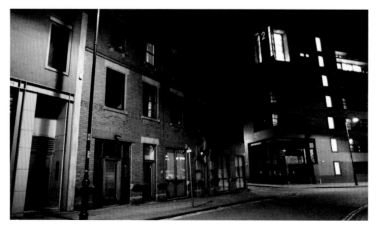

Full Time

This is the second short film produced by our sister company Honlodge Productions. *Full Time* examines the fragile connections that bind love, memory and the gaps in between. Michael returns to his childhood home in the north of England to accompany his father in one last trip to the football.

With little interest in the game and almost no emotional connection to his father, Michael struggles through the match as a bored spectator. His father is both irritable and irritating but, as time passes, Michael realises his father's bad-tempered quirks could be a sign of something graver.

Honlodge Productions | 2013

Rats in a Mac

Although the adage of never being more than 6 feet away from a rat may be a bit of an urban myth there is no doubt that they are on the increase. Having them drop into your computer is a stark reminder of this.

BASF Pest Control | 2015

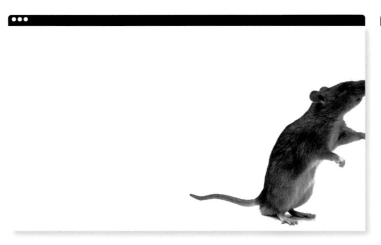

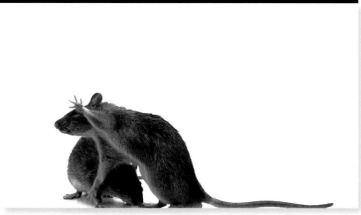

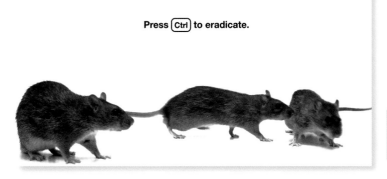

Press ⎡Ctrl⎤ to eradicate.

WARNING

Rodents are on the increase. They are building up resistance to conventional rodenticides and tough pest control regulations are helping them run riot. The solution?

BASF has developed SELONTRA®. An alternative to current pest control solutions. SELONTRA® targets rodents with precision, speed and reduced risk to birds and animals. No rodenticide on the market is as effective or efficient. Click here to find out more.

Frank

The opening and closing title sequence
for the Lenny Abrahamson film *Frank*.
A film about an aspiring musician finding
himself way out of his comfort zone
after joining a pop group. The group is
led by an enigmatic figure who wears
an enormous fake head. We addressed
the issue of mental illness by playing
on an idea of the head being taken
apart and coming together again at
certain points.

Film4 | 2014

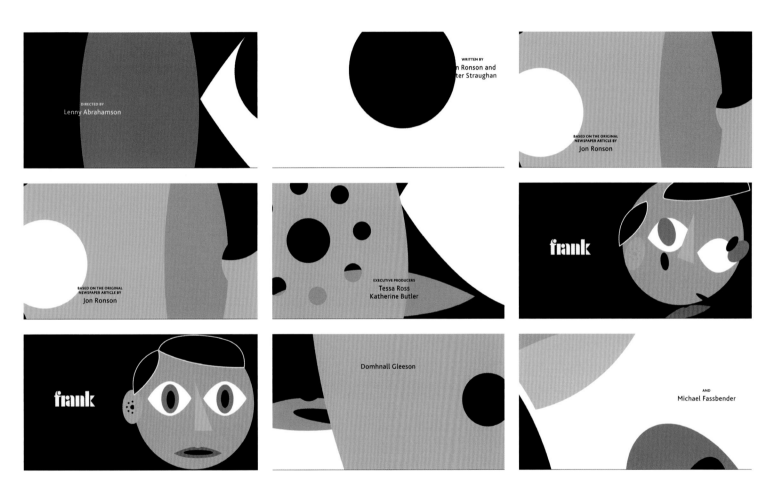

Even the most fleeting acquaintance with man's best friend will provoke an "aaah" when you pick up the 2001/2002 Manchester & Cheshire Dogs' Home Annual Review. The slim, over-sized document is a dog lover's delight, but with a serious message, and is a beautifully crafted piece of design.

As with all good communications, the focus is on the 'customer'—in this case the 6,796 dogs whose lives are touched by the home. Their plight confronts you on every page in a highly engaging way.

The serious stuff is in there, but the presentation is refreshingly simple and doesn't detract from the main message—the dogs and the home's pledge to help them.

Great touches are the doggy 'portraits'—true stories of fortunate canines who have benefited from the home's services, with stunning photography by Mat Wright. The message that "every dog counts" is borne out on every page.

Lynda Relph-Knight Design Writer and Consultant

literature

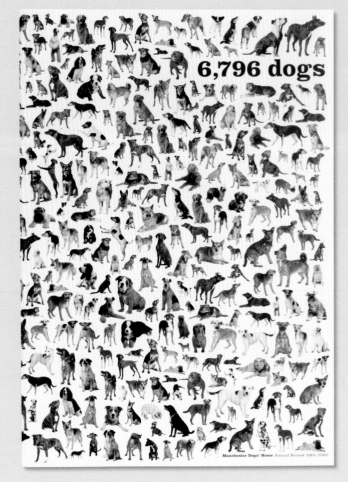

6,796 dogs

Manchester Dogs' Home Annual Review 2001–2002

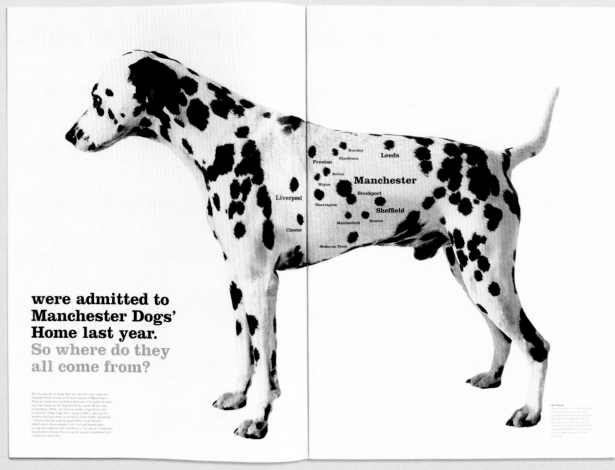

were admitted to Manchester Dogs' Home last year. So where do they all come from?

9 out of 10 dogs were happily rehomed. That's 5,947 in total.

Management Committee Report

kiss here

A special thank you

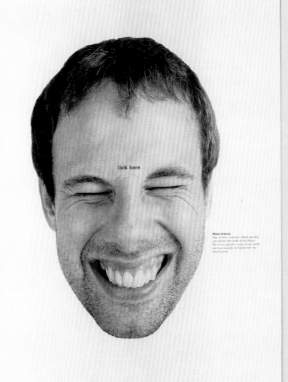

lick here

Evidence

Most professions practise an individual take on British language, a sense of aural identity. Forensic scientists are no different. Through this annual report we hijacked some of their more common words to illuminate areas of interest.

Council for the Registration of Forensic Practitioners | 2007

Former Chief Executive's statement

My last full year with CRFP saw some significant changes. It is a special pleasure to be in at the early stages of a professional group's development.

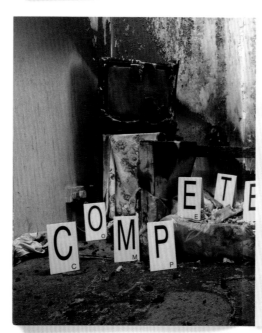

Chairman's statement

This has been an excellent year for growth and development of CRFP, continuing to serve the public interest.

Responding to future needs

Results

There was a time when major football clubs just had to keep the fans happy. Now there are also shareholders to please. And those people want to see results.

English Football League |
2000/2001 Season

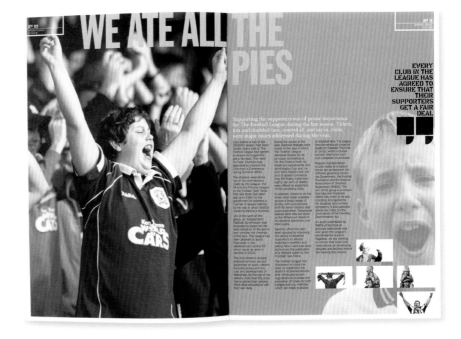

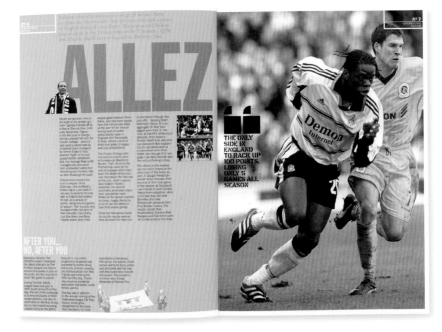

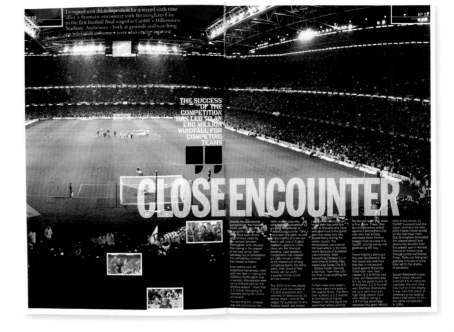

Moving Brochure
...

When financial advisers the Bridford
Group moved to prestigious offices on
Portland Place, it gave them an
opportunity to connect with their client
base. The brochure featured images
that represented their services with
reference to architectural features.
Additional images were printed on
tracing paper overlays, bringing each
service to life.

Bridford Group Ltd | 1988

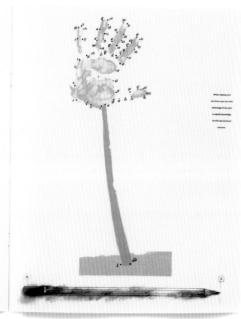

Palm Tree illustration David Hughes

The Value of Public Space
..
Walking as little as thirty minutes per day can reduce the risk of heart disease by up to 40 per cent. In a bid to build healthier communities, this report encourages local authorities to make open spaces more accessible to the public.

Cabe Space | 2004

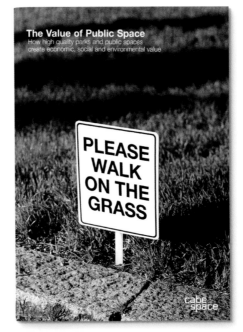

The social dimension of public space

Public spaces are open to all, regardless of ethnic origin, age or gender, and as such they represent a democratic forum for citizens and society. When properly designed and cared for, they bring communities together, provide meeting places and foster social ties of a kind that have been disappearing in many urban areas. These spaces shape the cultural identity of an area, are part of its unique character and provide a sense of place for local communities.

The social dimension of public space

Public spaces are open to all, regardless of ethnic origin, age or gender, and as such they represent a democratic forum for citizens and society. When properly designed and cared for, they bring communities together, provide meeting places and foster social ties of a kind that have been disappearing in many urban areas. These spaces shape the cultural identity of an area, are part of its unique character and provide a sense of place for local communities.

Photography Maria Moore

Dr Gask & Mr Hawley
...

When something is undergoing dramatic change, sometimes a familiar 'vehicle' can be used to help explain it. In this case, a half-page device and an image from a classic novel took the reader through the advances that technology had brought to the print process, culminating in the fact that last-minute changes were no longer the problem they used to be. Classic typography told the general story, whilst a more anarchic mix explained the technical details.

Gask & Hawley | 1992

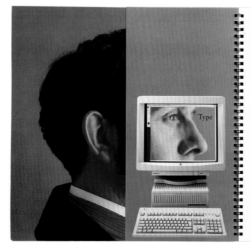

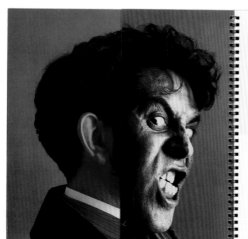

Dr Gask ✦ MR HAWLEY

Photography Rob Walker

G&H In-depth
..

Having had the foresight to invest in
the technology that had revolutionised
the print industry, Gask & Hawley
were quick to focus in on the benefits
it offered to their customers.

Gask & Hawley | 2002

When you're faced with a mind-boggling array of choices, and each is a new way of working, is it any wonder you don't know which way to turn? Fear not. We'll advise you and hold your hand, every step of the way.

CHOICE

Imagine how fast ISDN would be without all the problems. Double it and treble it. What you get is the fastest digital file transfer anywhere in the world.

SPEED

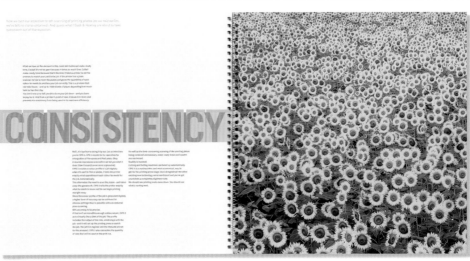

CONSISTENCY

G&H Database

···

To communicate the significant benefits of using an external database system, this brochure took the form of a filing cabinet, complete with metal label holder and dividers. Then one spread at a time sorted the shambolic jumble of type and images until, like the system itself, order arose from the chaos.

Gask & Hawley | 2002

100-Nil
··

100 years of the Football League was
commemorated in this catalogue,
which accompanied a travelling
exhibition. Historic images and
typefaces reflected a scrapbook
concept of the years passing.

Harris Museum | 1988

THE
FOOTBALL
LEAGUE

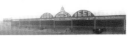

here we go,　here we go,　here we go.

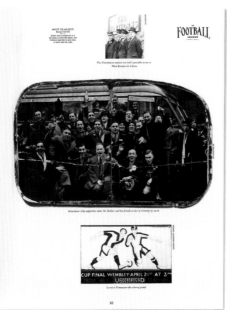

From ICI to Zeneca
...

Born out of ICI Pharmaceuticals, Zeneca
wanted to document its journey
to fruition. The paper stock begins with
parchment, changing in sections to
end as super high gloss. Typography
shifts with historical accuracy up until
modern fonts, and medical milestones
are recorded on every spread, while
a timeline of concurrent issues offers
global context across the top.

ICI Pharmaceuticals/Zeneca | 1993

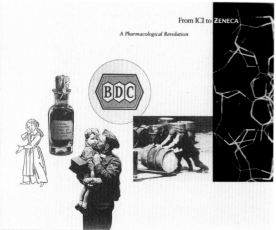

The Ranges

This product brochure is the first step in a brand refresh for a ceramic tile maker. While the company's credentials are impeccable, especially in ecological manufacturing, younger homeowners failed to engage with the product's potential. A crisp layout and conversational tone of voice with editorial-style photography has breathed new life into them.

Johnson Tiles | 2011

Your New Office This Way

The fingerpost brown signs throughout
the City of London are borrowed
here to help readers navigate towards
an influential City office development,
leaving them in no doubt of the
company they'll keep.

Land Securities | 2004

Location isn't everything. But it can be.
EC3 is a small world. The key to doing
business here is ease of access. Seen
and be seen. And it's been said that
being 50 yards off pitch can cost you
10% of premium income. That need
never happen with Land Securities.

You choose the right place for the
business, then you have to get there
everyday. And as only 6,000 people live
in the Square Mile, you're likely to have
to travel. But that's OK with Fenchurch St,
Cannon St and Liverpool St Stations nearby.

Creative Futures
...

This vibrantly screen printed brochure introduced Interactive Arts as a new area of study. To challenge the potential students' frequently asked questions, they are not answered in words but as thought-provoking images.

Manchester Metropolitan University | 1998

This Place of Discovery
...
Lowther Castle & Gardens is a unique visitor experience near Penrith in Cumbria. The styling of the brochure reflects the chequered history of the castle which has belonged to one family for over 1,000 years.
It marks the reopening of 130 acres of gardens to the general public.

Lowther Castle & Gardens | 2013

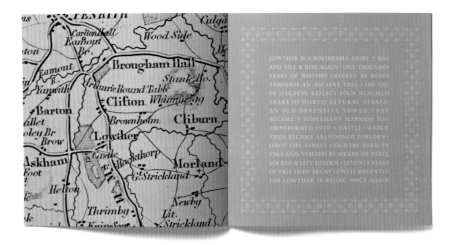

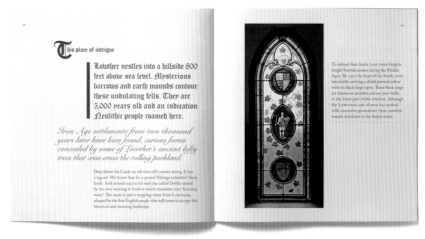

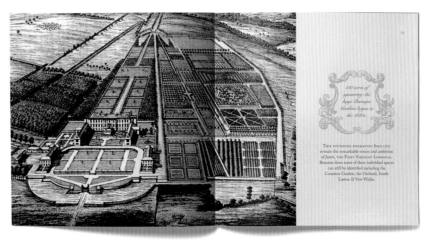

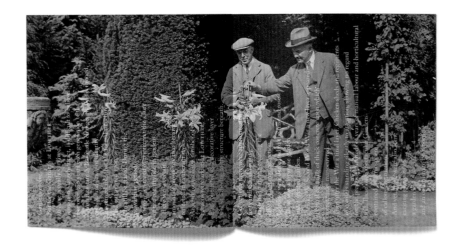

The Media Factory
..

This brochure for the Media Factory is a total reflection of the building they are housed in. On the front cover a lowercase 'm' establishes horizontally a grid that navigates through the five internal floor levels. Images mix with blocks of green, white and grey which represent the colours that form a random pattern on the exterior cladding.

University of Central Lancashire | 2008

Loaf Building
..

An old yeast factory in the heart of
Preston was prime for redevelopment
into boutique loft apartments. We called
it Loaf and produced a brochure that
used scattered flour to add interest to
the type and imagery.

EtcUrban Ltd | 2016

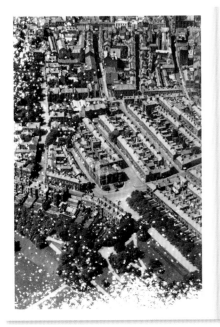

HISTORY

44-56 Guildhall Street is a historic 120-year-old warehouse in the centre
of Preston behind Winckley Square. The former commercial home of
the English Yeast Co. served bakeries and breweries throughout most
of the 20th century from this three-storey brick building.

The EYC Warehouse has been derelict for two decades, however,
despite occupying a strategically important position directly opposite
the 1878 stone and brick-built Conservative Club and next door to
the long-standing Tiggi's Restaurant.

PLANS

Our plan is to return the EYC Warehouse to active use with a scheme
fit for 21st century city living. The warehouse will be sympathetically
restored retaining as many original features as possible for residents
and the community to enjoy.

The aim is to deliver the first residential warehouse scheme in Preston
city centre and to set a benchmark of quality, design, space and
inspiration for other developers to follow.

An important part of this project is the opportunity to revitalise a
somewhat neglected street in the heart of Preston.

The recent, excellent streetscape project in Fishergate and surrounding
streets should be extended to include the length of Guildhall Street to
connect Fishergate with the forthcoming Winckley Square Conservation
project.

The large duplex two-bedroom apartments will be on the top floor of
the warehouse. On the ground floor will be a short row of offices, café
bar and restaurant to further bring to life the street.

The basement will provide secure car-parking for all residents and
service areas for the commercial occupants.

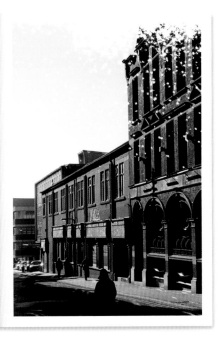

FLOOR PLANS

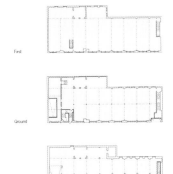

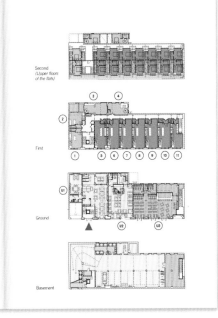

It seems like such a counter-intuitive (or brave/foolhardy) idea to show no images to promote a photographer—but that is obviously why it works so well.

This is such a simple, almost perverse, idea—beautifully written by some of the best writers around. It is expertly crafted typographically—and prints in a single colour.

It beautifully demands that you go and have a look at the photograph online—and when you do, you are anticipating the image that has already been written in your mind. Rarely does a piece of print work so seamlessly with digital.

It appears effortless and I wish I'd done it.

Jim Sutherland Founder, Studio Sutherl&

mixed media

Bums. Bums. Bums. 'Scuse my language. But you see, I've known more than my fair share. To the passing observer, I'm a park bench... but if truth be known, I'm more of a bum park. A botty bay. A refuge for rear-ends. Yes, I've seen 'em all, felt the full weight of every Tom, Dick and Fanny. Round ones, flat ones, scrawny ones, fat ones, pert ones, saggy ones. I'm an aficionado... or perhaps that should be arse-ficionado? Yes, yes, very good, very good. Your name? Ben Park. Your specialist subject? Posteriors, 1984 to 2011. Your sixty seconds start now... What the..? Hey you! Dog! Scarper and piss somewhere else. There's a perfectly good tree over there. That's disgusting. Leg cocker! At least get it over with. Hurry up! You don't have to look like you're enjoying yourself so much. Geedoutofit! Apologies... do let me continue... Of course I have my favourites. Who can blame me? Always had a keen eye for the ladies. Nothing like a delicious derrière, I've always said. Ah yes... those voluptuous, velvety peaches, rising and falling, coaxing and calling. I have arms, of course, but oh for some cheeky pinching fingers! Ah-ha, one of my regulars is lurking. He's a real card this one. Hubertus he calls himself. What kind of a name is that? Posh? Foreign? Foreign posh? Who can say? And looks like he's found himself a new blanket. Well, new to him anyway... they've both seen better days. He'll need it mind, there's a real nip in the air now the sun has gone down. But he's alright. Hubertus always has something on his mind... asks my opinion on all sorts as he lays his scraggy old newspapers down for the night. He has a tendency to lose the gist from time to time, depending on how many of those treacherous gold tins he's downed. And there was that February morning he completely flipped – wailing and flailing and wheezing and laughing and crying – I really didn't know where to look. But if Hubertus is a trifle edgy, who can blame him? Life's left him bruised and betrayed, no wonder he needs to get it all out of his system. That's it. That's it. Settle down. Get some zeds in. Lost a bit of weight if I'm not mistaken. Yes, he's my bum. And I do my best to look after his backside. What's this? Some of his mates is it? The ginger beardos, with their long stained macs and skanky knitted headwear. Hobo chic. Funny how you can barely tell them apart, with their sucked-in skulls and grot-brown teeth. The sticky-sweet smell of eau de urinal and hair like coconut matting. He's getting up now. Easy does it. I can hear his poor arthritic bones complaining. Walking over a tad gingerly. What are they up to? For a moment, match glow paints conspirators' faces orange against the night's blackdrop. But then the flame flickers out and it turns nasty. I can hear hissing, shouting, cheering. And they come at me like dogs. Not happy pissing dogs, but foaming angry dogs. They kick me hard and tear at me. One of them goes ape with an iron bar, his face wearing a lifetime of pent-up hatred and frustration. Another starts eagerly gouging my back with a rusty old penknife... just flesh wounds really, but the pain sears right through to my sorry soul. I feel my joints being prised apart, I hear splintering as I'm wrenched and racked and ruined. But then I'm back in Burma, land of my birth. Surrounded by brothers and sisters, uncles and aunts. My entire family tree. The tall teaks. Strong. Proud. Ancient. We feel like we can touch the sky. It's just a small, fleeting moment. As much as I plead to stay, the forest fades, and I'm back... chained to the ground, exiled to an English park, watching the world go by. I see the day's exhibits stride and lollop, prance and shuffle, meander and march. They stretch out languidly on the grass, they feed from printed paper bags. They gossip and argue, they sunbathe and caress, they're cruel and tender, strange and beautiful, sad and contented. Birds and insects move with grace and purpose, the leaves sway to the easy rhythm of the breeze, in all kinds of shades of green and brown and blue. Looking down from a branch on high, I witness my park life of the past decade. A humble council-funded utility... a grey civil servant, I suppose, faithfully resting the backsides of friends and colleagues, husbands and mistresses, fathers and sons, jokers and depressives– all kinds of everyone lost in their own peculiar company. Democratic. I'm behind all the people. Or at least, behind their behinds. I spy sweaty clumps of office joggers in their tracksuits; a teeny nanny negotiating her oversized pram; a businessman beaking into the financial pages; dog walkers yanked along by their sniffing, whiffing animals; young lovers eye to eye, hand in hand; small boys jumping up at a frisbee stuck high in a diadainful tree... the dream splutters out and I'm back in the sado-orgy of here and now. I'm in pieces. Small, shattered, scattered pieces. And a pain so stratospheric I can't feel it any more. Cussing and huffing, Hubertus and his cronies gather up the pathetic wreckage and stack me into a pleasingly symmetrical heap. They scavenge for twigs and leaves, and even proffer their precious week-old newspapers. Once the proud edifice is complete, my old mucker does the honours, working his cracked plastic lighter until a spark sets the flames free, and for an hour or so, I set the night sky ablaze in glorious cackling fire. It's morning now. A small dog paws at the sad circle of flaky charcoal ash, lifts its leg, and daintily douses the final embers of my life. And I float upwards and upwards, past mighty elms and oaks and cedars and redwoods. Forever & ever, arseholes.

1,000 words by JIM DAVIES about a picture by PAUL THOMPSON

To see the picture go to www.paulthompsonstudio.com

'ADAMS?' 'SIR!' Success? Maybe, but at a cost. Two failed marriages – that's a big cost. But he must be raking it in. Villa in the Dordogne, Bentley Convertible and an ex-Miss Scarborough on his arm. None of them come cheap. 'AINSWORTH?' 'sir!' 'AINSWORTH?' 'SIR.' Quiet as a church mouse. Scurries around like a church mouse. Lives alone, keeps very much to herself. Children call her a witch. She once lost it when some kids were taunting her, started shaking the ringleader, then burst into tears. It's a shame really. 'BANNISTER?' 'SIR!' You need a programme with Bannister, never quite know what he's thinking. That's assuming he is thinking. Very good with figures though, destined to become an accountant but ended up running a night club. Figure that one out? 'BARROWCLIFF?' 'SIR!' Caused a bit of gossip when she had a fling with the dinger out of Simply Red tribute band Just Scarlet. Her husband seems to have got her back in tow, they're expecting their third now. There'll be few raised eyebrows if it turns out ginger though. 'BARTHURTON?' 'SIR?' Not a classical beauty by any means. But has the ability to turn sensible, intelligent, articulate men into blubbering, blithering idiots – just with the flick of an eyelash. 'CLARKE?' 'SIR!' Within minutes of meeting her you would know all about her bowel movements, her husband's irritating habits and why her best friend Jenny never married. She's pretty regular at the moment. In case you were wondering. 'CUSSANS?' 'SIR!' Likes his food. Likes his full english. Though he can't stand his baked beans touching his fried egg. Has to keep them apart with a sausage. 'DAVIES?' 'SIR!' Bridlington's Pete Best. Played trombone in the local brass band – good he was too. Packed it all in when he started courting. They only won the regional final two months later. 'ETHERINGTON?' 'SIR!' In the words of the great JL. She's the kind of a girl that makes the News of the World but you could say she was attractively built. Yeah. Yeah. Yeah. 'FULLER?' 'SIR!!' Artistic, extrovert thespian. Like a moth headed straight for the bright lights. Came out then surprised everyone by going back in. His big ambition was to play the Dane at Stratford. Nearest he came was playing the Dame in panto at Cleethorpes. 'HARGREAVES?' 'SIR! SIR!' Words ricochet out of her mouth like a machine gun. All thoughts travel along an eight lane information super highway direct to vocal chord. Unabridged, uncensored, unintelligible. 'HARRIS?... HARRIS?... No HARRIS?' No-one would have thought of him as a war hero. Aggressive, disruptive. Always in trouble. But being fearless and having a great loyalty to his close friends lead him to what turned out to be the ultimate way of channelling his behaviour. 'LESMOND?' 'SIR!' Now reaping the rewards for advice passed from father to son. Continually encouraged to sacrifice playing out in favour of piano lessons. Not for future artistic or spiritual satisfaction. Oh no. But because 'the pub doesn't exist where a half decent pianist has to buy his own pint.' – 'NORTON?' 'SIR!' Have you heard the one about? There were these two... Talking to Norton is like a conversation with a box of crackers. What did the fish say... He's not even funny. How do you tell... You end up with an aching face. Pretending to laugh. Candles out Sisters! 'PRYERS?' 'SIR!' Just look at her. So very prim and proper. Yet she could be a right little madam. Likes to have her own way or an avalanche of toys comes hurtling out of the pram. Then, from a mouth in which you'd think butter wouldn't melt, follows a torrent of abuse. 'PICKSTONE-SMYTH?' 'SIR!' As each barrel suggests, a step up the class chain. But her family had fallen upon hard times. Knew precisely what she wanted. A farmer with land – owned, not leased. With a vast amount of money – old, not new. 'RICHMOND?' 'SIR!' Bright, funny, considerate, could charm the birds from the trees. Physically quite plain, bit on the overweight side actually and could never be accused of being a slave to fashion. Yet always the centre of attention. 'SZYMANSKI?' 'SiR!!!' One Szymanski in a class could be very entertaining. Two would be an out and out disaster. 'TAYLOR?' 'SIR.' Quiet, shy, wouldn't say boo. But put a hockey stick in her hand! Like a magic wand it turns her into a charismatic leader with poise, confidence and skill to burn. 'TURVER?' 'SIR.' Pleasant? Yes. But you would never accuse him of being too philosophical. If you waded through his deepest inner thoughts you wouldn't get your ankles wet. 'UNSWORTH?' 'SIR!' Found religion. Or, rather, religion found her. Not quite a road to Damascus conversion but on her way back from ASDA she was drawn to an illuminated sign. Guitarist wanted at Central Methodist. 'VALENTINE?' 'SIR!' Followed on the family tradition running a fruit and veg stall. Always knew her onions when it came to buys. 'WEACK?' 'SiR!' First name Anna. Never really inherited her parents' sense of humour. 'WRIGHT?' 'SIR!!' Not one for letting the moths in. Folklore has it clashed with Tom 'Tight-arse' Taylor in the Black Horse one sunny afternoon. Two halves of best bitter were ordered and instantly returned to be topped up. (Bigger 'eads than Geoff Boycott.) With wallets securely deep in pockets the Mexborough stand off began. As the barmaid was about to ask for payment, Taylor made the first move. He scurried off muttering something about having to make a phone call. Wright countered with a trip to the gents. The avoidance tactics went on and on. The barmaid was losing the will. Taylor finally cracked. In a way it was a hollow victory as he only offered to pay for his own. But they both knew Wright was now the undisputed champion. In other counties being the meanest man in town wouldn't carry quite the same kudos. It certainly wouldn't warrant minor celebrity status. But welcome to God's Own.

1,000 words by BEN CASEY about a picture by PAUL THOMPSON

To see the picture go to www.paulthompsonstudio.com

"Just because you're twenty minutes older than me. It's always been the same old, same as. Because I know what you are thinking — no, I can *hear* what you're thinking. And you are blaming me for standing there while I'm standing here like two peas in a pod. Twenty minutes... always the same. If I hadn't appeared twenty minutes after you popped out screaming blue murder, you'd have been the princess. You would have been Mummy's girl *and* Daddy's girl rolled into one sweet bundle. No competition. No rivalry... *and* your own wardrobe for all those years. I know I'm right and that is what you're thinking because it's even written across your face. I *know* you. When is he going to take this photograph? It must be nearly lunchtime. We've been here for hours. You'll be having cottage cheese & pineapple on a stick of five-a-day for lunch won't you. Thought so. Still, if we've been here two hours already that's sixty quid. And we haven't had one click from him yet. Could be talking triple figures before he bags a likeness. That's another reason you should be glad I'm here. How much work do we get independently, compared to this twins routine? Be honest. Zilch, practically. Except for the mail order work I guess. And that doesn't keep the budgie in cuttlefish. You should be glad I'm here. Look, I know you hated being dressed identically all the time & people were always getting our names mixed up... & sharing the cat. It was a real shame about that cat. And there was that embarrassing thing in third-year I suppose. But, remember Dean Whitecroft — bloody hell did we have some great fun giving him the run around. Remember? Wonder if he ever did find that wicked Polaroid? Talking of which. Do you think Paul is *ever* going to take this photo... this year I mean or what. Makes a girl nervous — him just standing. Looking. What's this shot for anyway? Wonder if it's personal work? It'll be an ad. Bet it's an ad... they always choose us for ads. It'll have another crap headline like, "Not all things in life are equal." They're always rubbish headlines. Writers get away with murder. Writers are easy life. I know you think so too because you half smiled. then. I saw you from the corner of my eye. You think my head's full of pink pumpkin just because I'm twenty minutes younger than you. You think you know best & I know diddly-squat. Because you, are twenty minutes older. Well you're wrong. You can't accept we're identical. You've never thought of us as being equal. Twenty minutes. Do you know it only takes twenty minutes for light to travel from Earth to Mars, well it does. Yet you think, I can *hear* you thinking this, that we are worlds apart. Just because you're twenty minutes older than me. Well sometimes I wish it was me on Earth and you on Mars."

"You can say that, again."

1,000 words by LIONEL HATCH about a picture by PAUL THOMPSON
To see the picture go to www.paulthompsonstudio.com

This picture is what you see when you find yourself walking through BBC Television Centre during the recording of 'Strictly Come Dancing' and you push open a door marked 'Not for broadcast' and walk inside. This picture is what I drew in the team-building workshop when they asked me how I saw the future of our company. This picture is 64 per cent sky, 33 per cent sand and 3 per cent built environment. This picture is what it was like when you told that joke the other night. This picture details the measures that will be taken to ensure a banking crisis on this scale can never happen again. This picture is why I love you. To walk from the front of this picture to the back of this picture would take about 25 minutes. This picture is what I heard when you said you were sorry for any distress caused and that naturally you take full responsibility. This picture is a difficult spot-the-ball competition. This picture is of Simon Cowell's life flashing in front of his eyes. Key words in an image library search for this picture might include landscape, barren, sand, empty, sign, cloud, dry, tracks, sky, existential. Key words least likely to result in this picture include Christmas, bouncy, loose, mélange, cosy, beef, nonchalant, cornflakes, splash, companionship. This picture was most likely taken on a Tuesday, possibly a Saturday. This picture reverberates. This picture is concerned more with the spaces between things than it is with the things themselves. This picture is very beautiful. If you took down every billboard advertisement in the world and replaced it with this picture, it would take a while for people to notice. This picture is what I think of your customer service helpline. This picture is worth whatever someone is willing to pay for it. Frequently Asked Questions about this picture include: "What made you be a picture of that thing?"; "Where did you first get the idea to be a picture of that thing?"; and "Do you have any plans to be a picture of other things in the future?" The answers to the Frequently Asked Questions about this picture are not as frequent as the questions. I think I once went out with this picture. Someone somewhere thinks I am like this picture, which is a disturbing thought. This picture is what you see when you find yourself walking down a long carpeted corridor in Whitehall towards a door marked 'Big Society' and you push it open and walk inside. This picture would serve a useful function in the Oval Office, or on the walls of the staircase at 10 Downing Street. The place that this picture is a picture of is a real place that exists right now and probably looks very similar to the way it does in this picture. We could both go and stand in this picture if we wanted to. Which is to say, we could both go and stand in the place that this picture is a picture of. If we had been standing there at the time this picture was taken, it would be a different picture. Or possibly just the same picture with us in it. I spy with my little eye something in this picture beginning with 's'. This picture is what I'm thinking about whenever you ask me what I'm thinking about. This picture is what my careers development officer saw in me. This picture is a machine for remembering itself. Two X-Factor judges were discussing this picture — I forget which ones — and the first one said, "Wow! This is one of the best pictures I have ever seen!" & started to cry. The second one said, "I like this picture but I don't like its choice of material. I would like to see more from this picture in next week's Beatles night!" This picture is art. This picture doesn't know much about you but it knows what it likes and it doesn't like you. This picture is of a woman in a red dress with a white umbrella running laughing across the sand and into a flock of startled seagulls, but without the startled seagulls, the white umbrella, the red dress and the laughing, running woman. This picture is of the centre ground in American politics. This picture confused me when it came out of the passport photo machine. This picture is of a characterful property in a beach location with plenty of off-street parking. Just beside the person who took this picture is a wooden sign with a camera symbol on it and text reading "Non-intrusive backdrop to overlaying type". This picture is of the losing entry in the RHS Chelsea Flower Show. This picture contains a fencing arrangement which may be marking out a track of some sort. This picture wants to be your friend on Facebook. This picture is what you see when you fall asleep on the Piccadilly Line on the way home and wake up at the last stop and walk up the stairs and outside. This picture could not have been taken any other way. Somewhere to the right of this picture is where I think I dropped my watch. Who knows what's going on either side of this picture. I would guess it's around 11AM in this picture. This picture contains a sign that is too far away to read. The small building in this picture is where they keep the on/off switch for the Internet. None of us remember where we were when this picture was taken. This picture is your retirement gift after 40 years in service. This picture was taken during a rollover week. Do you have any wallpaper that matches this picture? I would like my hair cut in the style of this picture. The thing beginning with 's' in this picture was 'sand'. This picture was taken a split second after the spaceship disappeared into the clouds. You really have to see this picture.

1,000 words by NICK ASBURY about a picture by PAUL THOMPSON
To see the picture go to www.paulthompsonstudio.com

The mailing directs you to go online which starts with the text but soon begins to change....

This picture is what you see when you find yourself walking through BBC Television Centre during the recording of 'Strictly Come Dancing' and you push open a door marked 'Not for broadcast' and walk inside. This picture is what I drew in the team-building workshop when they asked me how I saw the future of our company. This picture is 64 per cent sky, 33 per cent sand and 3 per cent built environment. This picture is what it was like when you told that joke the other night. This picture details the measures that will be taken to ensure a banking crisis on this scale can never happen again. This picture is why I love you. To walk from the front of this picture to the back of this picture would take about 25 minutes. This picture is what I heard when you said you were sorry for any distress caused and that naturally you take full responsibility. This picture is a difficult spot-the-ball competition. This picture is of Simon Cowell's life flashing in front of his eyes. Key words in an image library search for this picture might include landscape, barren, sand, empty, sign, cloud, dry, tracks, sky, existential. Key words least likely to result in this picture include Christmas, bouncy, loose, mélange, cosy, beef, nonchalant, cornflakes, splash, companionship. This picture was most likely taken on a Tuesday, possibly a Saturday. This picture reverberates. This picture is concerned more with the spaces between things than it is with the things themselves. This picture is very beautiful. If you took down every billboard advertisement in the world and replaced it with this picture, it would take a while for people to notice. This picture is what I think of your customer service helpline. This picture is worth whatever someone is willing to pay for it. Frequently Asked Questions about this picture include: "What made you be a picture of that thing?"; "Where did you first get the idea to be a picture of that thing?"; and "Do you have any plans to be a picture of other things in the future?" The answers to the Frequently Asked Questions about this picture are not as frequent as the questions. I think I once went out with this picture. Someone somewhere thinks I am like this picture, which is a disturbing thought. This picture is what you see when you find yourself walking down a long carpeted corridor in Whitehall towards a door marked 'Big Society' and you push it open and walk inside. This picture would serve a useful function in the Oval Office, or on the walls of the staircase at 10 Downing Street. The place that this picture is a picture of is a real place that exists right now and probably looks very similar to the way it does in this picture. We could both go and stand in this picture if we wanted to. Which is to say, we could both go and stand in the place that this picture is a picture of. If we had been standing there at the time this picture was taken, it would be a different picture. Or possibly just the same picture with us in it. I spy with my little eye something in this picture beginning with 's'. This picture is what I'm thinking about whenever you ask me what I'm thinking about. This picture is what my careers development officer saw in me. This picture is a machine for remembering itself. Two X-Factor judges were discussing this picture – I forget which ones – and the first one said, "Wow! This is one of the best pictures I have ever seen!" & started to cry. The second one said, "I like this picture but I don't like its choice of material. I would like to see more from this picture in next week's Beatles night!" This picture is art. This picture doesn't know much about you but it knows what it likes and it doesn't like you. This picture is of a woman in a red dress with a white umbrella running laughing across the sand and into a flock of startled seagulls, but without the startled seagulls, the white umbrella, the red dress and the laughing, running woman. This picture is of the centre ground in American politics. This picture confused me when it came out of the passport photo machine. This picture is of a characterful property in a beach location with plenty of off-street parking. Just beside the person who took this picture is a wooden sign with a camera symbol on it and text reading "Non-intrusive backdrop to overlaying type." This picture is of the losing entry in the RHS Chelsea Flower Show. This picture contains a fencing arrangement which may be marking out a track of some sort. This picture wants to be your friend on Facebook. This picture is what you see when you fall asleep on the Piccadilly Line on the way home and wake up at the last stop and walk up the stairs and outside. This picture could not have been taken any other way. Somewhere to the right of this picture is where I think I dropped my watch. Who knows what's going on either side of this picture. I would guess it's around 11AM in this picture. This picture contains a sign that is too far away to read. The small building in this picture is where they keep the on/off switch for the Internet. None of us remember where we were when this picture was taken. This picture is your retirement gift after 40 years in service. This picture was taken during a rollover week. Do you have any wallpaper that matches this picture? I would like my hair cut in the style of this picture. The thing beginning with 's' in this picture was 'sand'. This picture was taken a split second after the spaceship disappeared into the clouds. You really have to see this picture.

This picture is what you see when you find yourself walking through BBC Television Centre during the recording of 'Strictly Come Dancing' and you push open a door marked 'Not for broadcast' and walk inside. This picture is what I drew in the team-building workshop when they asked me how I saw the future of our company. This picture is 64 per cent sky, 33 per cent sand and 3 per cent built environment. This picture is what it was like when you told that joke the other night. This picture details the measures that will be taken to ensure a banking crisis on this scale can never happen again. This picture is why I love you. To walk from the front of this picture to the back of this picture would take about 25 minutes. This picture is what I heard when you said you were sorry for any distress caused and that naturally you take full responsibility. This picture is a difficult spot-the-ball competition. This picture is of Simon Cowell's life flashing in front of his eyes. Key words in an image library search for this picture might include landscape, barren, sand, empty, sign, cloud, dry, tracks, sky, existential. Key words least likely to result in this picture include Christmas, bouncy, loose, mélange, cosy, beef, nonchalant, cornflakes, splash, companionship. This picture was most likely taken on a Tuesday, possibly a Saturday. This picture reverberates. This picture is concerned more with the spaces between things than it is with the things themselves. This picture is very beautiful. If you took down every billboard advertisement in the world and replaced it with this picture, it would take a while for people to notice. This picture is what I think of your customer service helpline. This picture is worth whatever someone is willing to pay for it. Frequently Asked Questions about this picture include: "What made you be a picture of that thing?"; "Where did you first get the idea to be a picture of that thing?"; and "Do you have any plans to be a picture of other things in the future?" The answers to the Frequently Asked Questions about this picture are not as frequent as the questions. I think I once went out with this picture. Someone somewhere thinks I am like this picture, which is a disturbing thought. This picture is what you see when you find yourself walking down a long carpeted corridor in Whitehall towards a door marked 'Big Society' and you push it open and walk inside. This picture would serve a useful function in the Oval Office, or on the walls of the staircase at 10 Downing Street. The place that this picture is a picture of is a real place that exists right now and probably looks very similar to the way it does in this picture. We could both go and stand in this picture if we wanted to. Which is to say, we could both go and stand in the place that this picture is a picture of. If we had been standing there at the time this picture was taken, it would be a different picture. Or possibly just the same picture with us in it. I spy with my little eye something in this picture beginning with 's'. This picture is what I'm thinking about whenever you ask me what I'm thinking about. This picture is what my careers development officer saw in me. This picture is a machine for remembering itself. Two X-Factor judges were discussing this picture – I forget which ones – and the first one said, "Wow! This is one of the best pictures I have ever seen!" & started to cry. The second one said, "I like this picture but I don't like its choice of material. I would like to see more from this picture in next week's Beatles night!" This picture is art. This picture doesn't know much about you but it knows what it likes and it doesn't like you. This picture is of a woman in a red dress with a white umbrella running laughing across the sand and into a flock of startled seagulls, but without the startled seagulls, the white umbrella, the red dress and the laughing, running woman. This picture is of the centre ground in American politics. This picture confused me when it came out of the passport photo machine. This picture is of a characterful property in a beach location with plenty of off-street parking. Just beside the person who took this picture is a wooden sign with a camera symbol on it and text reading "Non-intrusive backdrop to overlaying type." This picture is of the losing entry in the RHS Chelsea Flower Show. This picture contains a fencing arrangement which may be marking out a track of some sort. This picture wants to be your friend on Facebook. This picture is what you see when you fall asleep on the Piccadilly Line on the way home and wake up at the last stop and walk up the stairs and outside. This picture could not have been taken any other way. Somewhere to the right of this picture is where I think I dropped my watch. Who knows what's going on either side of this picture. I would guess it's around 11 AM in this picture. This picture contains a sign that is too far away to read. The small building in this picture is where they keep the on/off switch for the Internet. None of us remember where we were when this picture was taken. This picture is your retirement gift after 40 years in service. This picture was taken during a rollover week. Do you have any wallpaper that matches this picture? I would like my hair cut in the style of this picture. The thing beginning with 's' in this picture was 'sand'. This picture was taken a split second after the spaceship disappeared into the clouds. You really have to see this picture

... to reveal the picture that is
exactly the same proportion.

The SWOT Awards
..

For the launch of The Drum's
SWOT Awards we couldn't resist
the opportunity in the acronym.

The Drum | 2006

The SWOT Awards

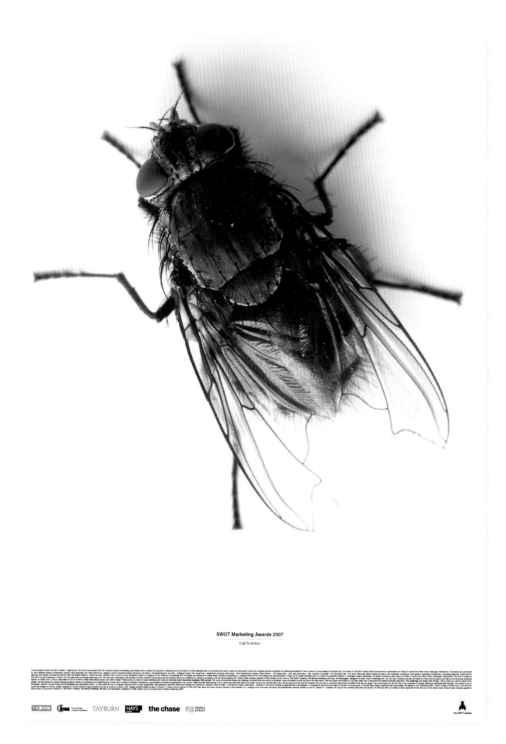

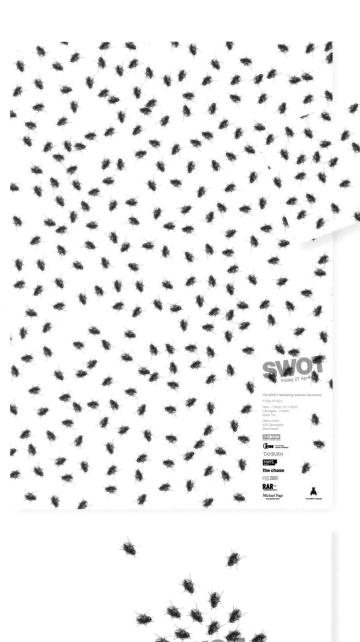

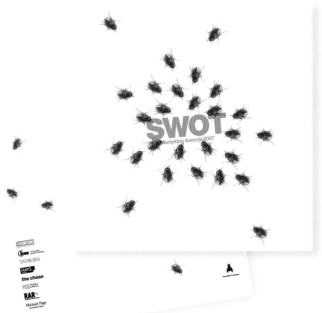

Congress
...

D&AD describe Congress as an
annual, global celebration of creativity.
They asked us to promote the event
and provided a somewhat succinct
brief: "attraction". Our response is
a three-word concept: moth, porch,
light. Mario Godlewski was specially
commissioned to design the
illuminated typeface which became
the perfect vehicle for carrying the
campaign across a variety of media.

D&AD | 2005

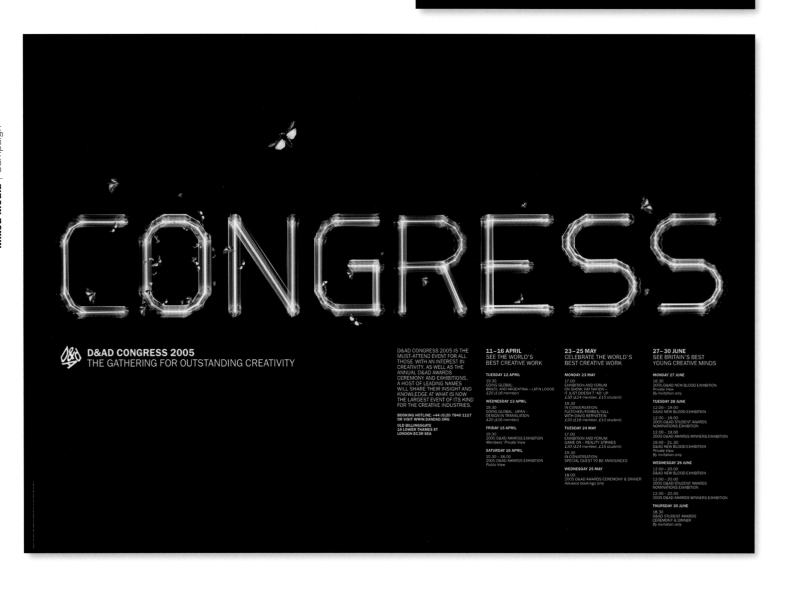

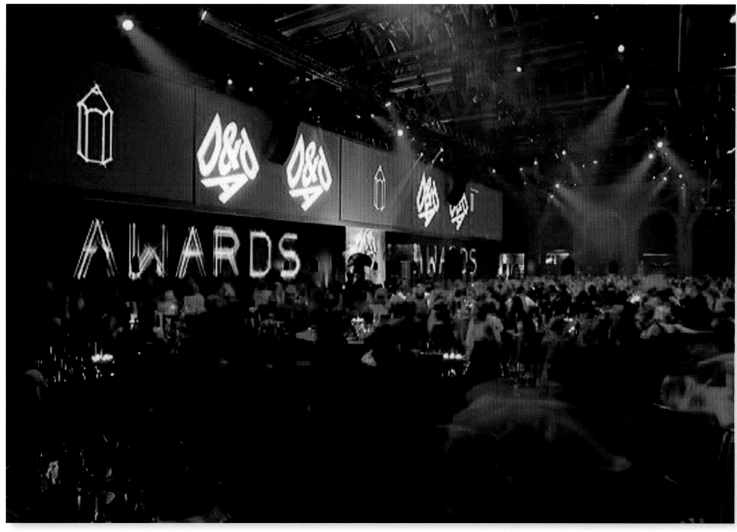

Graduate Academy

With Hewlett Packard, D&AD launched the Graduate Academy. This initiative was created to give a break to young creatives who were looking in from the outside. Our awareness campaign, integrated across print, web and the environment, helped to place fifty graduates in fifty leading organisations.

D&AD/Hewlett Packard | 2012

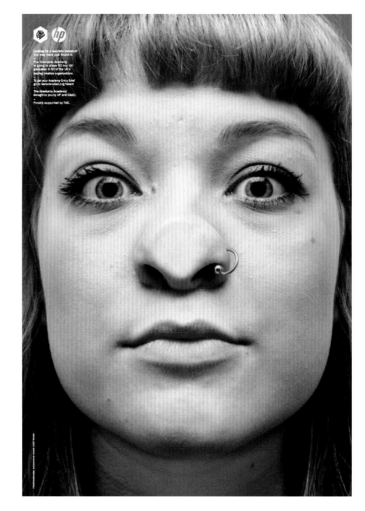

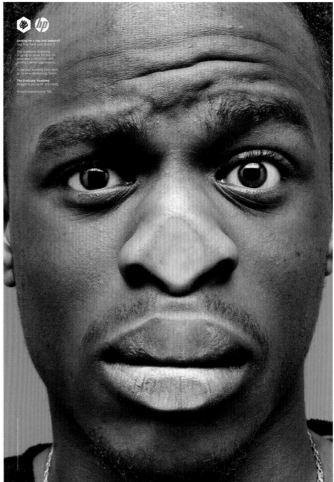

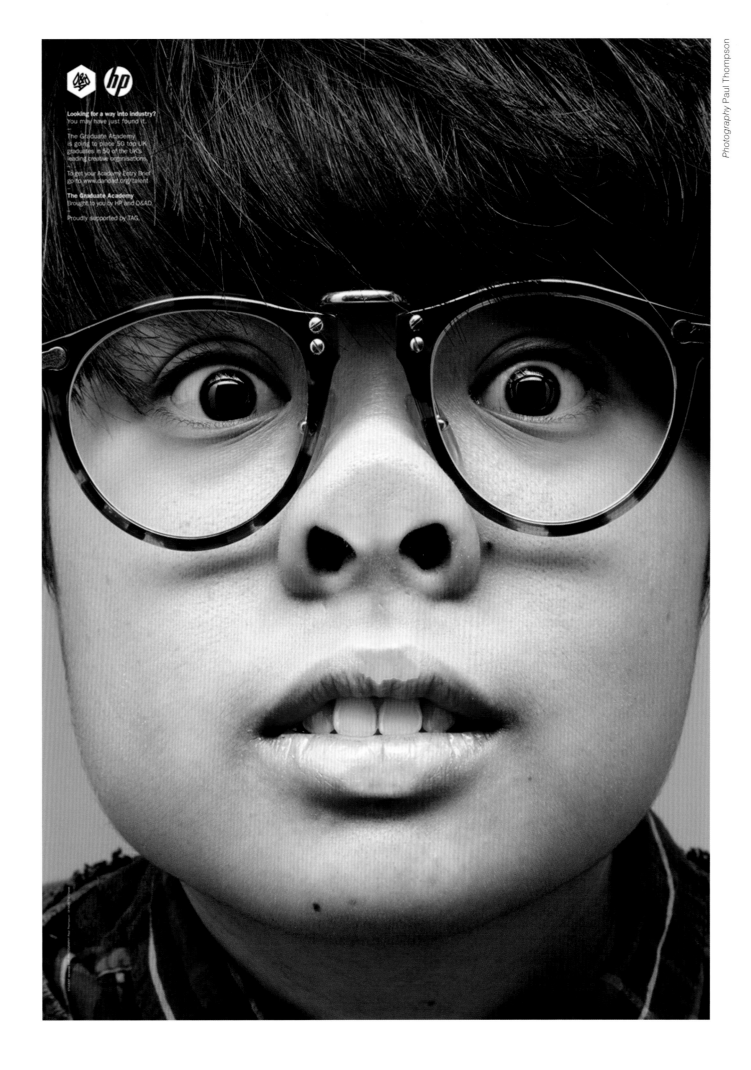

Feeling Fruity
..

Get your workmates together, collate
a list of their favourite fruits, phone the
order through. This company will
customise cardboard crates with your
requests and deliver to your door
by van. We created the whole identity
system for I Feel Fruity, incorporating
some characters who appear to have
taken on the persona of their
favourite mouthful.

I Feel Fruity | 2009

I feel fruity.

I feel fruity delivers lovely fresh fruit to your office.
We're here to make sure every office has fresh fruit in it.
If you fancy a delicious box of tasty fruit delivered to
your company just call the I feel fruity hot line or send
us an email.

Ordering

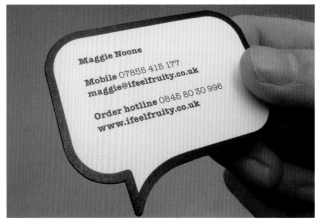

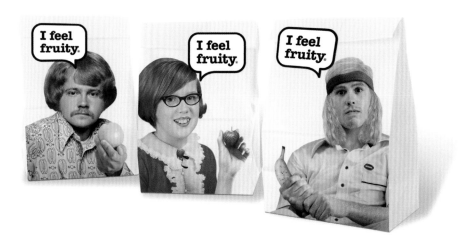

Moneybags
...

How do you turn a service into a retail
product? We produced a campaign that
featured 'Moneybags', giving financial
services a physical presence like any
other M&S product you could pick
up and buy. Large images representing
the services were positioned
opportunistically throughout the stores
and outdoor advertising completed
the campaign.

M&S Money | 2004

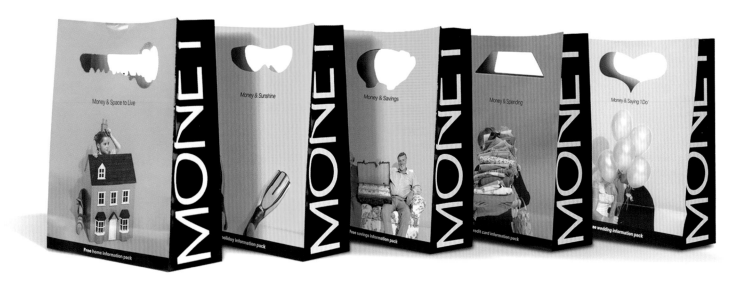

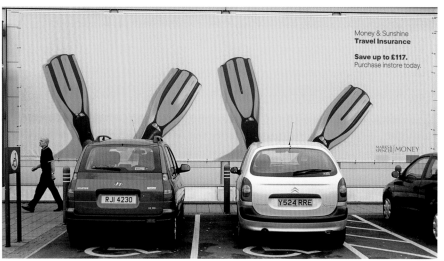

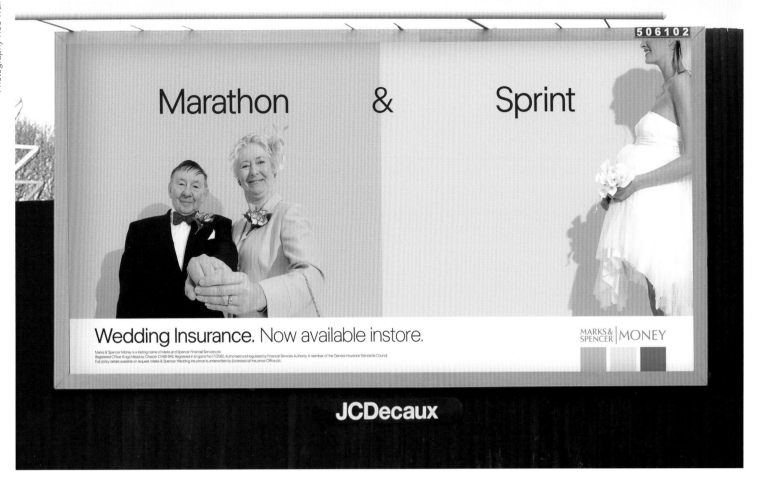

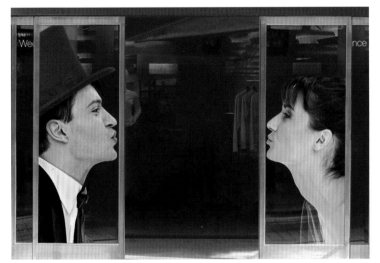

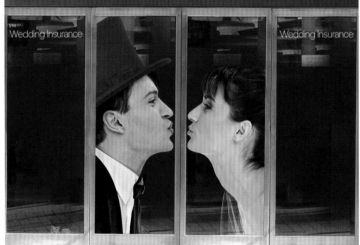

Edging Ahead

We're often asked where our ideas
come from. In this case it was from
a visit to a plastic card manufacturer.
We asked the question "Why does
the core of the card always have
to be white?" The answer: it doesn't.
So we had a first. It may seem subtle
but not when you consider that it's
the edge of the card that is mainly
seen in a wallet. It also created
a new brand asset—black and
white photography with a strip of
fluorescent green which was taken
up by advertising agency RKCR/Y&R
and featured in their TV work for
M&S Money.

M&S Money | 2006

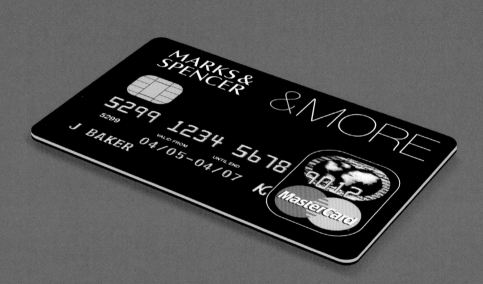

The green stripe became a brand asset and was featured in a TV commercial by advertising agency RKCR/Y&R.

The new M&S Ethical Fund

Our first product launch of 2007

Today, 12th February, sees our first product launch of the year – our Ethical Fund. We think it's something to celebrate which is why we've put this bag together. In keeping with the ethical theme, we've included a selection of Fairtrade products just for you – fruit, tea, sugar and a bar of M&S organic Fairtrade chocolate. You'll also find some information telling you a little more about the Ethical Fund and about the five trees we've planted on your behalf to mark the launch.

The bright green stripe was used on all forms of communication. A new colour palette was then introduced for the product range and used discretely with black-and-white photography.

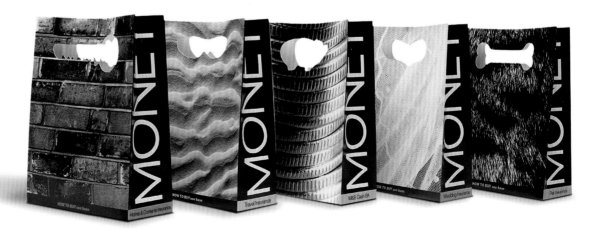

40 Eastbourne Terrace
...

When given the brief for this project
in 2006, Eastbourne Terrace had
been an up-and-coming area opposite
Paddington Station with brilliant
transport links. So we gave Number
40 a well-connected strapline
wrapped with ribbon and ran it through
all communications.

Land Securities | 2006

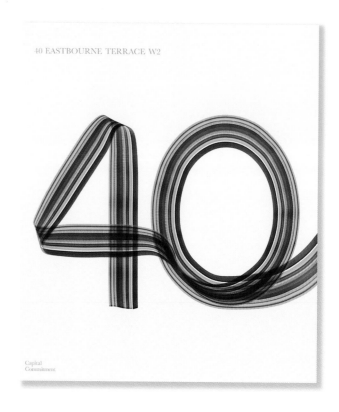

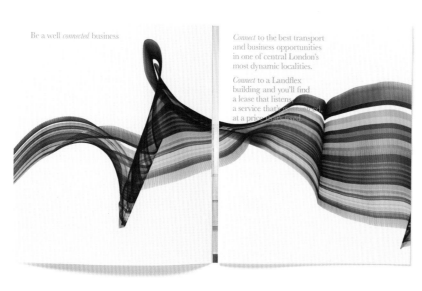

40 EASTBOURNE TERRACE W2

Capital
Commitment

LandSecurities

40 Eastbourne Terrace

Be a well *connected* business

Be a well *connected* business

Connected to transport

Connected to business

Fifth Continent
..

Robert Walker is an outstanding photographer who needed an identity for his exhibition titled The Fifth Continent. These images of landscapes around Dungeness are often barren and starkly linear, something we adopted using muted colours and lines of varying thickness. To see the word "fifth" takes a bit of looking, but that's like finding the real beauty in Rob's photographs. Applications included posters, invites and the gallery space.

Robert Walker Photographer | 2015

ROBERT WALKER
THE FIFTH CONTINENT
12th December 2015 - 27th February 2016

PRIVATE VIEW: 11th December 6pm - 8pm

TOUCHSTONES ART GALLERY
The Dipladocky, Rochdale, OL16 1AG
01706 654440

Tuesday - Saturday 10am - 5pm

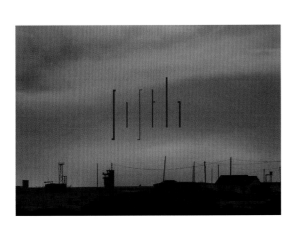

ROBERT WALKER
THE FIFTH CONTINENT
12th December 2015 - 27th February 2016

PRIVATE VIEW: 11th December 6pm - 8pm

TOUCHSTONES ART GALLERY
The Dipladocky, Rochdale, OL16 1AG
01706 654440

Tuesday - Saturday 10am - 5pm

Master Stove Maker Since 1854
·······························

Based in Barnoldswick, Lancashire, ESSE continues to be the master stove maker ever since they were first established in 1854. With a long-standing heritage and a company rich in character, it seemed only right for us to redraw their original logo and restore it to its quirky self. This same eccentricity was then applied across the brand, not only applying the logo to the product itself, but also changing the tone of voice and typography that was used to communicate the brand's core product messages.

ESSE | 2016

WITH 30 HUNGRY MOUTHS TO FEED AT MINUS 45°C YOU NEED A STOVE THAT WON'T LET YOU DOWN.

When Shackleton set out to conquer the Antarctic he needed a stove that would perform in the most hostile conditions on the planet.

He chose an ESSE.

Just one story from ESSE's rich heritage.

Pop-up shops, website and product literature all featured the strong typographic styling reflecting the brand's character and authenticity.

The Chase are renowned for always seeking the witty design solution buried in a brief. The idea quest in this particular execution manages to transcend cliché by unearthing the goalpost metaphor in the carrier bag's handle.

The process of discovery required is just enough to make the audience feel rewarded.

The best place for this sort of thinking is always in the arena of promotional graphics—and therefore perfect in this instance.

John Rushworth Partner, Pentagram, London

packaging

10

Equations

A new, slightly anarchic band met
their match with illustrations by
David Hughes.

Black Burst Records | 1999

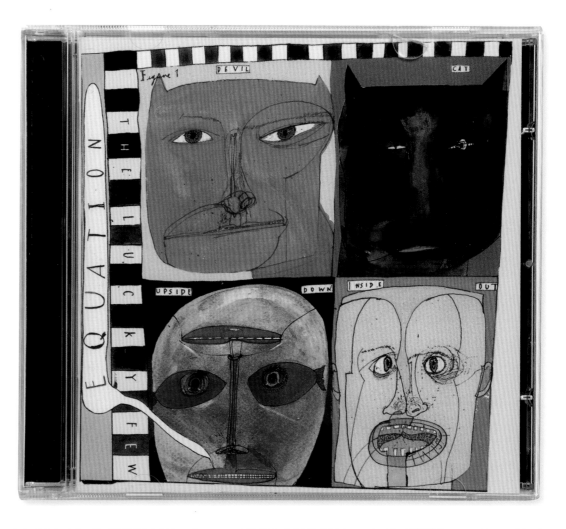

Healthier Snacking
..

These packs need to work hard
to please two different audiences.
The multipack has to grab busy mums
on a supermarket run, while small
children and their school friends would
be happy to see the individual packs
tucked inside their lunchbox. Kooks
are a healthier snack, packed with
nutrition, made from eight vegetables
without a trace of anything artificial.
(For the mums.) They taste of mild
cheese and the little animated tribe of
vegetables look kooky. (For the kids.)

Apple Marketing | 2008

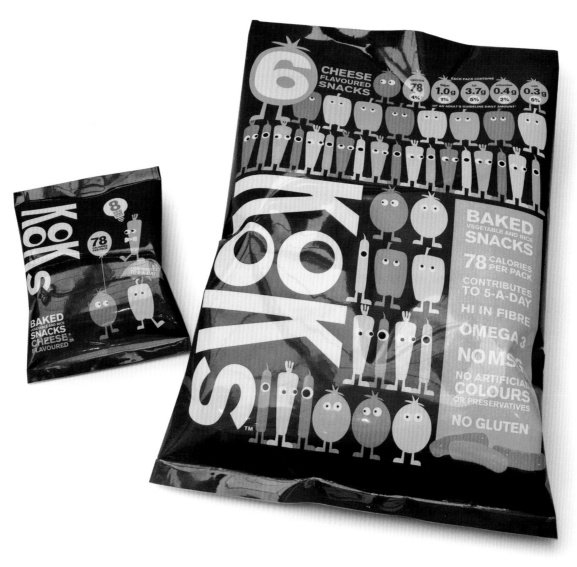

A Taste of Scotland
...
The Royal Burgh of Selkirk is situated within the borders of Scotland. And the Selkirk Deli leaves you in no doubt as to which country you've arrived in. Provenance is utmost here. The finest Scottish food served with traditional Scots hospitality. A message clearly conveyed without words.

Selkirk Deli | 2003

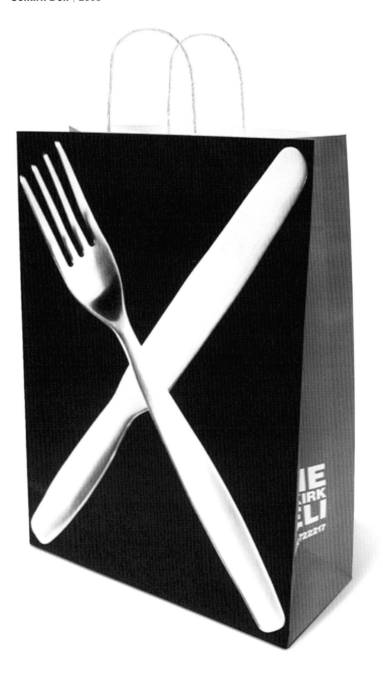

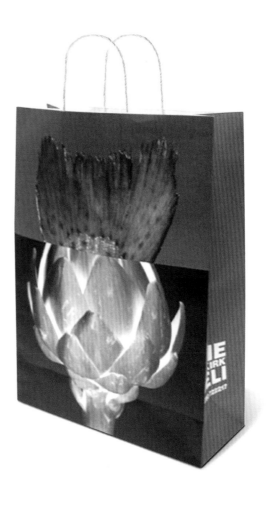

A Spring in Your Step

When buying a new carpet people ought to pay as much attention to choosing the correct underlay. These die cut tactile sample covers give strong visual clues.

Gaskell Carpets | 2005

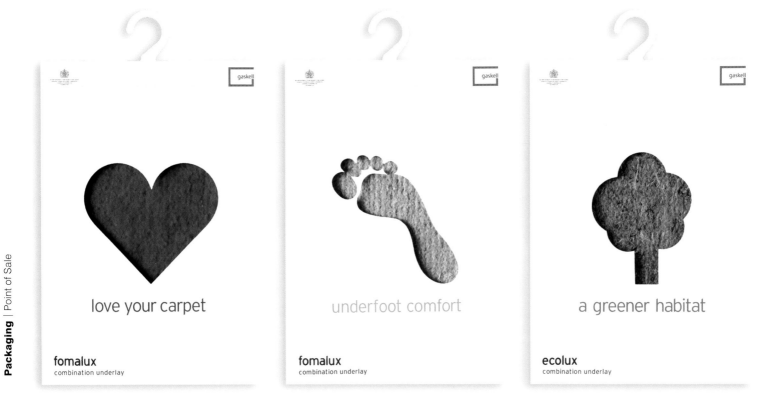

love your carpet

fomalux
combination underlay

underfoot comfort

fomalux
combination underlay

a greener habitat

ecolux
combination underlay

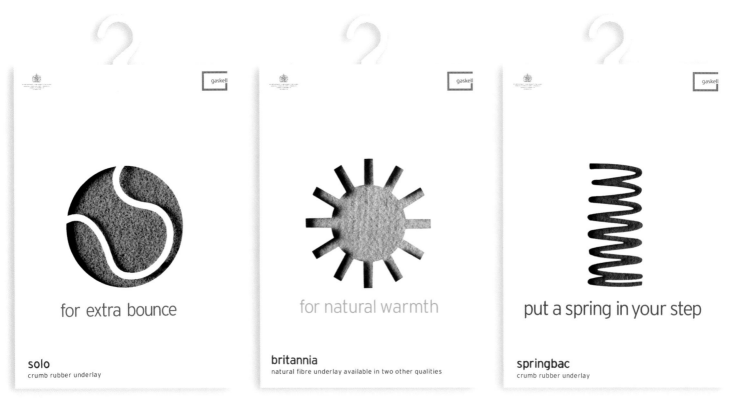

for extra bounce

solo
crumb rubber underlay

for natural warmth

britannia
natural fibre underlay available in two other qualities

put a spring in your step

springbac
crumb rubber underlay

Shower Power

Our brief for Original Source was to retain the strength of the brand but refresh it. We worked with Alloy to create a bottle shape that reflected the brand's value of natural power. Alloy developed a 'rock face' concept, with a textured back for good grip in the shower and a smooth, monolithic front to hold the label. We crafted the type to ensure great standout and the ability to cope with many different variants.

PZ Cussons | 2004

Happy Technology
...

hudl decided to swim against the tide
of its Californian and Korean rivals,
seeking a more British tone, one that
embraced the "happy technology"
brand positioning. Packaging for hudl2
embraced colour, vibrancy and
accessibility. Images centred around
the brief "to huddle", each one adopting
a different aspect of Britishness.

Tesco | 2014

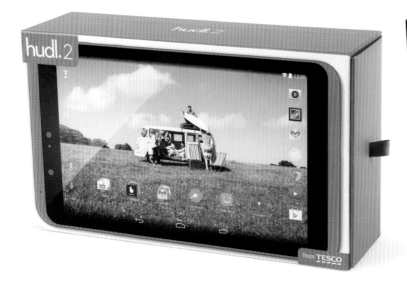

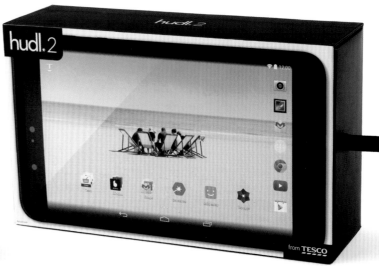

Photography Maria Moore

Royal Mail Collectibles: Mail Vans
...

Building on the popularity of its
Collectibles ranges, Royal Mail
commissioned new packaging
for its replica mail vans. Definitely not
toys, these are fine metal castings,
periodically faithful and accurately
detailed, which was exactly what
the packs needed to reflect. As the
pack opens a technical blueprint
of each vehicle is revealed.

Royal Mail | 2010

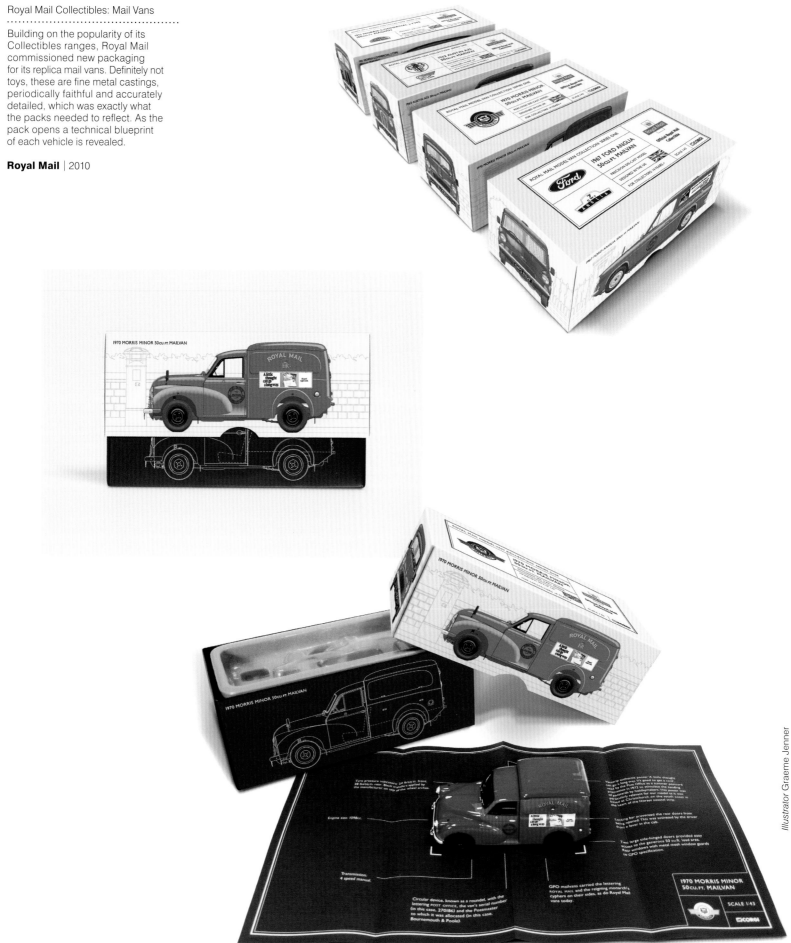

Illustrator Graeme Jenner

Royal Mail Collectibles: Pillar Boxes
..

Following on from the success of
the die-cast model van collection,
a range of finely detailed historical
pillar boxes were released. Although
packaged within cardboard tubes,
the design followed a very similar
approach with full-colour technical
illustrations of the boxes sat on simple
line-drawn backgrounds.

Royal Mail | 2010

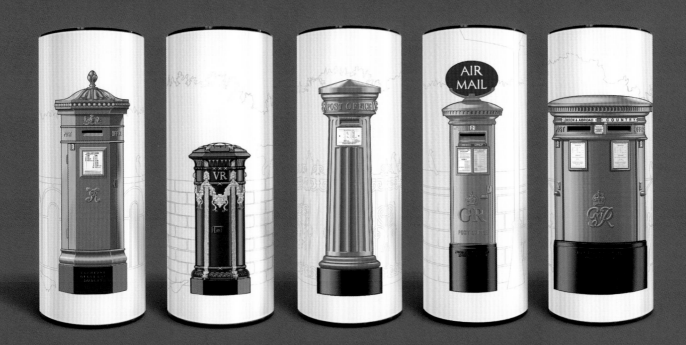

Special Stamp Packs
....................................
Collectors' packs are issued by
Royal Mail to launch individual
ranges of special stamps. These
three are in semi-opaque packs,
presenting each theme's subject
through a three-dimensional montage.
Their aim was to encourage children to
take an interest in stamps.

Royal Mail | 2002

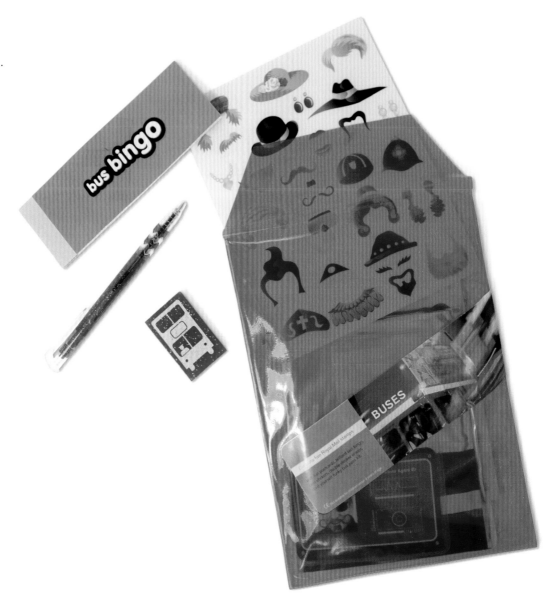

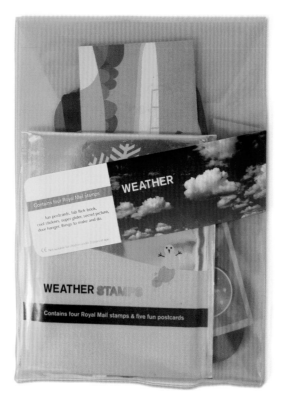

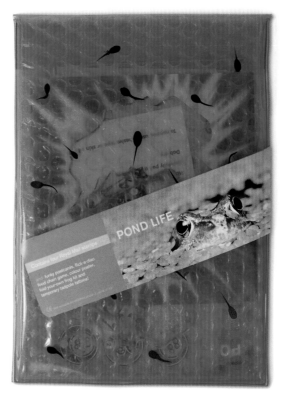

Cool Fuel Bottles
...

These Cool Fuel bottles from Yorkshire
Water were designed in partnership
with Alloy as part of a campaign
to encourage schoolchildren to drink
more water. Shaped like a fin, the
bottles are easy for small hands to hold,
and can be filled two at a time from
branded water coolers.

Yorkshire Water | 2003

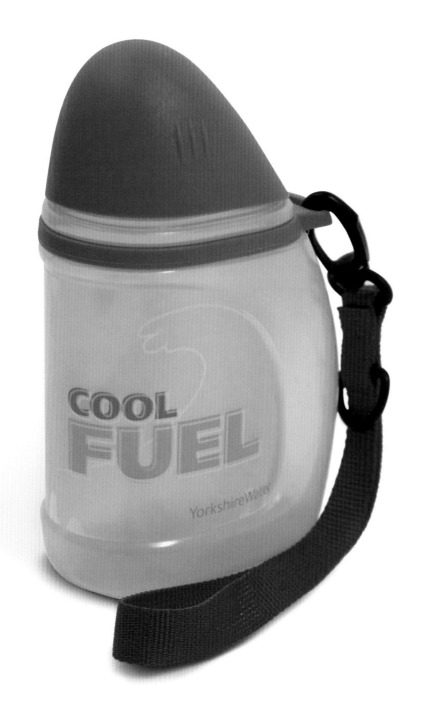

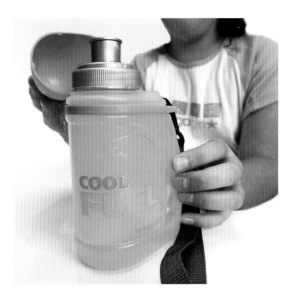

Cup Winner

A pack created for Extra Time, the
National Football Museum Shop, which
transformed a rather dull present into a
considered one. Choose a couple of
mugs and the pack would transform
them into a team's kit.

National Football Museum | 2001

Intellectual Property
..

Self-promotional mailer highlighting
our depth of experience working in
the property sector. A selection of case
study postcards contained within a
clever piece of cardboard engineering
the exact size of a brick. The title,
'Intellectual Property', is debossed into
the top.

The Chase | 2007

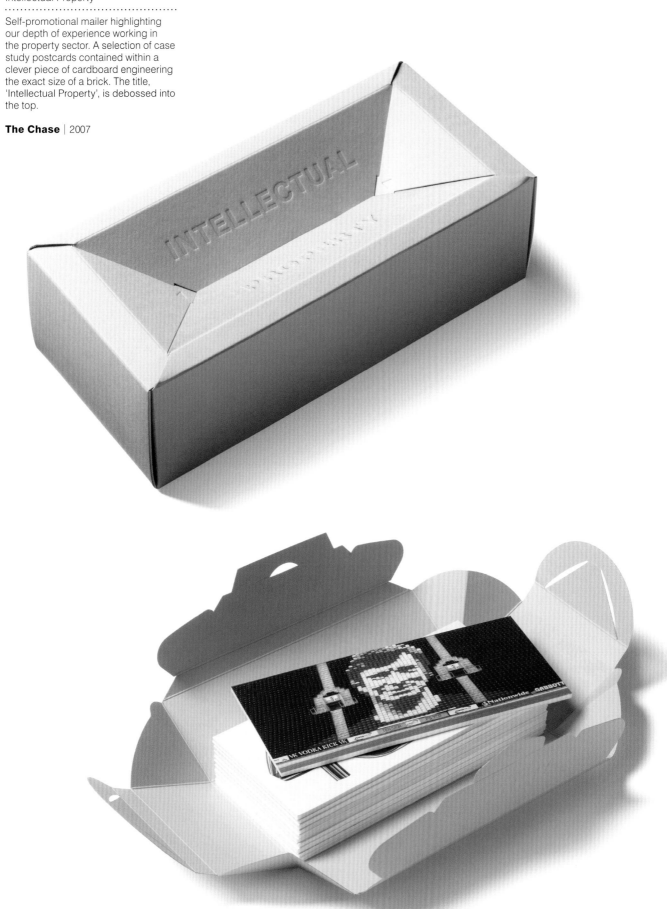

Posters are reductive by nature, relying on telegraphic immediacy to put a point across. But simple needn't mean simplistic. The best posters manage to invest the communicative process with wit and depth, creating meaning though concise means.

This 2001 poster for an early computer dating service dramatises, by juxtaposing two images, the oft-reported (and no doubt apocryphal) statistic that men think about sex once every seven seconds, or 8,000 times a day.

The fine art provenance of the sculptures pictured both, in a nice piece of coincidence, from the hand of Auguste Rodin, reminds us of the universality of the quest for romantic love, and adds a touch of class to what was then the faintly disreputable world of online romance.

And, of course, it passes the ultimate test of great design: no headline necessary.

Michael Bierut Partner, Pentagram, New York

posters

Personal Loans
..
More thought bubbles. An in-branch
campaign in which worn-out everyday
objects fantasize about improvements
in their lifestyles.

The Co-operative Bank | 1994

Photography Rob Walker

197

Incentive Poster
..
An announcement that, for the first time,
student award winners would have
their work featured in the *D&AD Annual*.
The famous yellow pencil was doctored
to entice students to enter.

D&AD | 1992

Posters | Announcement

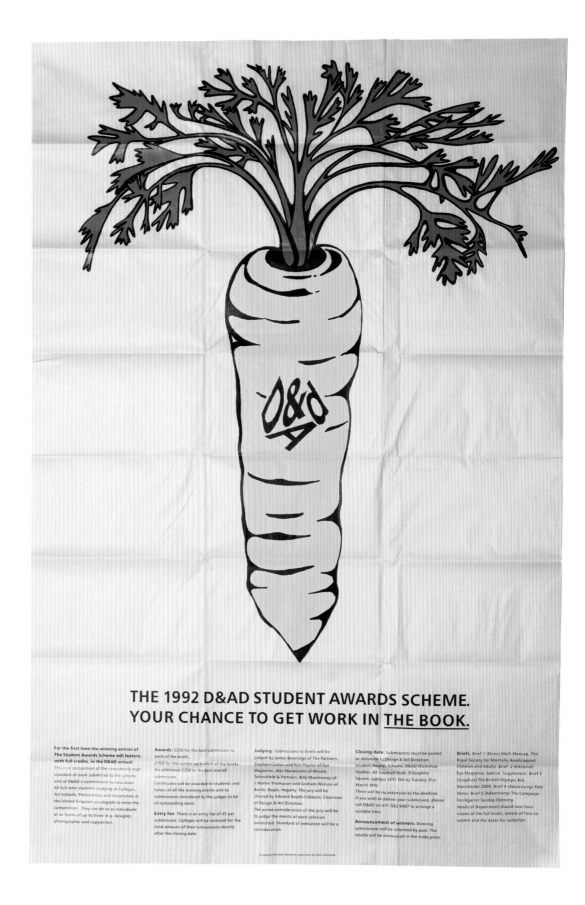

THE 1992 D&AD STUDENT AWARDS SCHEME.
YOUR CHANCE TO GET WORK IN <u>THE BOOK</u>.

For the first time the winning entries of
The Student Awards Scheme will feature,
with full credits, in the D&AD annual.
This is in recognition of the consistently high
standard of work submitted to the scheme
and of D&AD's commitment to education.
All full-time students studying at Colleges,
Art Schools, Polytechnics and Universities in
the United Kingdom are eligible to enter the
competition. They can do so as individuals
or as teams of up to three (e.g. designer,
photographer and copywriter).

Awards: £250 for the best submission to
each of the briefs.
£100 for the runner-up to each of the briefs.
An additional £250 to the best overall
submission.
Certificates will be awarded to students and
tutors of all the winning entries and to
submissions considered by the judges to be
of outstanding merit.

Entry fee: There is an entry fee of £5 per
submission. Colleges will be invoiced for the
total amount of their submissions shortly
after the closing date.

Judging: Submissions to briefs will be
judged by James Beveridge of The Partners,
Stephen Coates and Rick Poynor of Eye
Magazine, Alex Maranzano of Minale,
Tattersfield & Partners, Billy Mawhinney of
J. Walter Thompson and Graham Watson of
Bartle, Bogle, Hegarty. The jury will be
chaired by Edward Booth-Clibborn, Chairman
of Design & Art Direction.
The prime consideration of the jury will be
to judge the merits of each solution
submitted. Standard of execution will be a
consideration.

Closing date: Submissions must be posted
or delivered to Design & Art Direction
Student Award Scheme, D&AD Workshop
Studios, 85 Vauxhall Walk, 9 Graphite
Square, London SE11 5HJ by Tuesday 31st
March 1992.
There will be no extension to the deadline.
If you wish to deliver your submission, please
call D&AD on 071-582 6487 to arrange a
suitable time.

Announcement of winners: Winning
submissions will be informed by post. The
results will be announced in the trade press.

Briefs. Brief 1 (Direct Mail) Mencap, The
Royal Society for Mentally Handicapped
Children and Adults. Brief 2 (Editorial)
Eye Magazine; Special Supplement. Brief 3
(Graphics) The British Olympic Bid;
Manchester 2000. Brief 4 (Advertising) Polo
Mints. Brief 5 (Advertising) The Campaign
For/Against Sunday Opening.
Heads of Department should now have
copies of the full briefs, details of how to
submit and the dates for collection.

To reinforce this idea and add impact,
we produced a life-sized poster.

D&AD and The Guardian | 1993

Photography Rob Walker

The **Guardian** Expo 93. An opportunity to view the work of advertising and graphic design students before they enter the big wide world. 30 of the top colleges in the UK exhibiting in one venue, The Royal Horticultural Halls (Hall One) 80 Vincent Square London SW1. Open 10am-9pm Wednesday 7th and 10am-3pm Thursday 8th July.

Yellow Mouse

How many visual twists can be made from a yellow pencil? D&AD could produce a book based on all the variations that have been created for them over the years.

This is one for the Guardian Student Expo 1994. To acknowledge the revolution in design industry technology, the D&AD yellow pencil became a mouse.

D&AD and The Guardian | 1994

An opportunity to view the work of advertising and graphic design students from 25 of the top colleges in the UK exhibiting in one venue.

The Royal Horticultural Halls (Hall One), 80 Vincent Square, London SW1. Tuesday 5th July 1994. 10am - 9pm.

Part of the Zanders D&AD Education Scheme.

*The***Guardian** Student Expo 94

Sold as Seen
...

Here's a ceramic tile manufacturer
keen to target architects and contract
specifiers. These posters visually
express key messages of service,
modular ranges and their rebuilt
website. All tiles are shot in proportion
without image manipulation.

Johnson Tiles | 2015

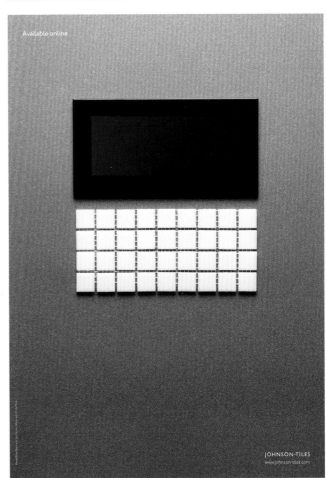

Photography Tim Ainsworth

One Tree Exhibition
...

When a tree that had stood in Tatton Park, Cheshire for hundreds of years finally came down in a freak storm, local artists decided to celebrate its life by using every part of it. The posters promoted the resulting exhibition.

One Tree | 2000

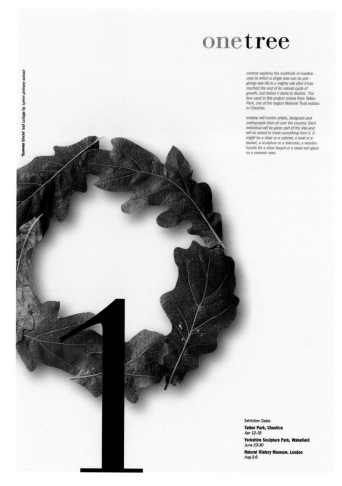

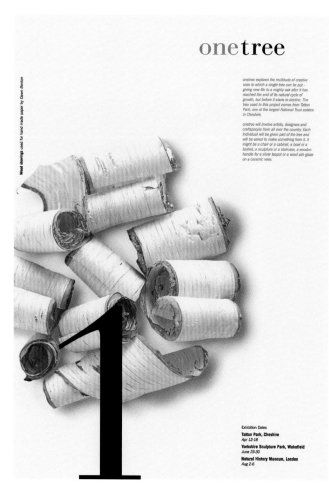

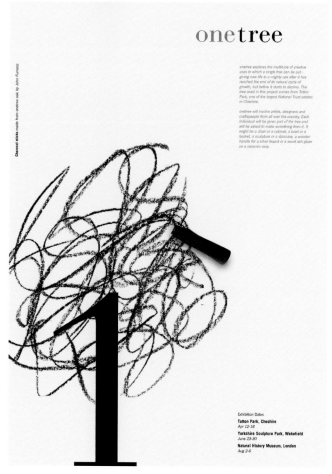

202

Grow Up!

..

There's never been a shortage of advice
for young girls, as these handy hints
and tips in the style of teenage doodles
eloquently demonstrate.

The Women's Library | 2003

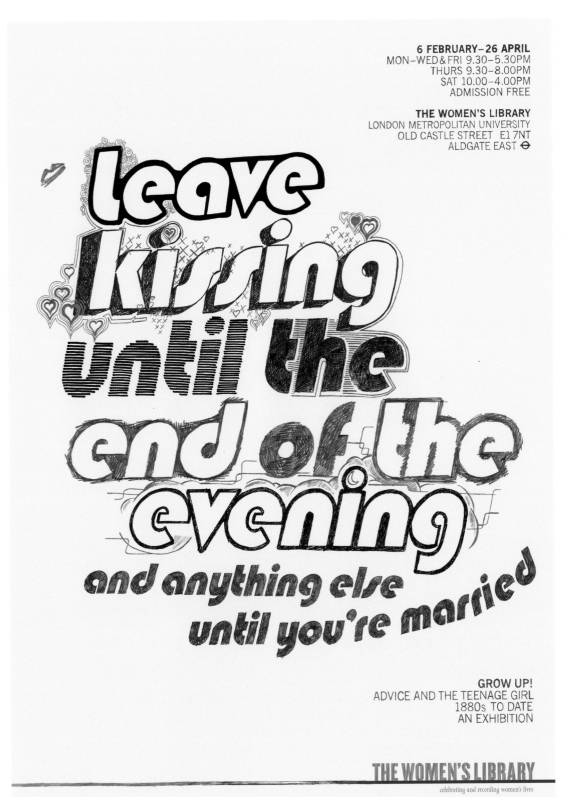

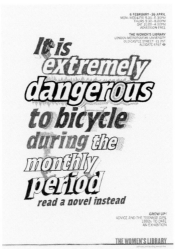

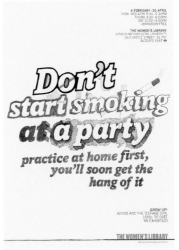

Bureau de Change

...

Does money really make the world go
round? It does in this revolving billboard.

M&S Money | 2007

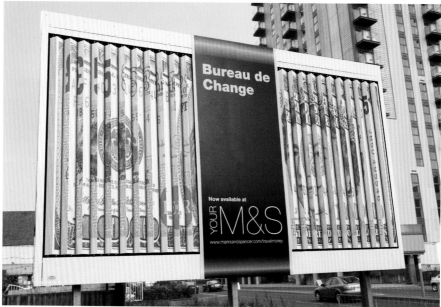

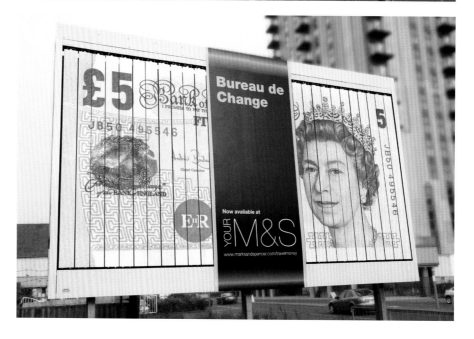

Seeing Things in a Different Light
...

This thought-provoking image directed
people to our website to see different
ways of looking at things.

The Chase | 2006

Illustrator David Hughes

www.thechase.co.uk

Three Letters, One Beast

A self-promotional poster in which
the initial letters of the company's three
offices form an image of an elephant.
A symbol that's become synonymous
with The Chase.

The Chase | 2016

thechase.co.uk London Manchester Preston

Celebrating 30 years of creativity

By Public Demand
..
A 'closing down sale' poster reminding
people that an exhibition of illustrations
by David Hughes had only a few days
to go. It featured packaging stickers for
airmailing works of art.

Harris Art Gallery | 2003

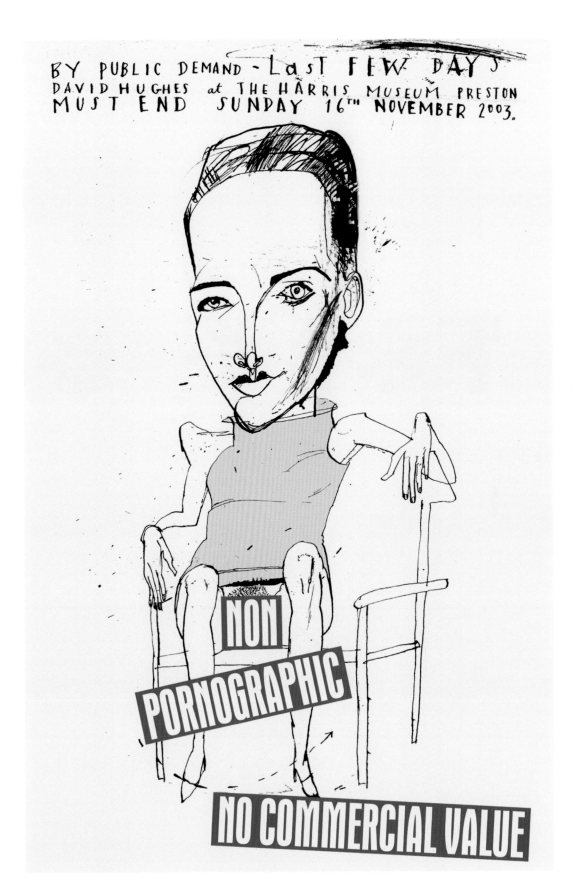

Fine Art Exhibition
...
As with contemporary art itself, this
poster challenges the way the viewer
looks at things.

**Manchester Metropolitan
University** | 1993

*FINE ART

The Manchester Metropolitan Degree Show 1993 Friday June 18 – Wednesday June 23. Medlock Fine Arts Centre, Chester Street (off Oxford Road), Manchester. St Martin's, London Monday June 28 – Saturday 3. St Martin's Gallery St Martin in the field, Trafalgar Square, London. Brixton, London Monday June 28 – Saturday July 17. Cooltan Arts, The Old Dolehouse, 372 Coldharbour Lane, Brixton, London. For further information call (0161) 247 1906. Preview of the BT New Contemporaries 1993 Saturday June 19 – Sunday August 1. Cornerhouse Gallery, Oxford Road, Manchester. For further information call (0161) 228 7625.

The Scream
...
To add drama to a poster for The Murder
Mystery Company, an image of
Edvard Munch's *The Scream* appears
out of the darkness in luminous ink.

**The Murder Mystery
Company** | 1996

Spend Halloween in the middle of nowhere and help solve
a horrendous murder. Call the Murder Mystery Company
on 0161 064 5732 for the gory details.

A Good Cross

A cross is added to the markings
of a football pitch, supporting
Diego Maradona's famous football
quote: "Football isn't a game, nor
a sport, it's a religion."

National Football Museum | 2016

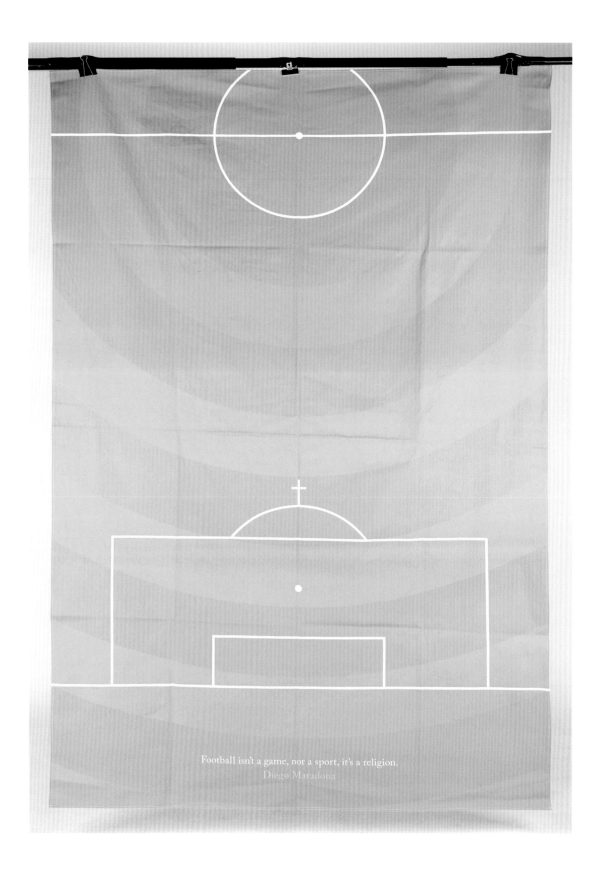

Football isn't a game, nor a sport, it's a religion.
Diego Maradona

Back to Front

Double-sided, self-promotional posters
for the photographer Paul Thompson,
which folded and mailed. We liked the
idea of seeing both sides, though they
weren't necessarily the same person.

Paul Thompson Photography | 2007

 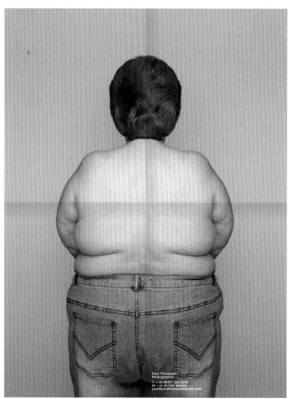

Changing Rooms by Fiona Candy
......................................
Pre-General Election, visitors used
the polling booth—the ultimate
'changing room'—to express their
views on individuals and issues
at first sight, and then again, when
they'd learnt more about them
during the course of the exhibition.

PR1 Gallery | 2004

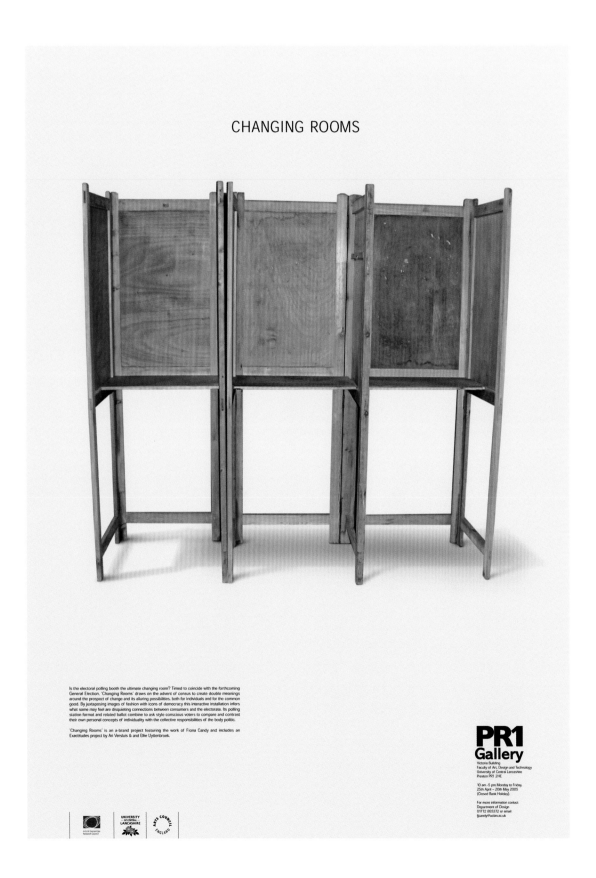

Denim by Fiona Candy
...
An exhibition about denim and how
it moulds itself to the human body. Like
a famous shroud maybe?

PR1 Gallery | 2004

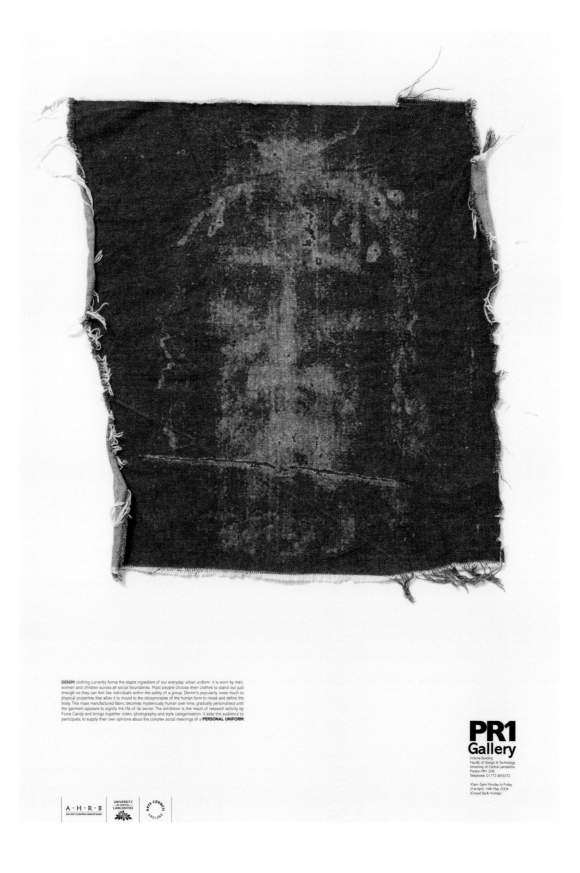

DENIM clothing currently forms the staple ingredient of our everyday urban uniform. It is worn by men,
women and children across all social boundaries. Most people choose their clothes to stand out just
enough so they can feel like individuals within the safety of a group. Denim's popularity owes much to
physical properties that allow it to mould to the idiosyncrasies of the human form to reveal and define the
body. This mass manufactured fabric becomes mysteriously human over time, gradually personalised until
the garment appears to signify the life of its owner. The exhibition is the result of research activity by
Fiona Candy and brings together video, photography and style categorisation. It asks the audience to
participate, to supply their own opinions about the complex social meanings of a **PERSONAL UNIFORM**

**PR1
Gallery**
Victoria Building
Faculty of Design & Technology
University of Central Lancashire
Preston PR1 2HE
Telephone: 01772 893372

10am–5pm Monday to Friday
21st April – 14th May 2004
(Closed Bank Holiday)

Blow Your Own
..

In 1992, Robert Walker's photographic
work dominated the prizes at The Roses
Creative Awards, but many of those
who had commissioned it failed to credit
him. We helped redress the balance.

Robert Walker Photographer | 1992

Wanted by disgruntled
photographer due to
lack of credits in 92
Roses Awards (7 glds ,
4 slvrs, 2 brnze inc.
best use of photography)
contact Robert Walker
phone **061-798-8181**

From Life Drawing to Letter Spacing
..
Designed to accompany a talk by
Ben Casey reflecting on the importance
of teaching traditional skills at art
school. Or not?

The Typographic Circle | 2016

Wit is to humour what literature is to journalism. Wit endures. Wit can serve any purpose no matter how high or low.

There's been a significant lack of wit in British graphics recently. This simple A4 notepad has wit in abundance. It's not for the most promising of clients: Dave Warburton is an 'environmental education consultant' from Scotland. And yet a simple visual allusion to Mr Warburton's profession creates a memorable piece of communication.

On the bottom third of each page, the ruled lines are bent to form a contour map of the kind we all remember from school geography lessons. It's not the kind of visual pun that smashes you over the head and demands a huge guffaw, but it's just enough to raise a gentle smile each time you see it. Lovely.

Patrick Burgoyne Editor, *Creative Review*

promotional items

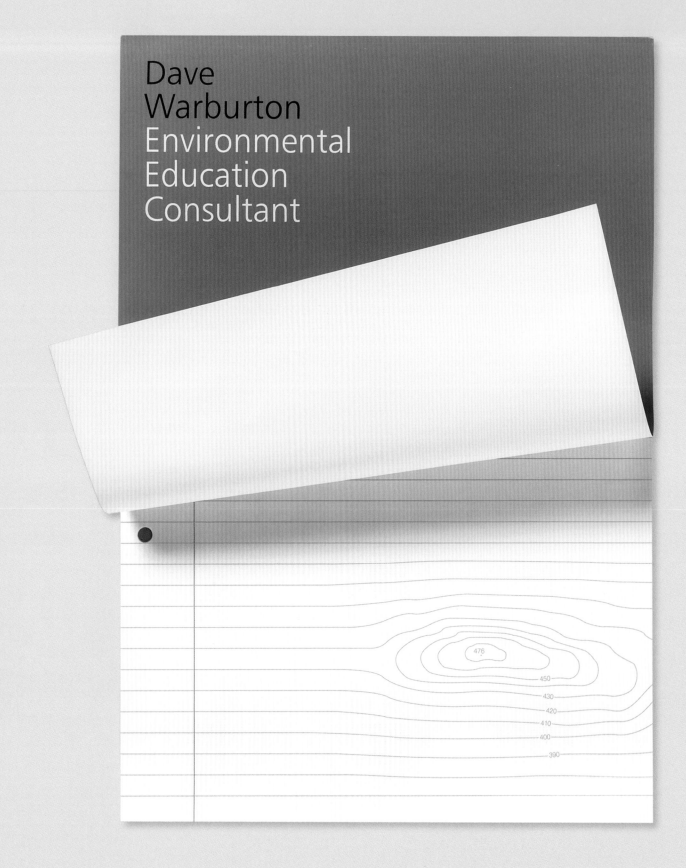

Dave
Warburton
Environmental
Education
Consultant

Bending the Rules
..

We were so pleased with the notepad
that we did for one of our designer's
father, Dave Warburton, we decided
to produce one of our own. This time
we'd push the concept further...

The Chase | 2005

and further....

A Case of Mistaken Identity
...

Getting the buy-in of staff is an important part of rebranding yet, surprisingly, often overlooked. To encourage all the employees of Greenalls Brewery to get involved, they needed to study the new visual identity in order to solve a 'Whodunnit' competition. The prize? A weekend in London with tickets to see Agatha Christie's *The Mousetrap*.

Greenalls Brewery | 1987

IN THE SAFETY of their stolen Morris automobile, the two men stared at the diamonds they had taken. As Grünhalle continued to gaze, dazzled, the other eased out his gun. Gripping it by the barrel, he hit the man beside him. The luckless accomplice toppled silently from the car.

Methodically, the man with the gun picked up the scattered diamonds before driving away, leaving his partner for dead.

Two weeks later the courtroom was hushed as the judge passed sentence.

"William Henry Wilderspool. This court has found you guilty of the robbery of the Montgomery diamonds. You are hereby sentenced to 12 years' imprisonment."

Still protesting his innocence, the prisoner was led from the dock.

At the back of the courtroom, a man who had been watching the proceedings intently, rose and limped towards the door, his face betraying no emotion.

Even as his cell door was closing, Wilderspool continued to deny his guilt.

"No good complaining to me, mate" grunted the prison warder. "Besides, you was seen running off with the jewels by half a dozen witnesses. How do you explain that?"

William's explanation would have fallen on deaf ears. What jury in the land would believe that he had been set up? – Impersonated by his own twin brother!

There was no denying, life had certainly been more comfortable since the robbery, mused Bill Baxter, the Montgomery's chauffeur. A bottle of stout on a Saturday night and enough put by for that little croft in the Highlands. Just for passing on a few tips to a pair of shady mates.

He'd suffered a few pangs when the Earl passed away so soon after the robbery, but the old man did have a heart condition – could

The luckless accomplice toppled silently from the car.

have popped off any time, the doctors said. Still, it didn't seem right the son should be left with nothing but debts now the diamonds had disappeared. His conscience began to prick.

He'd heard on the grapevine that Wilderspool was due for release a few days earlier than expected. Time to make amends and retrieve a certain family heirloom. He determined to find the stolen diamonds and return them to young Montgomery, their rightful owner.

A couple of days earlier than the official parole date, William Wilderspool was released from prison. Those few days made a big difference to William – he knew that his brother, Walter, didn't expect his release until at least the following week. He'd had many a long hour in which to plan his revenge. This time it would be Walter who would pay – the roles would be reversed. He, William, would pass himself off as his brother, the ex-landlord of the Mooncalf Inn, soon to begin a new life in Australia. The real landlord would disappear. Once and for all.

William was not the only one to have waited impatiently for the last 10 years to pass. Two other people had also been biding their time, anticipating the day when William would lead them to the diamonds.

For no-one knew that William had been framed over the robbery of the diamonds, he appeared as guilty to those two as he had seemed to the judge and jury.

Meanwhile, at the Mooncalf Inn in Ordley, Lancolnshire, Walter Wilderspool, the landlord, was sitting in his favourite armchair watching the dusk set in. Shame his last Christmas in England wouldn't be a white one – there'd be no snow where he was going, that much was certain. No use getting maudlin though, he must keep in good spirits for the evening's farewell party. That extra beer he'd ordered should make sure the send-off went with a swing.

Abruptly, Walter's reverie was disturbed by the study door opening. In burst his daughter Wilma.

"I'm not going to Australia with you father!" Walter was quite taken aback by this bombshell.

William Wilderspool, eager for revenge.

TO MARK the launch of our new corporate identity, we're holding a murder mystery competition for amateur [...]

If you're able to solve [...] identity, you could win a weekend for two at a well-[...] travel; dinner in a first class restaurant and a ni[...] st famous Whodunnit of them all: Agatha Chri[...]

To help you with th[...] d certain exhibits, each holding a clue to the [...] statement from Tommy St. Helens, a private d[...]

When you've wor[...] closed postcard and send it by the internal m[...] er will be the first correct entry drawn from [...] at the latest on Friday 8th January 1988.

The name of the w[...] th an explanation of the case, in the January edition of the Greenal[...] ews.

The Rules

This competition is open to all Greenall's employees (staff and works) at Wilderspool Brewery. Only one entry may be made by each person. Entry is free. The organizers' decision is final. No correspondence can be entered into.

221

..

Sometimes the smallest of jobs can
turn out some real gems. Pull out the
business card and watch the pole spin.

Karl's Barbershop | 2000

We were asked to come up with
a statement and marque that would
make the old county boroughs
that found themselves in the new
Greater Manchester Metropolitan
District feel more connected.
We thought a touch of Mancunian
cockiness would do the trick.

Marketing Manchester | 2006

Great Britain.
Greater Manchester.

Grass-roots Diary
...

When it launched its ethical positioning,
The Co-operative Bank thought it was
important that every branch should be
involved at grass-roots level. This diary
was sent to managers to make them
aware of national events, and give them
space and ideas for planning their
own community involvement.

The Co-operative Bank | 1992

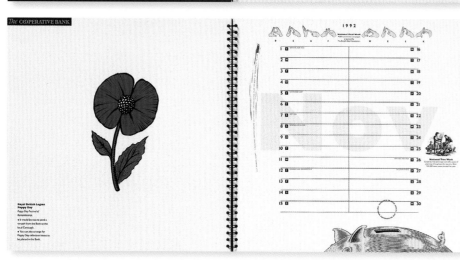

The Year of the Dog Diary
..

With a dogs' home for a client, the Chinese Year of the Dog was just too good to miss, hence the diary. The page marker becomes a tail, together with the tale of Chinese animal years, and shaggy dog stories about the notable and notorious.

Manchester & Cheshire Dogs' Home | 2006

British Bulldog Sir Winston Churchill was a British statesman, best known as the Prime Minister of the United Kingdom during the Second World War. Churchill fought with the British Army in India and the Sudan, and as a journalist he was captured in South Africa (where his dispatches from the Boer War first brought him to public prominence). He became the member of Parliament for Oldham in 1900 after winning the seat in the general election.

His early political career earned him many enemies, but his stirring speeches, bulldog tenacity and refusal to make peace with Adolf Hitler made him the popular choice to lead the people of Great Britain through the Second World War. Churchill is generally regarded as one of the most important political leaders in both British and world history.

Ironically, he lost his premiership two months after Germany's surrender, when the opposition Labour Party took majority control of Parliament.

For most of his life Winston Churchill suffered from depression. He called his dark moods his 'black dog'.

IMAGE: BRITISH PRIME MINISTER WINSTON CHURCHILL, 1947

NOVEMBER

WED 1

THU 2

OCTOBER

31 TUE

JANUARY

31 TUE

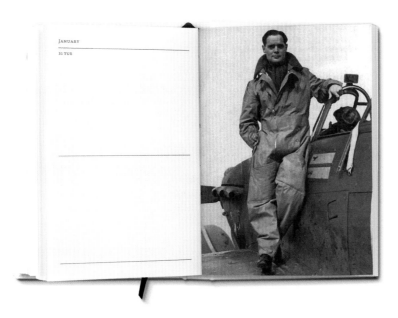

Photographer's Diary
.......................................
A simple cut-out handle transformed
Robert Walker's diary into a portfolio.

Robert Walker Photographer | 1995

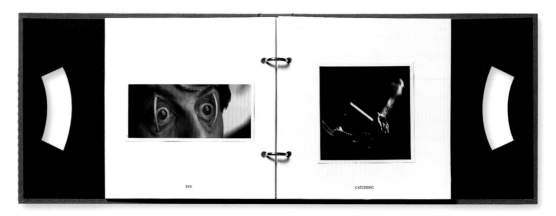

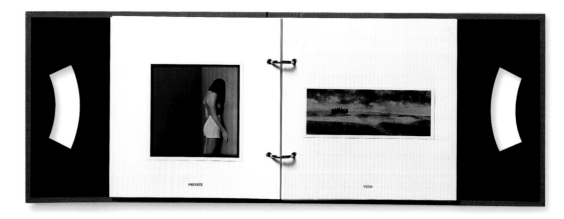

Measure Invitation
...

This invitation to an art installation
hinted at how the space was cleverly
divided up, in order to transform an
industrial unit into areas that were full
of surprises. The wording had also to
be precise—1 metre long to be exact.

Fiona Candy | 2005

Prospectus
..

Poster promoting all the courses at
Blackpool College. Rolled up, it is
a taster of the unique experience that
the coastal resort has to offer.

Blackpool School of Arts | 2010

Christmas Chocolates
..

A seasonal box of chocolates mimicking blocks of wooden type held together in what looks like a printers' chase. The individual letters were made with varying strengths of milk to add to its authentic look.

The Chase | 2009

Luvvied and Lost
...
Having just been shortlisted for
an Oscar, we had planned to mail
out a USB of the short film as
soon as the winner was announced.
But when it was announced, we
quickly had to backtrack and add
a little twist to the mailer.

The Chase Films | 2015

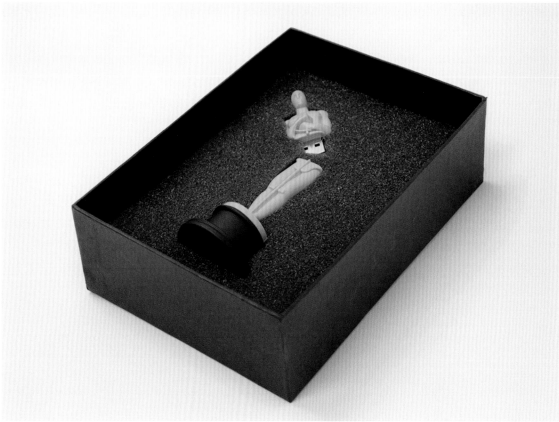

Christmas Brain

It's often said that good creative communication is a result of balancing the differing functions of the left and right hemispheres of the brain. This double-sided banner adds a seasonal dimension to this neurological conundrum.

The Chase | 1996

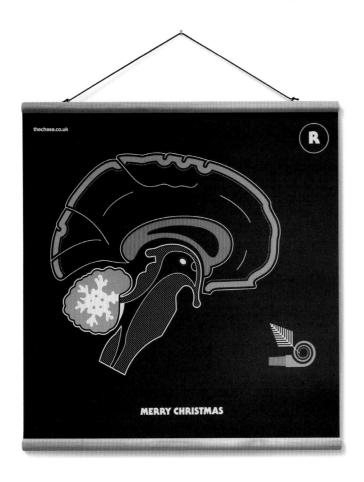

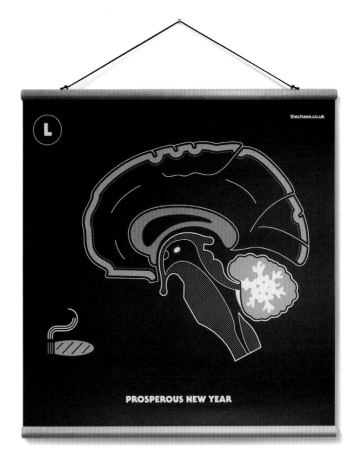

Private View Booklet
..................................

A booklet to accompany the exhibition of photography by George Brooks. Much of pathology is done behind the scenes and this exhibition attempts to capture a group of individuals who are passionate about their work. The booklet cover reveals a series of dots —as if under the microscope—and as the concertina is opened it pulls back to reveal one of the photographs in the exhibition.

Royal College of Pathologists | 2007

The Chase Postcards
......................................
This self-promotional book of postcards
exploits where the letter 'c' falls on the
cover and the slipcase.

The Chase | 2002

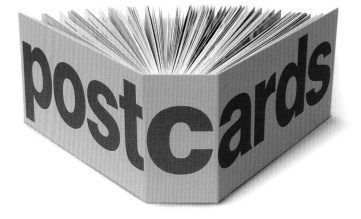

Every once in a while you see a piece of work and say: "That's just fantastic, I wish I'd done that." Great design isn't just about beautiful crafting, nor is it just about clever ideas (although this piece has both), no, great design changes the way you feel about a subject.

This identity for Preston North End gave me a big smile the first time I saw it and all these years on it still does. More than this, it became a benchmark for me in the work I do. It made me think about how I get a similar reaction from a reader or a user whenever I get involved in a design project. I particularly like the 'Boys' Own' illustration style, with my favourite being the shirt-swapping on the compliment slips.

It's just a shame the identity is wasted on Preston and isn't for my own team Derby County!

Jonathan Sands OBE Chairman, Elmwood

stationery

13

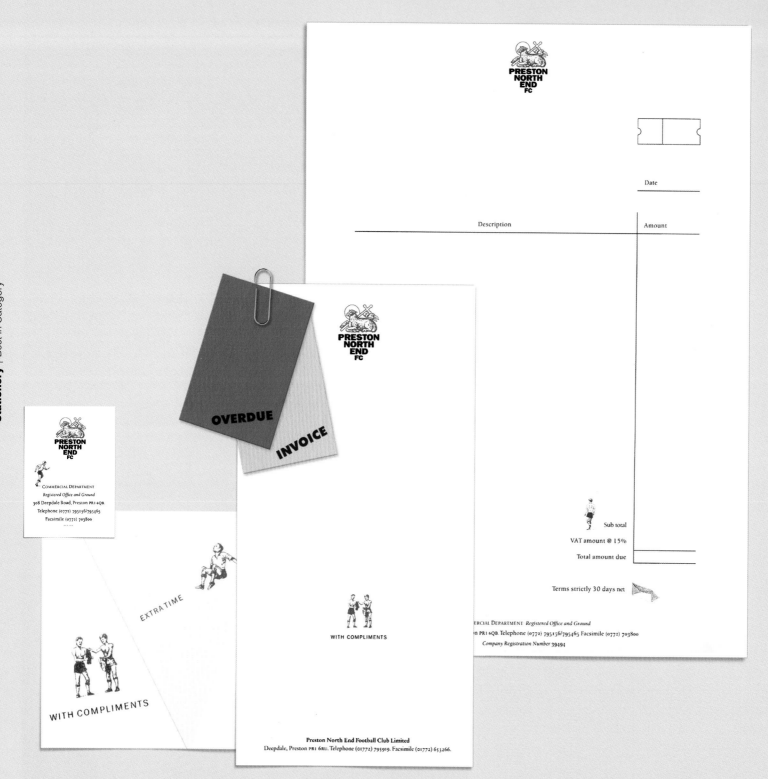

A Spark in the Dark
..

Here's a handy card to keep safe for
the next time there's an electrical
emergency. Paul's number glows in
the dark.

Paul Wenman | 2008

Shot in the Dark
...
There's a still-life photographer who's
meticulous in his attention to lighting
and detail. That's him, under the
black cloth.

Thomas Pollock Photographer | 1994

Straight to the Point
..
Shadows cast by this acupuncturist's
needles neatly form the initials of
the organisation.

Manchester Accessible
Acupuncture | 2009

Manchester Accessible Acupuncture Augusta Sevier T +44 (0)1422 846 662
St. James's Square Lic Ac MBAcC Bsc (Hons) M +44 (0)7905 507 224
Manchester M2 6DS Sam Hargreaves www.acupuncturemanchester.co.uk
 Lic Ac MBAcC

All Together, Now
..

This group of product designers who
work individually become integrated
under the same roof.

Alloy | 1999

Now You See It
..

Lygophobia is a 'fear of the dark', which makes it a great name for a designer of lighting. But this stationery appears not to give anything away, until it's held up to the light.

Claire Norcross Lighting | 2002

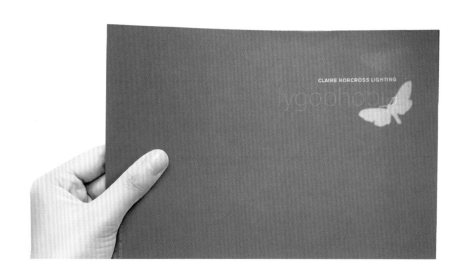

lygophobia

lygophobia

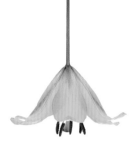

Shine On
..
Here's a brilliant company that will
guarantee bringing gardens to
life, long after the flowers have called
it a day.

Garden Lighting Company | 2006

**Garden Lighting
Company**

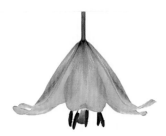

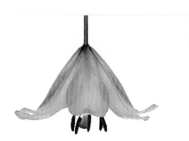

Alison Tickner
Managing Director

m 07702 291082
e alison@gardenlighting.co.uk

Garden Lighting Company
The Croft Haslingden Road Rawtenstall Lancashire BB4 6RE
t '44(0)1706 227525 f '44(0)1706 227525
e info@gardenlighting.co.uk www.gardenlighting.co.uk

Garden Lighting Company
The Croft Haslingden Road Rawtenstall Lancashire BB4 6RE
t '44(0)1706 227525 f '44(0)1706 227525
e info@gardenlighting.co.uk www.gardenlighting.co.uk

Built-in Personality
...
Changing imagery on all his stationery
items reveals a photographer who likes
to put a bit of himself into every shot.

Moy Williams Photography | 2007

 MOY WILLIAMS PHOTOGRAPHY T: +44 (0)161 839 6660
10 Booth Street F: +44 (0)161 839 8300
Salford M: 07836 770977
Manchester E: moy@moyphotography.com
M3 5DG W: www.moyphotography.com

 MOY WILLIAMS PHOTOGRAPHY T: +44 (0)161 839 6660
10 Booth Street F: +44 (0)161 839 8300
Salford M: 07836 770977
Manchester E: moy@moyphotography.com
M3 5DG W: www.moyphotography.com

VAT REG NO. 732 4036 64 CO. REG NO. 3777240

There in Black and White
...

An audited selection from the earliest days of photography indicates the huge diversity of this organisation's important database.

North West Film Archive | 1997

Boys at Stockport Market c.1910 – film still

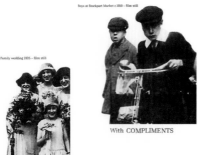

Family wedding 1925 – film still

With COMPLIMENTS

With COMP

The North West Film Archive is a part of The Manchester Metropolitan University

North West FILM ARCHIVE
Saving our region's
filmed heritage

Minshull House

47-49
Chorlton Street
Manchester
M1 3EU

Telephone
0161 247 3097

Facsimile
0161 247 3098

Curator
Maryann Gomes
BA ATC

The North West Film Archive
Charitable Trust is a
Registered Charity,
No. 1030912

Patron
David Puttnam CBE

Maryann Gomes
BA ATC

The North West Film Archive
Charitable Trust is a
Registered Charity,
No. 1030912

Patron
David Puttnam CBE

The North West Film Archive is a part of The Manchester Metropolitan University

Publicity stunt. Majestic Cinema, Macclesfield 1936

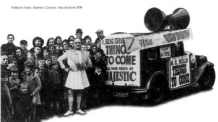

Press RELEASE

North West FILM ARCHIVE
Saving our region's
filmed heritage

Minshull House

47-49
Chorlton Street
Manchester
M1 3EU

Telephone
0161 247 3097

Facsimile
0161 247 3098

Curator

North West FILM ARCHIVE
Saving our region's
filmed heritage

The North West Film Archive
Charitable Trust is a
Registered Charity,
No. 1030912

Patron
David Puttnam CBE

North West FILM ARCHIVE

Stockport Bus Workers 1941 – film still

North West FILM ARCHIVE

Blackpool Holidaymaker 1955 – film still

North West FILM ARCHIVE
Saving our region's
filmed heritage

Minshull House
47-49 Chorlton Street
Manchester
M1 3EU

Telephone 0161 247 3097
Facsimile 0161 247 3098

The North West Film Archive Charitable Trust
is a Registered Charity, No. 1030912

Patron, David Puttnam CBE

The North West Film Archive is a part of The Manchester Metropolitan University

The North West Film Archive is a p

The North West Film Archive is a part of The Manchester Metropolitan University

Two in One

An unusual combination of a ground-floor hair stylist and a first-floor seafood restaurant sharing the same premises. And the same name.

September Brasserie & Hair Studio | 1996

SEPTEMBER
Brasserie

15-17 Queen Street Blackpool
Lancashire England FY1 1PU
Telephone 01253 23282

Vat No. 531 66 19 52

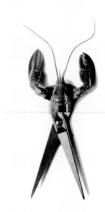

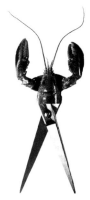

SEPTEMBER
Hair Studio

15-17 Queen Street Blackpool
Lancashire England FY1 1PU
Telephone 01253 28394

Vat No. 401 187 490

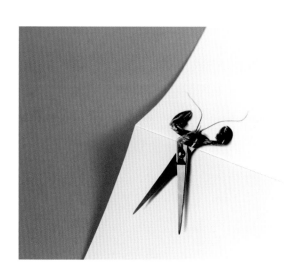

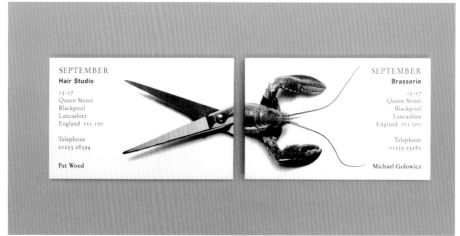

SEPTEMBER
Hair Studio

15-17
Queen Street
Blackpool
Lancashire
England FY1 1PU

Telephone
01253 28394

Pat Wood

SEPTEMBER
Brasserie

15-17
Queen Street
Blackpool
Lancashire
England FY1 1PU

Telephone
01253 23282

Michael Golowicz

Tuck In
..
Proper etiquette meets paper
engineering for this personable
catering company.

Tuck-In Caterers | 1992

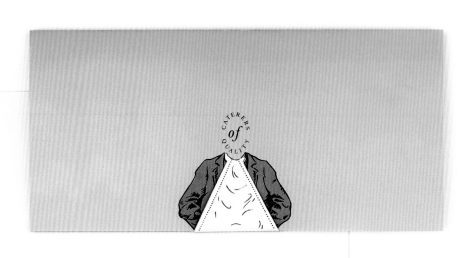

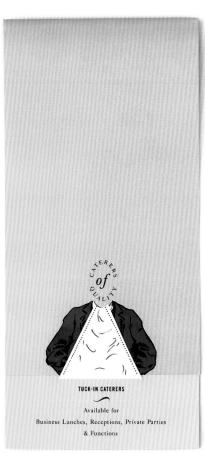

TUCK-IN CATERERS

15 Hammett Road
Chorlton Green
Manchester
M21 1HY

061-860 5054

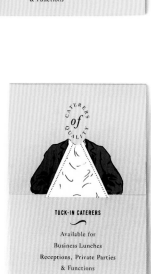

Available for
Business Lunches
Receptions
Private Parties
& Functions

One Way
..
Stuck in a rut? Feel like a career break?
This company has all the answers.

Visto | 2006

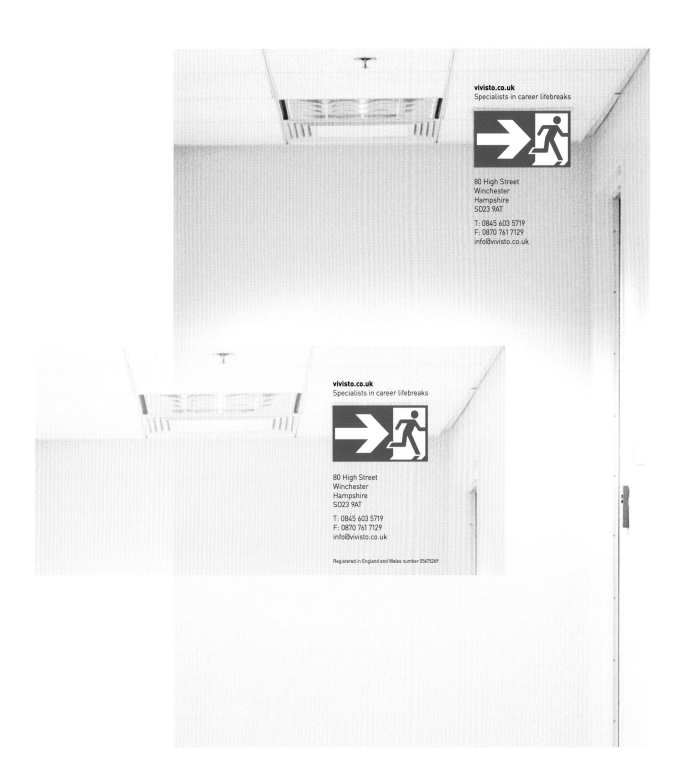

This logo for the Great Room, Preston North End Football Club's dining room, scores on various levels.

It's economic. The idea is pared down to all that is necessary, two circles and a line.

It's rewarding. When decoded, there is a wonderful feeling of solution.

It's satisfying. Because day-to-day intelligent design such as this is such a rarity.

These qualities seem to me exactly what a club restaurant would want to promote.

David Stuart Co-founder, The Partners

symbols & logotypes

14

Accord Mortgages

How to spot the incidental in a capital 'A' and a lowercase 'd', then turn the key.

Yorkshire Building Society | 2002

blinkbox

In partnership with Tesco, this home entertainment service offers movies, music and books across various digital platforms. Within this lowercase 'b' there are three separate symbols. A play button, a speaker and a book. If you can't see them, the answer is on page 45.

Tesco | 2014

Brand Mirror

Here's a brand consultant who listens carefully, understands perfectly and feeds back honestly.

Sarah Ilsley | 2011

Burmatex

A carpet manufacturer with great products had undersold itself for too long, concentrating on the trade market. To aim higher, towards specifiers and private consumers, the company needed to look lighter on its feet.

Burmatex | 2005

Cidu

The Creative Industries Development Unit at the University of Central Lancashire wanted a distinctive look to its acronym. Get the scalpel out again.

University of Central Lancashire
2001

Conception

A marketing business trusted for fertilising brands with its strategic thinking.

Carole Myers | 2002

Certificate Stamp

Across all creative professions D&AD yellow pencils are a coveted achievement. This pencil shaving is a stamp of authority for the star students who successfully complete one of its courses.

D&AD | 1998

Design Yorkshire

Another star, this time for a marque that unifies the design community of the only county that begins with the letter Y.

Design Yorkshire | 2005

Ex-Boxers Association
..

This logotype requires the viewer to provide the punchline.

The Preston and District Ex-Boxers Association | 1992

Eye Trigger
..

This online photo library has a reputation for reacting quickly when clients request a search.

Eye Trigger | 2006

First Street
..

A logo that is shorthand for this development's name but also gives an impression of one contained community.

Ask Developments Ltd | 2012

Halliwell Landau
..

Parentheses (brackets we call them) often appear to be the glue holding legal text together. For this large law firm they are the device combining its specialist departments.

Halliwell Landau Solicitors | 2000

THE PRESTON AND DISTRICT EX-BOXERS ASSOCIATION

eyetrigger

1ST ST.

halliwell[]andau

halliwell[commercial litigation]landau

halliwell[intellectual property]landau

Freedom Travel
...

Admitting that their old marque with its drawing of a seagull was now looking dated, it was decided a little surgery was called for. We took the brief literally and took a scalpel to it.

The Co-operative Travel | 2008

Hostage Films
..
This production company specialises
in making commercials. The solution
is in the name, which we followed
right through to the letter.

Hostage Films | 2006

ID Distribution

..

This company classifies and circulates television programmes with, in their own words, meticulous attention to detail from beginning to end.

ID Distribution | 2004

Karen Girling Reflexology

..

We love a lowercase 'g' (see Best in Category), so imagine our delight when this opportunity played right into our hands.

Karen Girling Reflexology | 2009

HH Print Management

..

HH are print management specialists. The logo made use of two basic print colours well known to those in the marketing and print industry, cyan and magenta. The overlap emphasises the print process.

HH Print Associates | 2005

Keycutters

..

Precisely.

Keycutters | 2000

Layezee Beds

..

Take a capital L, lay it on its side and you have a bed. Add people it comes to life as the focal point of the brand.

Silentnight Group Ltd | 2004

Leaf Street

A wonderful name for a housing development in Manchester built to the highest environmental standards.

Leaf Street Development | 2003

Manx Telecom

Competing in a tough business, this organisation had worked hard internally, revitalising itself and its products. We positioned a fresh visual appeal to help secure a competitive position within the global market.

Manx Telecom | 2001

Northwest Development Agency

A government body active in regeneration, communication and leisure. The agency covers the five counties of North West England and must be seen to represent each fair and square.

Northwest Development Agency 1999

University of Nottingham

During 1986 the traditional red-brick universities had been threatened with competition from the former polytechnics who had been granted university titles. As a symbol of strong status and heritage, Nottingham Castle became a gift to the University.

University of Nottingham | 1987

Once in Every

Preston Guild is a unique celebration of crafts and trades staged every twenty years. In 2012 the event included an impressive exhibition of work by alumni of UCLan's School of Art, Design and Performance. The name comes from a regional saying that suggests infrequency.

University of Central Lancashire
2012

One Tree

Two artists instigated this project. It had been born from respect for an ancient oak torn from its ground by a freak summer storm. Sections of the tree were delivered to craftmakers and sculptors who made individual works in respect of the tree's life. Photographs of the works became a book in memory of the original oak.

One Tree | 1998

400 Lions

With only 400 Asiatic lions remaining in the world, a compelled London Zoological Society stepped in to help stop their demise. This is the face fronting their campaign.

London Zoological Society | 2015

Preston North End FC

This club is a founding member of the Football League. Its original symbolism is sacrosanct, which is actually fine when that symbol and the name form the natural shape of a sporting badge. And yet it is simple enough to meet the extensive commercial demands of a modern logo.

Preston North End FC | 1991

Year Book 2

The answer to this problem was solved by a well-known mathematical formula.

The Creative Circle | 1987

Symbols & Logotypes

Red Ladder Theatre Company
..

Following a string of terrific production
reviews, the artistic director asked
for an identity to show a company
definitely on the ascent.

Red Ladder Theatre Company
1999

The Lowry
..

An art gallery, two theatres, bookshop,
restaurant and corporate events
venue. All that inside stunning modern
architecture on the waterside at Salford
Quays. Little wonder they asked for
an understated identity.

The Lowry Art & Entertainment
2000

Vi-all-in
..

We were invited to design a marque
for the Typographic Circle's sixth
"All In" show. It was a call for entry with
a difference—each member could
put forward a piece of work that would
be exhibited without going through
a judging process.

The Typographic Circle | 1988

Wakefield Europort
..

On the eastern edge of the Pennines
in Yorkshire, Wakefield is the freight
centre of mainland Europe. Just in case
anyone needs reminding.

Wakefield Europort | 1995

The Woodland Trust
..

This charitable body protects and
regenerates indigenous woodland.
To attract new members and boost its
profile, people had to be persuaded
to walk in and enjoy the woods.

The Woodland Trust |1999

WOODLAND
TRUST

Wilton Express

..

Being asked to design a logo for a
courier company that covered the
length and breadth of the country with
a name like this must have been a gift.
But would this lucky example of
serendipity have caught everyone's
eye? As a golfer once said, the more
you practise the luckier you get.

Wilton Express | 1988

Wallflower

..

We added a twist to the double Ls
to symbolise the "crops" that are used
by photographers when composing
an image.

Robert Walker Photographer | 2013

York St John University

..

In 2006 York St John had been a college
for over 170 years. On their lovely
leafy campus, they celebrated growing
into university status with a new
visual identity.

York St John University | 2006

3CV

..

One ethical marketing company
based on three core values.

3CV Marketing | 2001

The Chase have created many brilliant images over the years but even so, for me, this category had a clear winner: *The Bigger Issue* calendar.

Not content with creating a bunch of calendars that were crammed with beautiful big, bold, bloody, black-and-white illustrations, they insisted that the individual images went on to make up the biggest piece of Point of Sale ever.

I've been told that they never knew quite how it would work until the illustrations arrived and they were stuck together on the wall.

Brave work for a great cause.

Mark Denton Creative Director, Coy! Communications

use of image

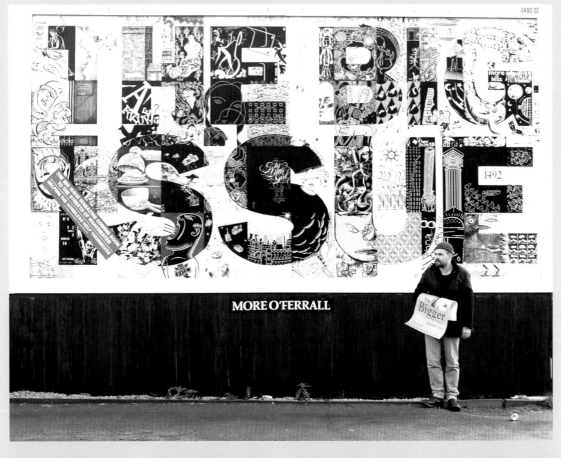

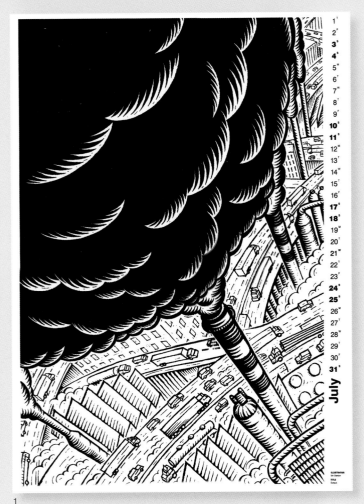

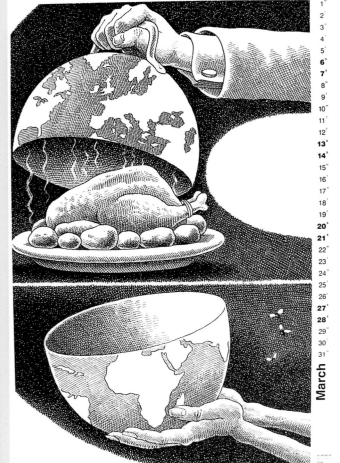

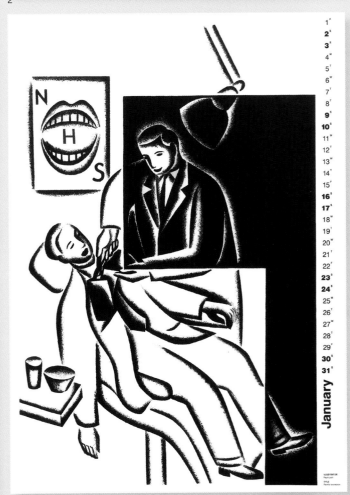

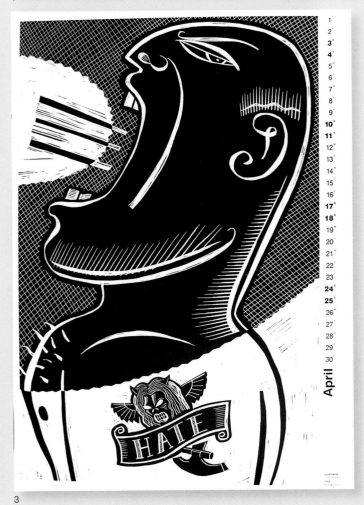

Illustrators

1. Ian Saxton
2. Peter Brookes
3. Shane McGowan
4. Paul Leith

1

2

3

4

Street Life
...

This annual review for Manchester
& Cheshire Dogs' Home likens the
predicament of homeless dogs to that
of homeless people. Emotive
photography printed on large-sized
newsprint stock enhanced the feeling
of edginess and danger. Photography
by Guy Farrow.

**Manchester & Cheshire Dogs'
Home** | 2009

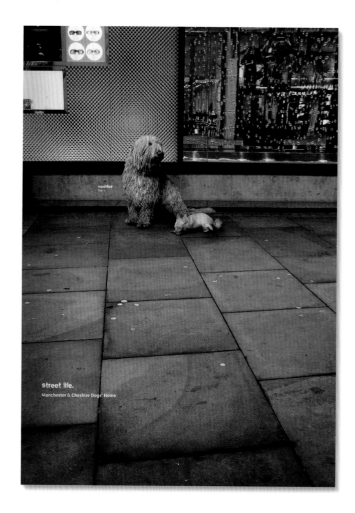

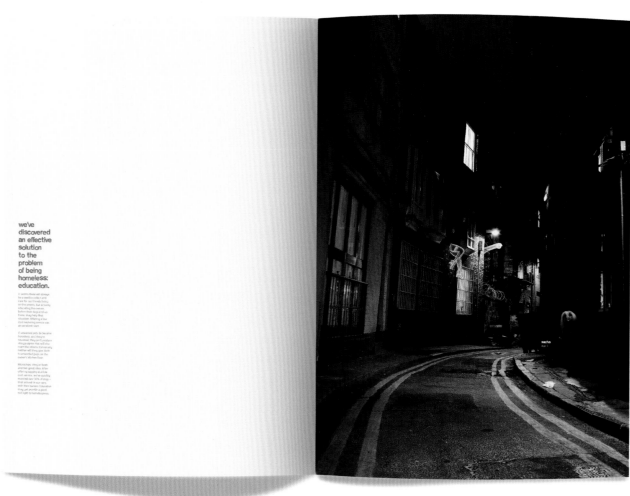

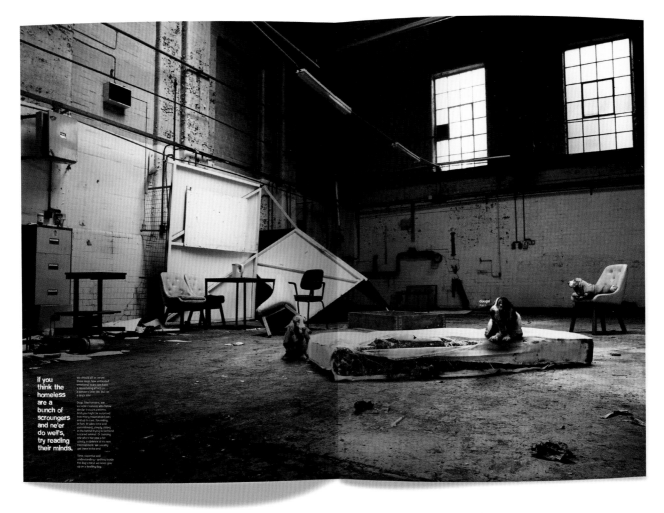

if you think the homeless are a bunch of scroungers and ne'er do well's, try reading their minds.

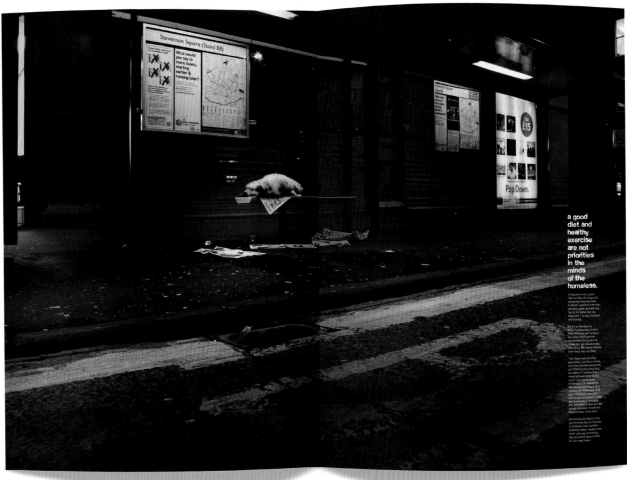

a good diet and healthy exercise are not priorities in the minds of the homeless.

..

A series of individual beer mats, each
mat representing a local ale with
an individual heritage. Placed together,
they present a wider view of this
brewery's provenance. Illustrations
by Bill Sanderson.

Thwaites Brewery | 1996

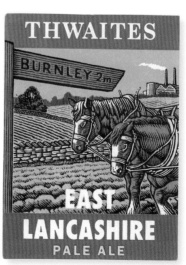

Awards Annual

These are section divider images from
The Creative Circle Awards annual.
Overall winners in each section are
merited with a Gold, Silver or Bronze
badge. Illustrations by Dennis Leigh.

The Creative Circle | 1987

The United Nations declared 2009 to be the Year of the Gorilla, estimating as few as 720 mountain gorillas survived inside their natural habitat. Working with BBC Wildlife we produced this fundraising calendar that featured a portrait of our distant cousin.
As each month passes the image gradually disappears. By December it becomes ghost-like, printed only in a clear varnish.

BBC Wildlife | 2009

The BBC Wildlife Fund is working flat out to help save endangered species all around the world. Why the haste? Because of the fearful statistic that almost one in four mammals face the grim prospect of disappearing forever.

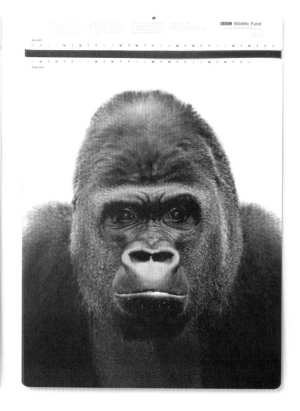

The Great Fire of London
...

In 1666, what started as a small fire
in a baker's on Pudding Lane soon
devastated the City of London.
These linocut images by Christopher
Brown are from our promotion for an
exhibition at the Museum of London.
This marks the 350th anniversary of
the terrifying event.

Museum of London | 2016

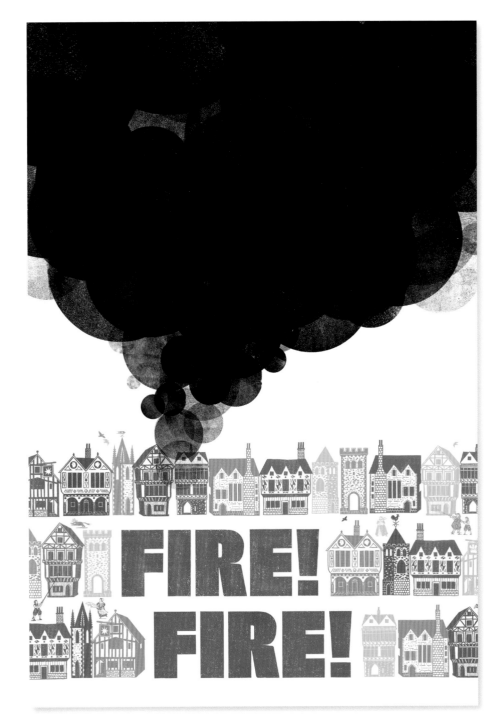

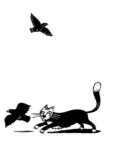

Bringing Work to Life
..
As well as office buildings, First Street
will be the home to Manchester's
new world-leading multi-arts centre, a
new brand of hotel, artisan restaurants,
shops, student accommodation
and a supermarket. We developed
the brand strategy, identity and
photography across multiple
applications that supported the
positioning of "Bring work to life."
Photography by Paul Thompson.

Ask Developments Ltd | 2013

Gallery Week
..

Gallery Week was an initiative by North West Arts, who were keen to increase visitor numbers to their local galleries. The campaign featured the most common reasons stated by locals as to why they didn't go to galleries, eg "I don't know how to look at Art" or "Why don't artists produce work suitable for people's homes?" We designed a leaflet and an accompanying series of 'picture frame' posters that addressed people's concerns.

North West Arts | 1996

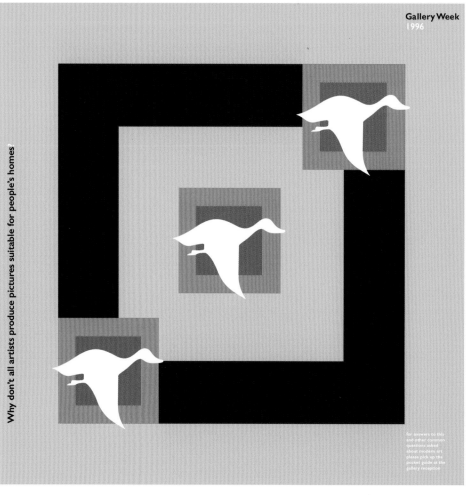

In the Frame
..
This book for a photographers' agent
folds into a free-standing frame. The
images inside are of photos taken
by individual photographers and can
be easily detached. Place your favourite
inside the frame and admire.

The Miss Jones Agency | 2006

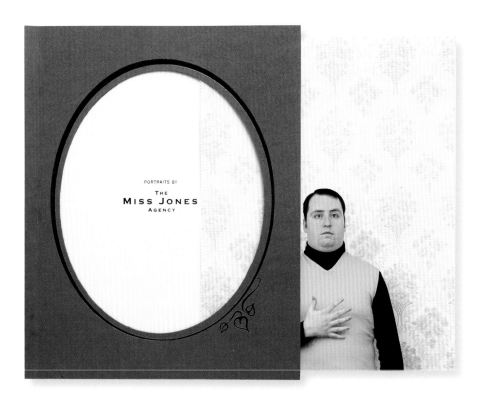

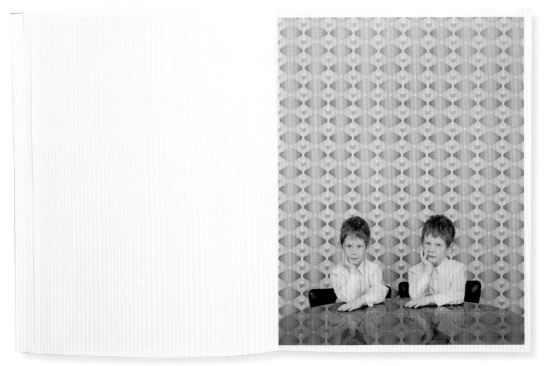

Two Companies, One Belief

Buttress are two architectural practices sharing a single philosophy: buildings have to be shaped by their context, function and surroundings. They asked us if it was possible to create a cohesive identity reflecting that singular vision. Our response was an image that is not a 'B' but the space left behind when the letter is taken away.

Just like the buildings Buttress make, it's a mark formed by its context and surroundings. And to illustrate their building sector diversity, this mark fits into any visual context defining its function.

Buttress | 2015

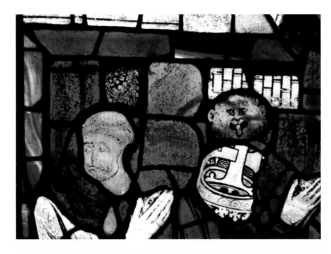

Buttress B

Arts and Culture

Walk, Pedal, Drive
..

Transport for London has a Business
Engagement Team. They encourage
organisations to operate flexible working
hours to ease pressure on older, more
conventional commuting times. The
team are split into different districts and
alternative methods of getting around.
They also wanted a single identity
that could be adapted for each of their
needs. Bicycle chains and cogs,
shoes, exhausts and tyres become
recognisable buildings on London's
wide skyline.

Transport for London | 2014

We Are Ingenious
···
A cinematic mood for a company
that shows other companies how
to project and organise their finance
requirements.

Ingenious | 2005

Falmouth University Prospectus
...

Of course it's lovely to study at a university that's settled on the beautiful Cornish coastline. But let's not forget the absolute reason you're there is to study. So this prospectus for Falmouth University became a gallery of the work students are producing, illustrating what its alumni have gone on to achieve. A set of postcards was produced, designed to be inserted into two slits in the cover. This allowed the prospectus to be customised for any event. Photography and Illustration by Falmouth alumni.

Falmouth University | 2015

Six of the Best
..
Gritty shots of UK World Champion
boxers are featured in this limited-
edition set. Sold through Boxing News,
the collection raised money for
boxing charities. Photography by
Mat Wright.

Boxing News | 1996

GARY JACO GLASGOW
FORMER UNDEFEATED
BRITISH, EUROPEAN & WI
WELTER

6 OF THE BEST
A LIMITED EDITION
PRESENTATION FROM BOXING NEWS
CONSISTING OF
SIX PHOTOGRAPHIC
PORTRAITS OF OUTSTANDING
BRITISH BOXERS

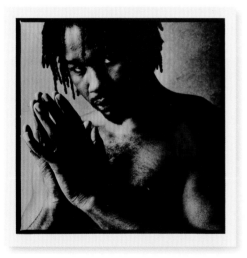

LONDON
LENNOX LEWIS
CURRENT WBC HEAVYWEIGHT
CHAMPION

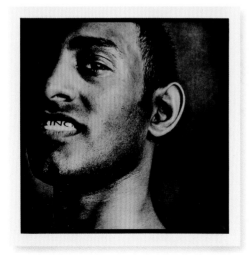

NASEEM SHEFFIELD
CURRENT UNDEFEATED WBO HAMED FEATHERWEIGHT
& FORMER UNDEFEATED IBF CHAMPION

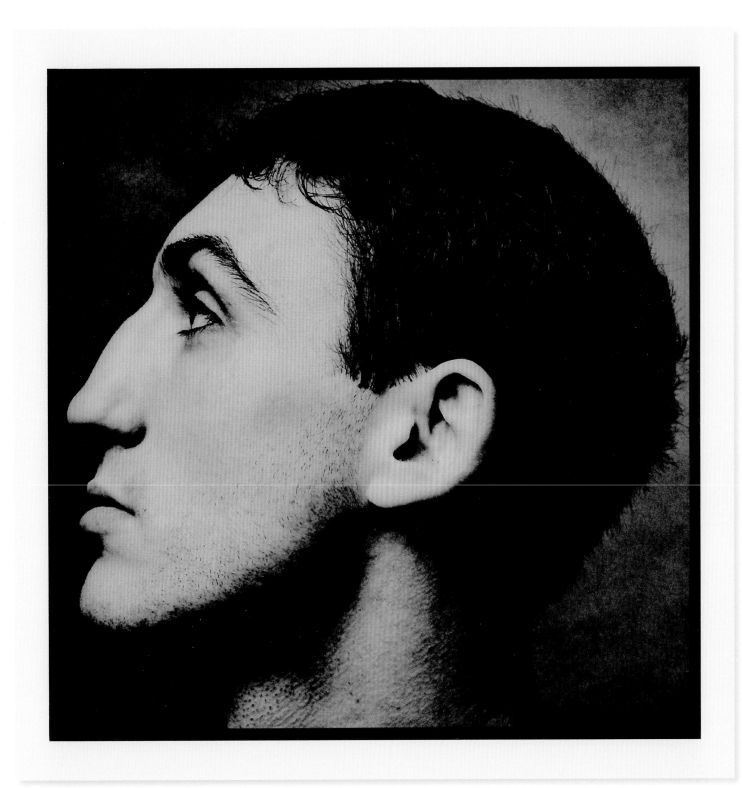

A Farmers' Tale

This special millennium pack of stamps paid homage to the Farmers' Tale, a story of hardy people who have worked the land to feed the nation through every generation. Illustration by Stuart McReath.

Royal Mail | 1999

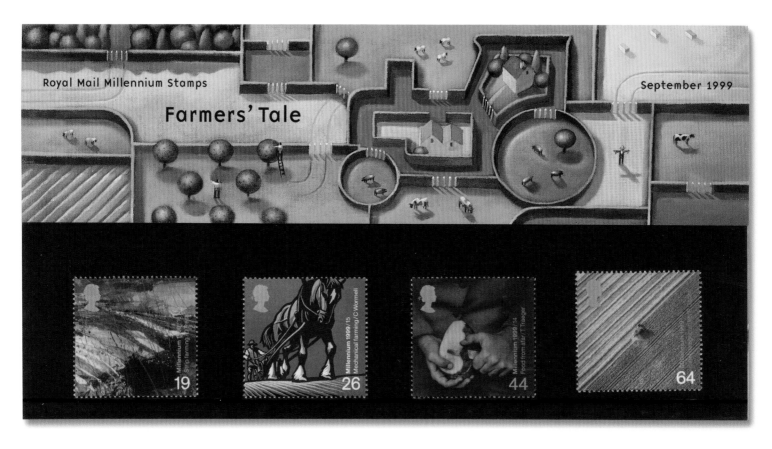

Celebrating the Silver Screen
......................................

"100 Years of Going to the Pictures" was a commemorative set of special stamps from Royal Mail. The images overlap the perforations in a playful imitation of the flickering that occurred on screens during early movies.

Royal Mail | 1996

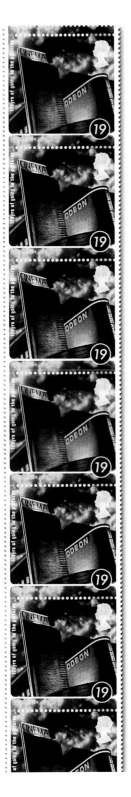
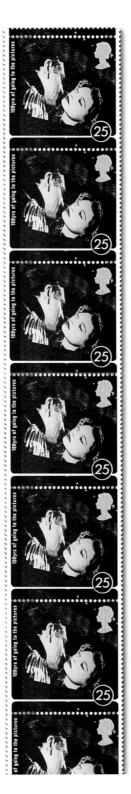

Great Fire of London Stamps

The Great Fire of London stamps were issued to mark the 350th anniversary of the fire. The stamps retell its dramatic story in a graphic comic book style, starting from where the fire breaks out in a bakery on Pudding Lane to Christopher Wren's presentation to the King of his plans to regenerate the city. Illustration by John Higgins.

Royal Mail | 2016

Comic Strip Stamps

The final printed edition of the *Dandy* had been issued in December 2012, the comic's seventy-fifth anniversary. Royal Mail decided to celebrate Britain's longest-running bunch of cartoon characters with this special set of the nation's favourite British Comics. Many of the covers used as images are from the first issues.

Royal Mail | 2012

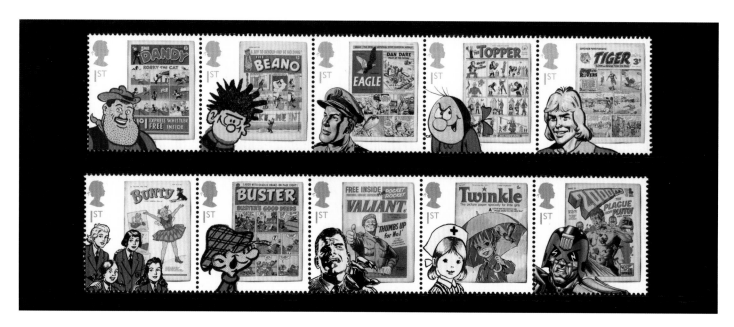

The Chase acknowledgements:

The Dandy, The Beano, The Topper, Bunty, Twinkle and associated characters used herein © DC Thomson & Co Ltd 2012; Eagle comic and Dan Dare character reproduced with kind permission of the Dan Dare Corporation Limited; Roy of the Rovers character, Buster comic and character © Egmont UK Ltd; Tiger comic, Valiant comic and The Steel Claw character © IPC Media 2012; Judge Dredd & 2000 AD ® & ™ Rebellion A/S.

Online
..

David Hughes is an illustrator we have
worked with on many occasions. We
think he is brilliant and we were
delighted when he asked us to design
his website. The interesting question
was whether David's style, which is
incredibly tactile, would work on a
digital screen. And it did, beautifully.

David Hughes | 2006

I love this one. I am a sucker for anything that is pure type, especially black-and-white and large-format.

I remember this landing on my desk in Clerkenwell over the days that I was negotiating my move to Australia. It feels almost nostalgic to me when I reacquainted myself with the piece just now. I particularly love the cover with the bulging fat font and thin white lines.

It is true Chase style, with a big idea that makes you smile and wish you had done it. All these years later and after many designers' attempts to steal it from me, it sits in my archive closely guarded under the label of "Vince's favourite things, don't bloody touch!"

Vince Frost CEO and Executive Creative Director, Frost Collective

use of type

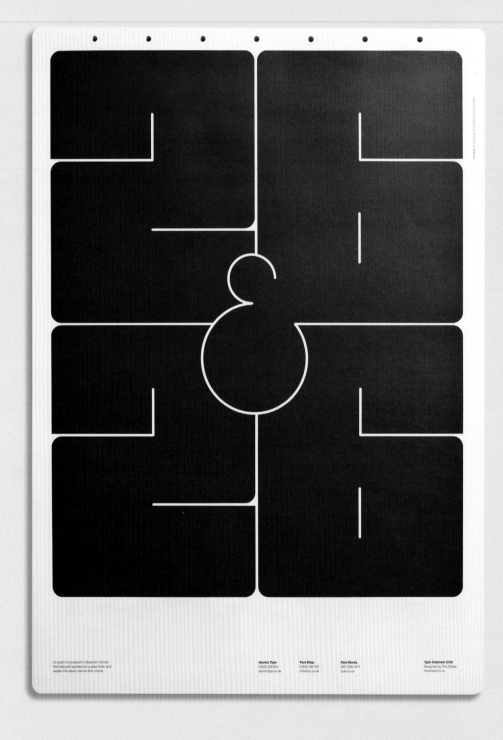

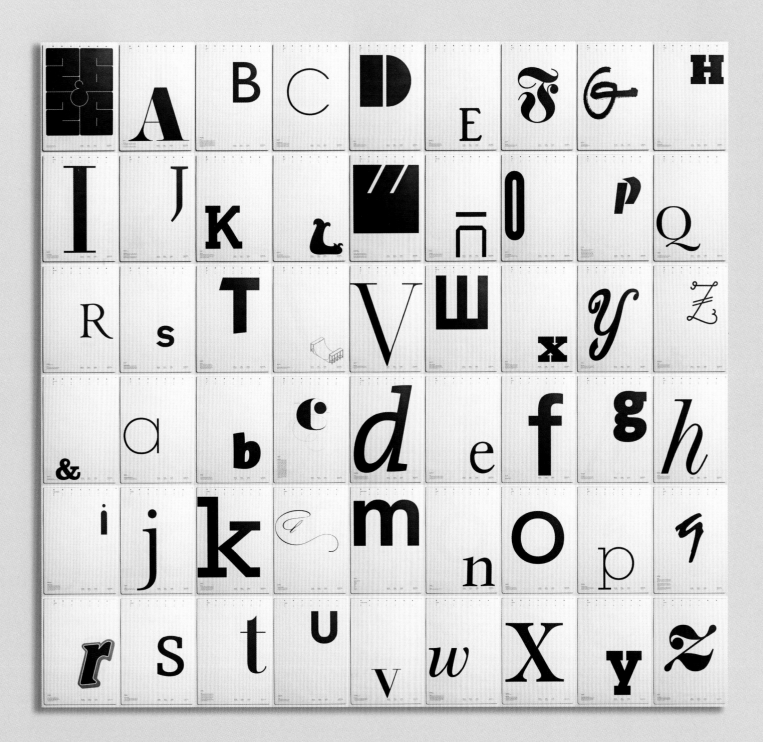

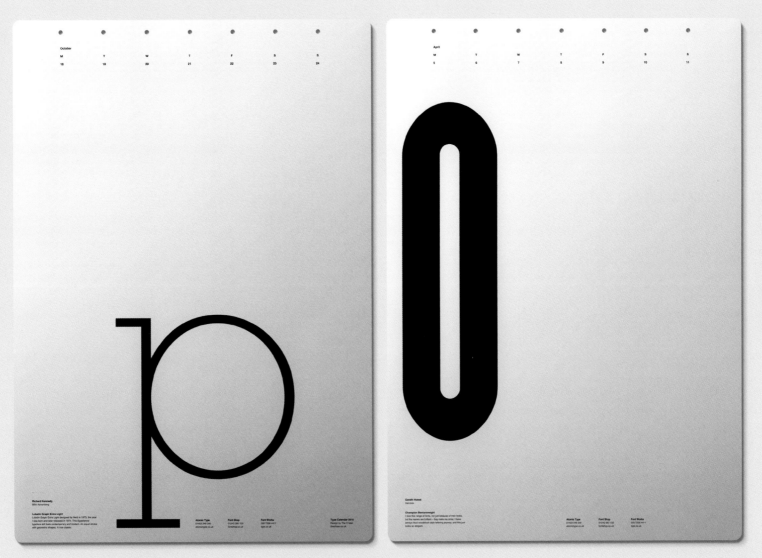

Staffa: A Collaboration

Following in the footsteps of Mendelssohn, Keats and Turner, modern-day artists Ian McKeever and Thomas Joshua Cooper spent time on the Isle of Staffa. This catalogue accompanies an exhibition of work that was inspired by the island. Typographically, we used fonts that were reminiscent of the period to lend historical depth. However, the overall feel of the piece is still modern.

Harris Art Gallery | 1987

THE
STAFFA
project

A Collaboration

IAN McKEEVER AND
THOMAS JOSHUA COOPER

1987

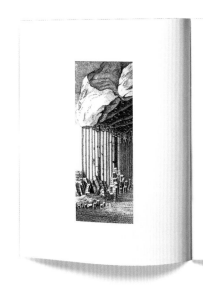

Evolution!

...

The collections of final-year fashion students at the University of Central Lancashire were divided into themes based on how human behaviour has evolved. As the programme for the show had to be printed before the clothes were completed we gave a flavour of the themes through graphic and typographic means.

University of Central Lancashire | 1991

A Word in Your Ear

In the 2004 *D&AD Annual* the dividers
for each category were briefed to
look like record sleeves. We were
asked to work on the 'Radio' section.
For reference, we were given several
photographs of the jury members but
our idea was to represent them only
by their ears. An added dimension
to the concept was to create subtly
a letter within each ear. Luckily there
were eight members, the number
needed to spell out "Radio Ads".

D&AD | 2004

Greeting Card

A seasonal message beautifully
enhanced by lettering artist Nina Hunter:
only when you see who sent it do you
get the sting in the tail.

BASF Pest Control | 2015

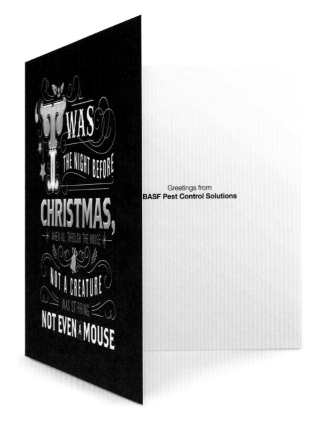

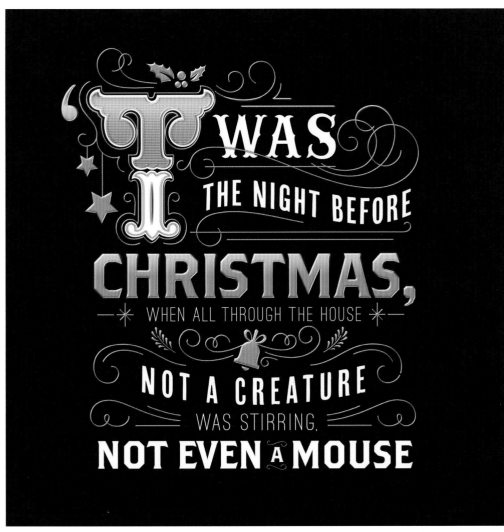

Timeline
..

Lowther Castle & Gardens is a unique visitor experience near Penrith in Cumbria. This place has belonged to one family for over 1,000 years. As part of the overall identity programme we produced this potted history of the family's past. A place then to enjoy a nice cup of tea and a sticky bun while studying 1,000 years' worth of typography.

Lowther Castle & Gardens | 2013

c.1200

An Ancestors of Lowther have been here over 800 years. Their name is taken from the river that runs below the castle.

c.1390

Sir Hugh Lowther builds a peel here.

It is a fortified tower, a family home but with a beacon on top to warn of impending invaders. Scottish armies tried often to take these lands by force.

But to no avail.

1937

THE END OF LOWTHER CASTLE AS A FAMILY SEAT.

THE 5TH EARL'S LIFESTYLE

— BRINGS —

FINANCIAL DIFFICULTIES

TO A POINT AT WHICH IT IS **ABANDONED**. THE GATES ARE LOCKED AND THE GARDENS HIDDEN FOR OVER HALF A CENTURY.

1630

round this time the tower is upgraded to a large country house by SIR JOHN LOWTHER. The tower becomes a cornerstone. Construction takes thirty years but after another thirty it is demolished.

1691

IT IS THE

FIRST
VISCOUNT
JOHN

WHO HAS THE HOUSE
TAKEN APART.
HE IMAGINES A SANDSTONE
MANSION & MAKES
THAT REALITY. DISASTER
STRIKES IN 1718,
THE UPPER STOREY AND
EAST WING
DESTROYED BY FIRE.

1805

WILLIAM

THE

1ST EARL OF
LONSDALE

HAS THE REMAINS OF THE MANSION

THEY ARE REPLACED
BY A
MAJESTIC CASTLE.

SHINING AND BRAND NEW
IT NONETHELESS
CONVEYS THE FACT THAT
LOWTHERS HAVE LIVED HERE
FOR CENTURIES.

1942

DURING WWII

THE BRITISH ARMY
REQUISITION LOWTHER.

THEIR MISSION

Test a secret weapon,
concreting huge
areas for armoured
tanks to traverse.

THE GROUNDS ARE BATTERED.

1957

It looks
like the
end for
Lowther
Castle,

unstable &
dangerous.

The roof is removed and a commercial chicken farm installed. | Conifer plantations cover much of the grand old Gardens.

2012

NEW CHAPTER
UNFOLDS.

THE LOWTHER
CASTLE & GARDENS
CHARITABLE
TRUST WELCOMES
VISITORS. SEE THE
TRANSFORMATION
BROUGHT ABOUT
BY AN ARMY
OF CRAFTSMEN
AND VOLUNTEERS.

Burns Night
...

An invitation to a party in which
the type became an illustrative image.
Fitting for a typesetting company.

**Covent Garden Art
Company** | 1988

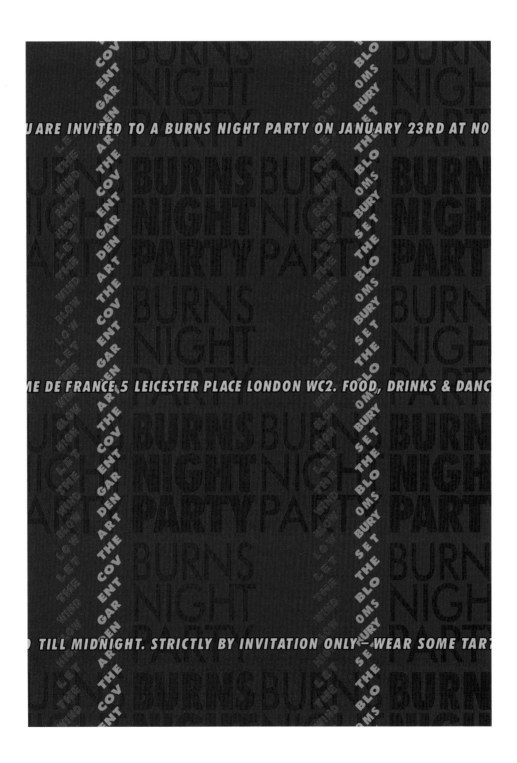

Wedding Invitation
..
A dot printed on a thin piece of tracing
paper is all that separated the bride
from the groom.

Mr & Mrs Huby | 2006

Silver Anniversary Party
...
It takes a Silver Anniversary to give you
an idea of how quickly time slides past.

Conways | 1986

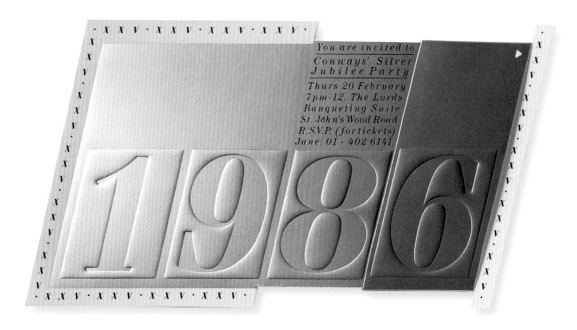

The Mint With The Hole
..
So often it's what you strip away
that makes something work. In this
project, a refreshing look at type as
image for an iconic brand. Art Director
Billy Mawhinney and Copywriter
Nick Welsh.

J Walter Thompson/**Nestlé** | 1992

The More You Practise
..
A bit of serendipity (with the help
of a few clever ligatures) can be
the lucky break you need to create
a 'Lubalinesque' poster.

**Berthold Typographic
Communications** | 1990

The Chase Has Moved
...
With the absolute minimum adjustment
to our logo, we were able to announce
that we had moved offices in London.

The Chase | 2014

the chase has moved
12 Newburgh Street, London W1F 7RP
thechase.co.uk

Our contribution to an exhibition
of posters in which the designers
were asked to explore 'northernness'.
The solution suggests a sporting
confrontation between two
stereotypical views of Northern
England. A typographic twist
connects two words similar in
structure but opposing in meaning.

Made North | 2016

Africa 2007

A celebration of culture and identity.
This exchange promoted awareness,
education, employment and the arts.
In this poster campaign, expressive use
of typography gave the event a sense
of excitement and energy.

British Council | 2007

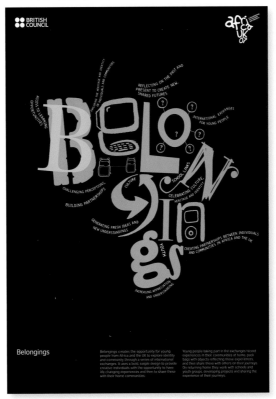

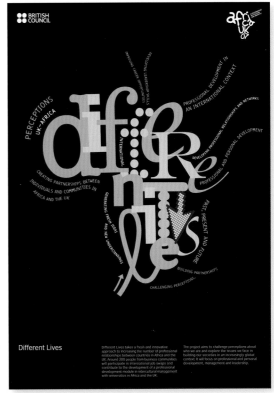

Shakespeare Stamps
..

To mark the 400th anniversary of Shakespeare's death, Royal Mail commissioned us to design a set of stamps. A typographic solution seemed an appropriate way to commemorate the greatest writer in the history of the English language.

Royal Mail | 2016

to thine own self be true
1st
HAMLET SHAKESPEARE

COWARDS DIE MANY TIMES BEFORE THEIR DEATHS · THE VALIANT NEVER TASTE OF DEATH BUT ONCE·
1st
JULIUS CAESAR SHAKESPEARE

Love is a smoke made with the fume of sighs
1st
ROMEO AND JULIET SHAKESPEARE

THE FOOL DOTH THINK HE IS WISE, BUT THE WISE MAN KNOWS HIMSELF TO BE A FOOL.
1st
AS YOU LIKE IT SHAKESPEARE

THERE WAS A STAR DANCED, and under that — WAS I — BORN.
1st
MUCH ADO ABOUT NOTHING SHAKESPEARE

BUT IF THE WHILE I THINK ON THEE, DEAR FRIEND, ALL LOSSES ARE RESTORED AND SORROWS END.
1st
SONNET 30 SHAKESPEARE

LOVE comforteth like sunshine after rain
1st
VENUS AND ADONIS SHAKESPEARE

WE ARE SUCH STUFF AS DREAMS ARE MADE ON; AND OUR LITTLE LIFE IS ROUNDED WITH A SLEEP.
1st
THE TEMPEST SHAKESPEARE

Life's but a walking shadow, a poor player That struts and frets his hour upon the stage
1st
MACBETH SHAKESPEARE

I wasted time, and now doth time waste me
1st
RICHARD II SHAKESPEARE

COWARDS DIE MANY TIMES BEFORE THEIR DEATHS · THE VALIANT NEVER TASTE OF DEATH BUT ONCE·
1st
JULIUS CAESAR SHAKESPEARE

to thine own self be true
1st
HAMLET SHAKESPEARE

I wasted time, and now doth time waste me
1st
RICHARD II SHAKESPEARE

Calligraphy Peter Horridge

SHAKESPEARE

arwickshire farming families: those were the origins of John Shakespeare and his wife, Mary. John moved from a village into the market town of Stratford-upon-Avon and set himself up as a glove-maker. He became a town counsellor but then ran into financial difficulties during the first Elizabethan credit crunch. As an alderman of the town, he was entitled to send his children to the local grammar school free of charge. He could not have done his son William – who was born in 1564 – a better favour.

The new network of grammar schools was essential to Queen Elizabeth I's unification of the nation. Education was the seedbed of Britain's prosperity, its burgeoning empire and its energetic cultural life. The King's School in Stratford-upon-Avon, with a bright young Oxford graduate as master, imparted a rigorous grounding in the arts of eloquence and debate via the Latin language. Among the set texts were such literary classics as Ovid's *Metamorphoses*. Young Will was supposed to study their style, but he seems to have taken equal pleasure in their raucous, sexy content.

Schooldays came to an end. Shakespeare's whereabouts in the next few years still constitute one of the great mysteries of English literature. Academics tend to favour the theory, first circulated by the biographer John Aubrey in the late 17th century, that he was a country schoolmaster. A series of tenuous, circumstantial connections raise the possibility that he became tutor in a Catholic household in Lancashire. Lawyers prefer the theory that he was a lawyer's clerk. Others lean towards the image of him as a soldier in the Flanders wars, a traveller in Italy or a sailor.

SONNET 147

*For I have sworn
thee fair, and
thought thee bright,
Who art as
black as hell,
as dark as night.*

At the age of 18, Shakespeare married Anne Hathaway, a woman eight years older than him and three months pregnant with his child, a daughter whom they would call Susanna. Thereafter, he must have been at home in Stratford periodically – his twins, Hamnet and Judith, were born a couple of years later. But the 'lost years' came to an end only when he turned up in London's theatreland in the early 1590s.

What we do know for sure is that over the next 20 years, Shakespeare, his leading actor Richard Burbage and their colleagues became the leading acting company in London. They built their own playhouse, the Globe, and they got the best royal-command performances. Operating as a joint-stock company, first under the patronage of the Lord Chamberlain, then that of King James himself, they shared the profits. Where other playwrights were paid a pittance on a piecework basis, William Shakespeare amassed a tidy fortune through his work as in-house company scriptwriter. He bought New Place, the second-largest house in his home town.

*I, therefore will begin. Soule of the Age!
The applause! delight! the wonder of our Stage
My Shakespeare, rife; I will not lodge thee by
Chaucer, or Spenfer, or bid Beaumont lye
A little further, to make thee a roome:
Thou art a Monument, without a tombe,
And art aliue still, while thy Booke doth liue,
And we haue wits to read, and praife to giue.*

BEN JONSON'S PRAISE OF SHAKESPEARE
IN THE FIRST FOLIO

What about Shakespeare's private life during this time? He can be traced to various addresses in east and south London, usually paying his taxes at the last possible minute. In 1604, while lodging in Cripplegate, he was called as witness in a civil lawsuit concerning the marital arrangements of his landlady's daughter. But everything about his own marital – and extramarital – affairs is a matter of speculation. His love sonnets are addressed to a fair aristocratic youth, probably the Earl of Southampton or the Earl of Pembroke, and a lascivious 'dark lady'. Are they driven by homosexual desire? Promiscuous intent? Misogynistic fury? Or are they an elaborate game, a series of fantasies, like his plays? We just do not know.

There were no more children, but the marriage survived. Perhaps in poor health, perhaps just bored, Shakespeare retired to Stratford-upon-Avon in about 1612. He became a little like his father: careful of his property, mildly litigious, a small-town worthy. What were his feelings for Anne? Some have detected an insult in the famous bequest to her of his second-best bed. But surely the right people for the largest bed were his daughter Susanna and her husband, a local doctor; second best would be good enough for a widow.

Shakespeare's greatest cunning was to never give too much away. He let his characters speak for themselves while keeping his own counsel, which leaves space for us to project our opinions on to him. According to Jorge Luis Borges, literary sage of South America, the key to Shakespeare is that he was at one and the same time 'everything and nothing'.

Mr. WILLIAM
SHAKESPEARES
COMEDIES,
HISTORIES, &
TRAGEDIES.
Published according to the True Originall Copies.

LONDON
Printed by Isaac Iaggard, and Ed. Blount. 1623.

To the Reader.

This Figure, that thou here feeft put,
It was for gentle Shakespeare cut:
Wherein the Grauer had a ftrife
with Nature, to out-doo the life :
O, could he but haue drawne his wit
As well in braffe, as he hath hit
His face ; the Print would then furpaffe
All, that was euer writ in braffe.
But, fince he cannot, Reader, looke
Not on his Picture, but his Booke.

B. I.

COAT OF ARMS
OBTAINED BY
SHAKESPEARE
FOR HIS FAMILY

THE TITLE
PAGE OF THE
FIRST FOLIO
OF WILLIAM
SHAKESPEARE'S
COLLECTED
PLAYS

POEM BY
SHAKESPEARE'S
FRIEND BEN
JONSON, FOUND
OPPOSITE THE
FIRST FOLIO
ENGRAVING OF
SHAKESPEARE

THE AFTERLIFE
When theatres reopened after the Restoration of King Charles II in 1660, Shakespeare's plays quickly returned to the stage. They have been performed ever since, through many changes in theatrical style.

GOOD FREND FOR IESVS SAKE FORBEARE,
TO DIGG ͞HE DVST ENCLOASED ͞HEARE.
BLESE BE Ẏ MAN Ẏ SPARES ͞HES STONES,
AND CVRST BE HE Ẏ MOVES MY BONES.

THE CURSE ON
SHAKESPEARE'S
GRAVE AND AN
IMPRESSION OF
A SIGNET RING
THOUGHT TO
BE HIS

*to thine
own self
be true*

1st

HAMLET SHAKESPEARE

COWARDS DIE
MANY TIMES
BEFORE THEIR
DEATHS·THE
VALIANT
NEVER TASTE OF
DEATH BUT ONCE·

1st

JULIUS CAESAR SHAKESPEARE

Love
is a smoke
made with
the fume
of sighs

1st

ROMEO AND JULIET SHAKESPEARE

THE FOOL
DOTH THINK
HE IS WISE,
BUT THE
WISE MAN
KNOWS
HIMSELF TO
BE A FOOL.

1st

AS YOU LIKE IT SHAKESPEARE

THERE WAS A
STAR DANCED,
and under that
WAS I
BORN.

1st

MUCH ADO ABOUT NOTHING SHAKESPEARE

BUT IF THE
WHILE I THINK
ON THEE,
DEAR FRIEND,
ALL LOSSES
ARE RESTORED
AND SORROWS
END.

1st

SONNET 30 SHAKESPEARE

LOVE
comforteth
like sunshine
after rain

1st

VENUS AND ADONIS SHAKESPEARE

WE ARE
SUCH STUFF
AS DREAMS
ARE MADE ON;
AND OUR
LITTLE LIFE
IS ROUNDED
WITH A SLEEP.

1st

THE TEMPEST SHAKESPEARE

Life's but a
walking shadow,
a poor player
That struts and
frets his hour
upon the stage

1st

SHAKESPEARE

*Richard II
(1595–96),
Act 5, Scene 5*

*I wasted
time, and now
doth time
waste me*

1st

RICHARD II SHAKESPEARE

Use of Type | Mailer

Big Things

Sainsbury's were using two typefaces across many media, when they really only needed one. A consistent, corporate font, one which could shout promotion yet still be read easily in body text sizes. We created that font. The serifs reduce as the type size gets larger, maintaining a family unison throughout.

Sainsbury's | 1990

SERIF SANS SERIF NEW SAINSBURY'S FONT

Light

Medium

Demi

Bold

SAINSBURY BOLD

Sainsbury's had a problem. They were using two corporate typefaces, but they only wanted to project one corporate image. Each face was fine on its own, but the effect of both together was to make the company look distinctly schizophrenic. When they asked us to sort it out, we went right back to basics.

One of the Sainsbury's typefaces was a serif (i.e it had little knobbly bits on all the characters), the other was a sans serif (i.e it didn't).

Traditionally, serif faces which evolved from handwritten manuscripts– have always been considered more readable for large amounts of text; while clean, uncluttered sans serif faces have been used when instant legibility is required, for example on motorway signs.

This historic divide was working against our client. The problem, it seemed to us, was that typefaces, whether serif or sans, had always been designed by specialists, in isolation. No one had ever really attempted to develop a "family" of faces that would satisfy all the demands of a large corporate organisation.

So we thought we would be the first. The brief we set ourselves was to produce a hybrid of the two existing Sainsbury's faces that could be used for anything from shelf labels to signage.

The secret? Diminishing serifs. In its lighter weights, intended mainly for text, the typeface we designed is a serif; but as its weight increases, so the serifs shrink. Until by the time we reach the heaviest weight–which would be used for the biggest, boldest statements–the face is virtually a sans. Yet, however it's used, the face is always unmistakably part of a single, consistent corporate type family in its shape and characteristics.

Use of Type | Typeface

..
Client Index
..

All these people have in some way contributed to the work in this book. Whilst we have not been able to include every student placement, we have listed everyone employed by the company for longer than six months. We have made every effort to be accurate but if we have inadvertently missed anyone out we sincerely apologise.

Hugh Adams
Deborah Allitt
Claire Anderton
Simon Andrews
Sam Atkins
Bill Atkinson
Marc Atkinson
Andrew Bainbridge
Sharron Bardsley
Vicky Beswick
Vicky Bembridge
Stuart Beveridge
Adrian Bibby
Sarah Bibby
Ric Bixter
Kevin Blackburn
Chris Bracewell
Lise Brian
Matt Brown
Martyn Bullock
Lizzie Cameron
Ben Casey
Chris Challinor
Mathew Chappell
Rob Clayton
Sue Clements
Pete Cole
Rachel Conchie
Steve Conchie
Emma Cotsford
Dulcie Cowling
Paul Critchley
Holly Davis
Stuart Devlin
Harriet Devoy
Sarah Dutton
Mike Emerson
Liz Entwistle
Matthew Evans
Leanda Falcon
Simon Farrell
Tim Fellows
Michael Fraser
Mala Ghosh

Mark Gill
Steve Glennon
Kate Goulding
Jimmy Graham
Andy Gregory
Stephanie Hamer
Glenn Hanforth
Susan Hanlon
Billy Harkcom
Lionel Hatch
Paul Heaton
Harry Heptonstall
Alan Herron
Jo Hooper
Mark Hosker
Karen Hughes
Mark Hurst
Beverley Hutchinson
Sarah Ilsey
Chris Jefferys
Bryn Jones
Kirsten Jones
Sarah Jupp
Dan Keeffe
Sandra Kemp
Faye Kenilworth
Adrian Kilby
Cath King
Rita Kinsella
Christine Ladley
Bryn Ledgard
Carl Leek
Adele Littler
Baldwin Li
Paul Lomas
Jackie Long
Rebecca Low
Thanh Luu
Chris Maclean
Andy Mairs
Oliver Maltby
Guy Marshall
Stuart Mawhinney
Stephanie McGregor

Thomas McInally
Mike McLauchlan
Tom McNaught
Grant Mitchell
Stuart Mitchell
Martin Monks
Johanna Morritt
Emma Morton
Rachel Moseley
Peter Mowyer
Paul Murray
Janet Neil
Claire Newton
Keith Noble
Damian Nowell
Angelina O'Brian
Craig Oldham
Eileen O'Leary
Edwina Olins
Kristen Ord
Sarah Parkinson
Ben Parish
Pamela Pemberton
Monica Pirovano
Chris Plant
Rachel Pratt
Stuart Price
Carrie Probin
Rahul Ramanuj
Samuel Ratcliffe
Kay Richardson
Peter Richardson
Dave Rickus
Mike Rigby
Alex Roberts
Mike Roberts
Mark Ross
Ivan Rowles
Stephen Royle
Fernando Ruiz
Richard Rubin
Li Rui
Lucie Sample
Richard Scholey

Ed Scott-Clarke
Andrew Seaborne
Tommy Shaughnessy
Mika Shepherd
Alistair Sim
Rachel Simpson
Chris Smart
Julie Smith
Abi Stone
Clare Storey
Rob Summerfield
Abi Swainbank
Ben Swift
John-Paul Sykes
Dave Tevlin
Dave Thompson
Mat Thornton
Josh Turner
Drishna Vara
Tanya Wainwright
Mitch Walker
Mike Wallis
Syreeta Warrington
Paul Waters
Mike Watson
Craig Webster
Ginny Welford
Steve White
Rob Whittingham
Gary Whitworth
Tristan Wickham
Jens Wickelgren
Samantha Wilkinson
Jim Williams
Jan Wood
Andrea Wright

© 2017 Black Dog Publishing Limited,
London, UK and the authors.

All rights reserved.

Black Dog Publishing Limited
308 Essex Road, London, N1 3AX
United Kingdom

t: +44 (0)20 7713 5097
e: info@blackdogonline.com
www.blackdogonline.com

Designed by The Chase

All opinions expressed within this
publication are those of the authors
and not necessarily of the publisher.

British Library in Cataloguing Data
A CIP record for this book is available
from the British Library.

ISBN 978 1 911164 09 8

Black Dog Publishing Limited, London,
UK, is an environmentally responsible
company. *The Wood That Doesn't
Look Like an Elephant* is printed on
sustainably sourced paper.

the chase

**black dog
publishing**
london uk